STREET CARS
OF WASHINGTON D.C.

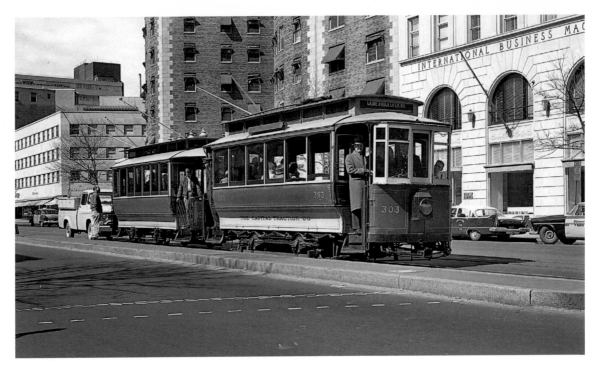

On an April 16, 1961 rail excursion, car No. 303 and trailer No. 1512 are on Connecticut Avenue at K Street NW. This trackage was used by street car routes 40 and 42. Washington, DC, is divided into four unequal quadrants centered on the Capitol Building. Northwest (NW) is located north of the National Mall and west of North Capitol Street. Northeast (NE) is located north of East Capitol Street and east of North Capitol Street. Southeast (SE) is located south of East Capitol Street and east of South Capitol Street. Southwest (SW) is located south of the National Mall and west of South Capitol Street. (Bob Hadley photograph - C. R. Scholes collection.)

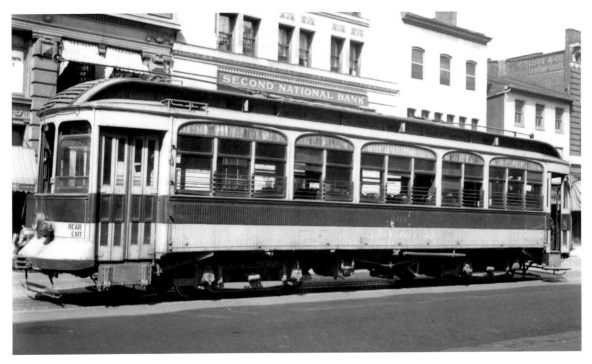

Interurban car No. 964, with its distinctive arch windows, is at 14th and G Streets NW on August 30, 1936. This was originally Washington Railway & Electric Company (WRECO) car No. 594 built by the J. G. Brill Company in 1908. Seating 48 and weighing 53,100 pounds, the car was powered by four Westinghouse type 101b motors which in 1910 were replaced by Westinghouse type 3066 motors. The car was assigned to the longer routes from Washington, DC, to Rockville and Laurel. In 1933 it was operated by Capital Transit Company (CTC), renumbered 964, and was scrapped in 1941. (Bob Hadley photograph - C. R. Scholes collection.)

STREET CARS
OF WASHINGTON D.C.

KENNETH C. SPRINGIRTH

AMERICA
THROUGH TIME®
ADDING COLOR TO AMERICAN HISTORY

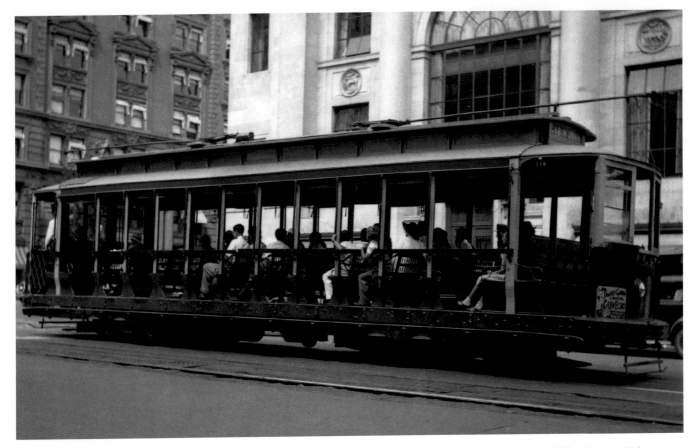

Double truck open motor car No. 1625 is at G and 14th Streets NW on August 26, 1934. Powered by two General Electric type 57A motors, this was one of 50 cars Nos. 400-449 built by American Car Company in 1899 for the Metropolitan Railroad Company. These cars became Capital Transit Company cars Nos. 1600-1649 in 1933. (Bob Hadley photograph - C. R. Scholes collection.)

On the top portion of cover: DC Transit System route 54 Presidents' Conference Committee (PCC) car No. 1103 is at the 14th Street and Colorado Avenue loop in Northwest Washington, DC, for a trip to the Navy Yard on March 29, 1957. This was one of 22 PCC cars Nos. 1101-1122 built in 1937 by St. Louis Car Company. Each car was powered by four Westinghouse type 1432 motors and weighed 33,800 pounds. This car was scrapped in 1963. (C. Abel photograph - C. R. Scholes collection.)

On the bottom portion of cover: Car No. 303 (one of 70 double ended cars built in 1898 by the American Car Company of St. Louis for Capital Traction Company seating 26, weighing 19,990 pounds, and powered by two General Electric type 1000 motors) and trailer No. 1512 (a single truck closed trailer No. 212 built by the John Stephenson Car Company in 1892 for the Washington & Georgetown Railroad Company and renumbered as 1512 by Capital Traction Company in 1906) are at 14th and E. Capitol Street in Washington, DC. Both cars are at the Smithsonian Institute. (Kenneth C. Springirth photograph.)

Back cover: Car No. 303 and trailer No. 1512 are posed for a picture stop at Union Station on an April 16, 1961 rail excursion. Car No. 303 was originally painted yellow and cream plus lettered for the 7th Street line, and was repainted green and cream in 1906. Although the car was taken out of service on January 31, 1913, it was later used in excursion service with trailer No. 1512. (Kenneth C. Springirth photograph.)

America Through Time is an imprint of Fonthill Media LLC

First published 2016

Copyright © Kenneth C. Springirth 2016

ISBN 978-1-63499-012-7

Typeset in Utopia Std

Published by Arcadia Publishing by arrangement with Fonthill Media LLC

For all general information, please contact Arcadia Publishing:

Telephone: 843-853-2070
Fax: 843-853-0044
E-mail: sales@arcadiapublishing.com
For customer service and orders:
Toll-Free 1-888-313-2665

Visit us on the internet at www.arcadiapublishing.com

Contents

Acknowledgments 6

Introduction 7

Chapter 1 Capital Transit Company 11

Chapter 2 DC Transit System 19

Chapter 3 Routes 10/12 Kenilworth/Seat Pleasant 23

Chapter 4 Route 20 Cabin John 29

Chapter 5 Route 30 Friendship Heights 39

Chapter 6 Routes 40/42 Lincoln Park/13th & D St. 49

Chapter 7 Routes 50/54 Bureau of Engraving/Navy Yard 59

Chapter 8 Route 60 Eleventh St.–6th Pennsylvania Ave. 71

Chapter 9 Routes 70/72/74 Georgia Ave.–7th St. 73

Chapter 10 Route 80 N. Capital St. 87

Chapter 11 Route 82 Branchville 95

Chapter 12 Routes 90/92 New Jersey Ave.–17th 105
 Pennsylvania Ave./Florida Ave.–Navy Yard

Chapter 13 DC Streetcar H St.–Benning Rd. 113

Chapter 14 National Capital Trolley Museum 125

Acknowledgments

Thanks to the Erie County (Pennsylvania) Public Library system for their excellent inter-library loan system. Cliff R. Scholes was an excellent source for pictures. Books that served as excellent reference sources were *Capital Transit: Washington's Street Cars, The Final Era 1933-1962* by Peter C. Kohler and *100 Hundred Years of Capital Traction, The Story of Streetcars in the Nation's Capital* by LeRoy O. King Jr. The report *Peer Review for the District Department of Transportation Washington, DC, Final Report June 2015* by the American Public Transportation Association provided an insight on the new Washington, DC, H Street Benning Road street car line. Thanks to the National Capital Trolley Museum located at 1313 Bonifant Road, Colesville, MD 20905-5955 (telephone number: 301-384-6088) for conducting their Cavalcade of Trolleys on April 17, 2016 which showcased four of their marvelously restored street cars. Their all-volunteer staff headed by Director of Administration Ken Rucker has created an outstanding museum. Ken Rucker also provided information on the museum and had proof read the chapter pages of the book. United States transit systems could actually use this museum as a benchmark for well dressed, informed, friendly, and safety conscious car operators. This well-kept museum, which even features a theater – where street cars are the main attraction in the films – is a must see for students of transportation, educators, and anyone visiting the Washington, DC, area. This book is dedicated to the author's daughter Grace Turnbull, her husband Eric, and their daughter Faith.

In this book, "street car" will be written as two separate words in all of the chapters except for Chapter 13, because that was how it was used by Capital Transit Company and DC Transit System. In Chapter 13, it is written as one word, "street-car," because that is how it is used by the new DC Streetcar line.

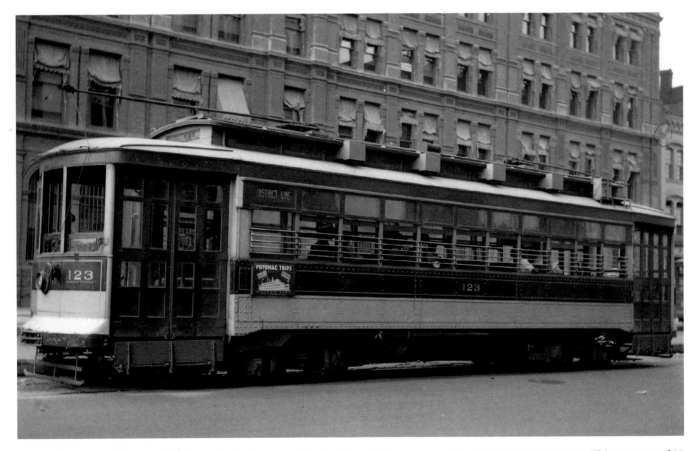

New York Avenue NW east of 15th Street is the location of Capital Transit Company car No. 123 on August 26, 1934. This was one of 28 cars Nos. 104-131 built in 1906-1907 by Cincinnati Car Company for Capital Traction Company. Powered by two Westinghouse type 101B motors, each car weighed 35,285 pounds and seated 40. These cars retained their original number by Capital Transit Company in 1933 and were scrapped in 1939. (Bob Hadley photograph – C. R. Scholes collection.)

Introduction

Rail transit development in Washington, DC, was influenced by Congressional oversight, and civic pride that took the extra effort to make sure progress would not undermine their beautiful urban avenues.

On July 29, 1862, horse car service of the Washington & Georgetown Railroad Company connected the United States Capitol to the State Department and was expanded to Georgetown on August 20, 1862. The second horse car operator was the Metropolitan Railroad Company, which began service between the Capitol and the War Department on January 6, 1865. Columbia Railway Company was the third horse car operator, completing a double track line in March 1872, operating on New York Avenue, K Street, Massachusetts Avenue, and H Street, and ending at what is today 15th and H Streets.

Horses required feed, water, shelter, and were prone to epidemics. The slow moving horses had difficulty handling hills and produced large amounts of waste on the roads. The advent of electric railways helped to solve these problems, with Naval Academy graduate Frank Julian Sprague successfully supervising the installation of the first large scale electric railway in Richmond, Virginia, in 1888. That same year, the Eckington & Soldier's Home Railway Company – incorporated on June 19, 1888 – opened the first electric street car line with center pole overhead wire construction on October 17, 1888 from 7th and New York Avenue via New York Avenue to Boundary Street (now Florida Avenue) to Eckington Place; north on R Street; R Street to 3rd Street; 3rd Street to T Street; and T Street to 4th Street.

On May 12, 1890, the Washington & Georgetown Railroad Company opened Washington's first cable car line on 7th Street using a continuous cable for the entire route. The Rock Creek Railway Company opened a line on Calvert Street, across the Rock Creek Valley via what later became Connecticut Avenue to Chevy Chase Lake on September 16, 1892.

Under a new law, after July 1, 1893 overhead wire could not be used in the city south of Boundary Street (later Florida Avenue) because of Congressional concern over the appearance of overhead wires in the City of Washington. Overhead wire could still be used in what was historically known as the County of Washington, and Maryland and Virginia suburbs. On August 2, 1894 an Act of Congress required the Metropolitan Railroad Company to construct an underground conduit system. Construction began on the conduit system designed by the General Electric Company. The Metropolitan Railroad Company began electric street car operation, with the new underground conduit system, on 9th Street on July 29, 1895 followed by the F Street line on June 30, 1896.

While the cable car track had a moving cable under the center slot, the new conduit system had two parallel conductor bars, carrying 600 volts, installed under the slot. A collector known as a plow (with two sliding shoes that collected positive and negative current from the two conductor bars) was suspended from under the street car into the slot making contact with the bars which supplied current to the motors. This system required a three-foot ditch; 350 pound cast iron yokes at five foot intervals to support the running rail with a cutout for the conductor bars; a drainage system; and inspection hatches on the street surface used to gain access for the cleaning, repair, and maintenance of the conduit system. The parts were supported by a continuous six-foot-wide concrete box designed to withstand use by the street cars. At switches, there was a break in the conductor rails so that the positive and negative conductors would not meet on crossing. The switch mechanism directed both the car wheels and the plow. As a car moved from the conduit system to the overhead wire section, the plow was removed. From the overhead wire to the conduit system, the plow was installed. This was done by a person stationed in the pit. The plow system was efficient and avoided overhead wires which enhanced the urban environment. There were many detractors in conduit systems: conduit track construction was three times more expensive; very hot weather resulted in expansion of the slot rails which could pull the plow; snow had to be cleaned out of the conduit; tire chain parts could foul the slot resulting in pulling the plow; track work had to be done under traffic because temporary track could not be used; the drainage system was cleaned semiannually to prevent flooding of the system's slot cavity; and plows needed repair. During snow storms, snow sweepers were required to clear snow from the tracks. Salt could not be used on streets that had the conduit system, because it would short out the conductor bars.

The Rock Creek Railway Company acquired the Washington & Georgetown Railroad Company on September 21, 1895 and formed the Capital Traction Company which began electric street car service on the 14th Street line on January 28, 1898, followed by a new line from the Peace Monument to Georgetown on March 20, 1898. By December 31, 1898, Capital Traction Company was entirely electrified. The Eckington & Soldiers Home Railway Company, the Columbia & Maryland Railway Company, and the Maryland & Washington Railroad

became the City & Suburban Railway of Washington on June 14, 1898 which opened electric street car service from the District Line to Hyattsville. In 1899 a number of properties including the Brightwood Railway Company, Metropolitan Railroad Company, Anacostia & Potomac River Railroad Company, Columbia Railway Company, City & Suburban Railway of Washington, and Potomac Electric Power Company became part of the Washington Traction & Electric Company. Following a January 26, 1901 reorganization, on February 1, 1902, the company became the Washington Railway & Electric Company (WRECO).

In its early years, Capital Traction Company mainly operated two car trains of single truck cars painted for route identification. Georgetown cars were green with cream trim. Dark yellow with cream trim were used for 7th Street cars. Lemon yellow with cream trim was used for 14th Street cars. During 1906-1907, Capital Traction Company extended its 14th Street line from Park Road to Colorado Avenue and constructed a carbarn at 14th and Decatur Streets NW. The need to regulate public utilities including street railways in Washington, DC, resulted in the formation of the DC Public Utilities Commission (DCPUC) in March 1913.

A number of street car companies served Washington's suburban areas. The Kensington Railway Company opened on May 30, 1895 from Chevy Chase Lake to Kensington. Facing financial problems, it became the Sandy Spring Railway Company on March 23, 1906 and was completed to Norris Station in 1916. Capital Traction Company operated through service on this line to downtown Washington, DC, beginning August 1, 1923 until August 1, 1933. The Kensington line operated independently until Capital Transit Company abandoned Connecticut Avenue service in September 1935.

During 1896, the Washington, Alexandria & Mount Vernon Railway connected Washington, DC, with Mount Vernon, Virginia, with service ending on January 18, 1932.

Baltimore & Washington Transit Company, in September 1897, opened a line from 4th and Butternut Streets via Aspen Street, Laurel Avenue, Carroll Avenue, and Ethan Allen Avenue, to Heather and Elm Streets in Takoma Park Avenue. Financial problems, plus a carbarn fire, resulted in it becoming the Washington & Maryland Railway Company. Capital Traction Company leased the line on May 2, 1918 and later acquired stock ownership. The Maryland portion of the line was abandoned in August 1927 and the remainder ended in April 1937.

In 1900, the Washington Ohio & Western steam railroad reached Bluemont, Virginia. It was leased by the Washington & Old Dominion Railway in 1911 and electrified in 1912. Passenger service was operated from Georgetown (Rosslyn after 1923) to Bluemont until ending in 1941.

The East Washington Heights Traction Railroad Company of the District of Columbia opened a 0.72-mile line from 17th and Pennsylvania Avenue across the Anacostia River on September 1, 1905 with service ending on December 1, 1923.

Street car lines continued to open until World War I. After World War I, transit ridership declined as automobile usage increased, and lines were converted to bus operation. Washington, Spa Spring & Gretta Railroad Company opened a line from 15th and H Streets NE to Bladenburg on August 27, 1910 and Berwyn Heights in 1912. Buses took over the section from East Riverdale to Berwyn Heights on June 11, 1921; from 15th and H Streets NE to Bladensburg on April 22, 1923; and from Bladensburg to East Riverdale on April 4, 1925.

On July 2, 1913, the Washington and Great Falls Railway and Power Company opened a 10.5-mile line that left a junction with the Rockville line at Bethesda to Great Falls and was discontinued on February 12, 1921.

In 1923, WRECO converted its Bladensburg street car line to bus operation followed in 1925 by buses replacing street cars on the Macomb line, plus service from Beltsville to Laurel was abandoned with service provided between Beltsville and Branchville. During 1925, the North American Company acquired control of WERCO. Since WERCO controlled Potomac Electric Power Company (PEPCO), it meant that the North American Company now controlled PEPCO. The Washington Rapid Transit Company, a new bus company, began bus service March 1, 1921 on 16th Street.

Capital Traction Company converted the F & G Street line to bus operation on May 3, 1931. In 1932, Capital Traction Company had 71 miles of track (47 miles conduit and 24 miles with overhead wire) with 337 street cars while WRECO had 155 miles of track (64 miles conduit and 91 miles with overhead wire) with 452 street cars.

Following five years of review and hearings, Capital Traction Company and WERCO officially merged into Capital Transit Company (CTC) on December 1, 1933. During 1935, 20 new streamliner street cars were purchased, 10 from J. G. Brill Company Nos. 1001-1010 and 10 from St. Louis Car Company Nos. 1051-1060. The Electric Railway Presidents' Conference Committee, which included street car manufacturers and suppliers, had completed a new Presidents' Conference Committee (PCC) car in 1936 that revolutionized street car service with its quiet comfortable ride. By 1937, the first PCC cars entered service in Washington, DC. Transit ridership increased during World War II; however, after the war, ridership declined.

Louis Wolfson obtained control of CTC in 1949 leading to fare increases, decline in service, and a lengthy strike that caused the company's franchise to be revoked. DC Transit System (DCTS) took over on August 15, 1956 under a requirement to provide an all-bus system. Although DCTS made every effort to retain the street car system – including a new paint scheme and creating the world's first air conditioned street car – they were forced to convert to bus operation. Street car service ended on January 28, 1962, but returned 54 years later on February 27, 2016 with the 2.4-mile H Street/Benning Road streetcar line.

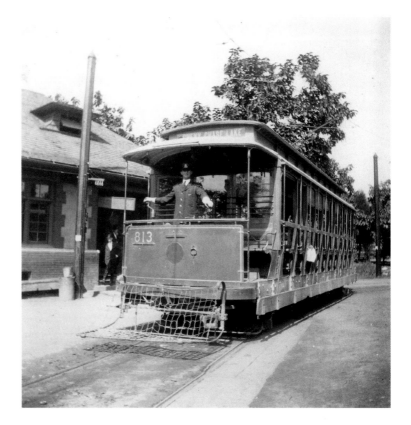

Car No. 813, built in 1909 by the Cincinnati Car Company, is operating on the Rock Creek Railway Company connecting Chevy Chase Lake with Washington, DC. This line began service on September 18, 1892. The Chevy Chase Land Company opened the Chevy Chase Lake Amusement Park in 1894 to attract potential buyers of house lots for their new suburban development, plus increase evening and weekend ridership for the street car line.

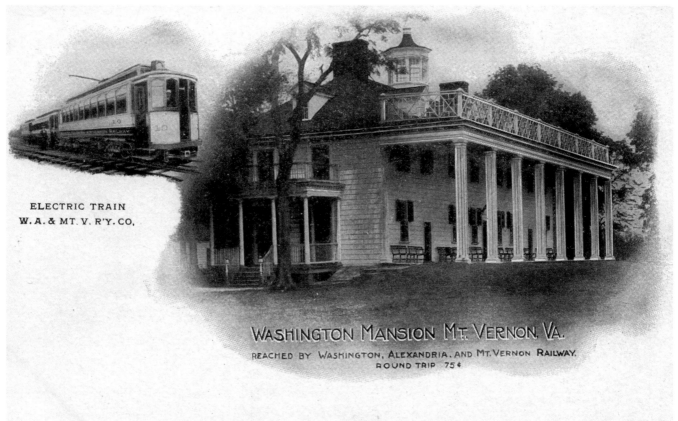

ELECTRIC TRAIN
W. A. & MT. V. R'Y. CO.

WASHINGTON MANSION MT. VERNON. VA.
REACHED BY WASHINGTON, ALEXANDRIA, AND MT. VERNON RAILWAY.
ROUND TRIP 75¢

In this postcard view of the Washington mansion at Mt. Vernon, a Washington, Alexandria & Mount Vernon (WAMV) street car has been added. The WAMV opened between Alexandria and Mount Vernon, Virginia, in 1892 and was extended into Washington, DC, in 1896. It merged with the Washington, Arlington & Falls Church Railway forming the Washington-Virginia Railway Company in 1913. The company went into receivership in 1923 and was sold at auction as two separate companies. Street car service ended on January 18, 1932.

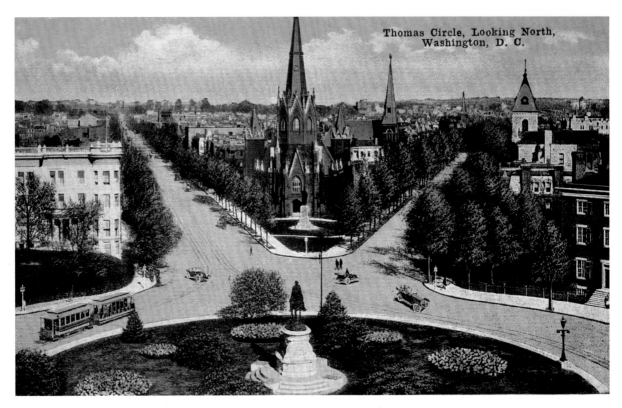

A Capital Traction Company two-car train of single truck cars on the 14th Street line is passing around Thomas Circle (named for Union Army General George Henry Thomas with his statue in the center) looking north at the intersection of 14th Street, M Street, Massachusetts Avenue, and Vermont Avenue NW, around 1910. In the top center of this postcard is the red sandstone Luther Place Memorial Church, built in 1873, with a statue of Martin Luther in front of the church.

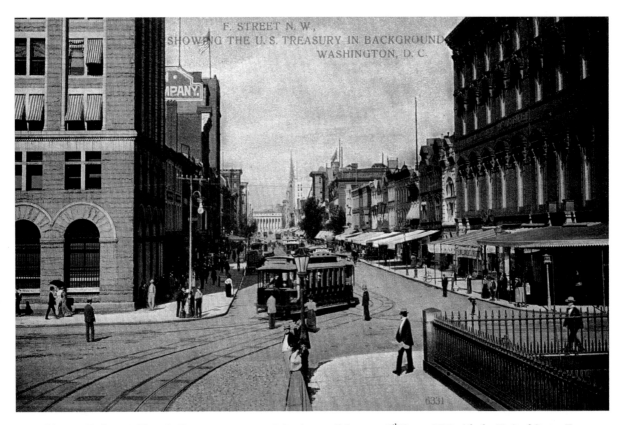

A Washington Railway & Electric Company open car is in view on F Street at 9th Street NW with the United States Treasury Building in the distance west of this intersection in this 1908 postcard scene.

Chapter 1

Capital Transit Company

On December 1, 1933, Capital Traction Company and WRECO merged into the Capital Transit Company (CTC) resulting in all of the street car lines in Washington, DC, falling under the management of one company.

Within two years, many street car lines were converted to bus service. The 4½ Street branch of the Soldiers Home line was converted to bus operation in 1934 with bus service looping at Constitution Avenue, 10th Street, Pennsylvania Avenue, and 6th Street. On January 7, 1935, the Le Droit Park street car line (4th & New York Avenue-Georgia Avenue & W Street) was converted to bus operation. The P Street line (Dupont Circle to Wisconsin Avenue) was converted to bus operation on June 16, 1935. Buses took over the Anacostia Heights line (1st and B Street SE to Congress Heights) on July 16, 1935. The Rockville line was converted to bus operation north of the District Line to Rockville on August 4, 1935 followed by the conversion to bus operation of the Chevy Chase line from Rock Creek loop to Chevy Chase Lake to bus operation on September 16, 1935.

As well, in 1935 Capital Transit Company invested in new street cars numbered 1001-1010 from J. G. Brill. Weighing 35,000 pounds, each car was powered by four Westinghouse type 1426L motors. Car No. 1001 arrived on May 12, 1935 and made its first test run between Rosslyn and the Peace Monument on May 14, 1935. Capital Transit Company purchased cars 1051-1060 from St. Louis Car Company in 1935. Weighing 34,750 pounds, each car was powered by four General Electric type 1193 motors. Cars 1001-1010 & 1051-1060 seated 49, had a length of 43.98 feet long, width of 8.43 feet, and a wheel diameter of 24 inches. These cars first operated from Georgetown carhouse and were used on the Rosslyn-17th & Pennsylvania Ave. SE line. From November 1936 to September 1953, these cars operated from Western carhouse (Tenleytown), providing base service on route 30 Friendship Heights 17th & Pennsylvania Avenue SE. CTC purchased 49 street cars from the United Electric Railways Company of Providence, Rhode Island on May 25, 1936 for $1,800 per car. These cars were upgraded with helical gears, leather upholstered seats, new lights, and repainting at an additional per car cost of $3,000.

The new handsome stylish Friendship Heights terminal, designed by Washington, DC, architect, Arthur B. Heaton,

opened on Jun 11, 1936. On July 8, 1936, two of the refurbished Providence, Rhode Island, street cars were placed on display with one car at the Mt. Pleasant and Park Road storage track and the other car at the Wisconsin Avenue and Western Avenue terminal. The DCPUC ruled on September 23, 1936 that 45 of the former Providence, Rhode Island, cars and the 20 streamliners could be one man operated with implementation beginning October 2, 1936.

Route numbers were introduced on November 22, 1936. Under a modernization program, CTC ordered 45 new Presidents' Conference Committee (PCC) cars on December 24, 1936. CTC placed two of the new PCC cars on display at the Peace Monument loop on August 27, 1937 followed by a street car parade west on Pennsylvania Avenue and north on 14th Street to the Colorado Avenue loop. The parade, attracting crowds along the route, returned to the Navy Yard carbarn via 14th Street, Pennsylvania Avenue, and 8th Street SE. PCC car service began on the 14th Street line on September 4, 1937.

A new street car terminal and loop opened on January 26, 1941 at Barney Circle at the west end of the John Philip Sousa Bridge. On March 15, 1941, CTC opened street car service to the Southwest Mall with construction of tracks on 7th Street east and the loop costing $400,000 to better serve Government workers in the Social Security, Railroad Retirement, and Census Bureau buildings. Route 30 (Tenleytown-Pennsylvania Avenue) car line was rerouted from 7th and Pennsylvania south on 7th to Independence Avenue and over Independence between 7th and 1st Street. Cars of route 70 that went to the 7th Street wharves were operated south on 7th to Independence Avenue to the Southwest Mall. In addition, rush hour routes into the Southwest Mall were: route 13 (Rosslyn-Benning); route 33 (Friendship Heights-Tenleytown-Pennsylvania Avenue); route 43 (Mt. Pleasant); route 53 (14th Street); and route 63 (11th Street). Benning car house at Benning and Kenilworth Avenues NE, which opened on November 2, 1941, was the last new CTC car house.

During World War II, many men were drafted into the armed forces, so CTC started training women to help alleviate the labor shortage. The growth of the population of Washington, DC, plus gas rationing, had a huge impact on

transit ridership. In 1943, CTC carried 536,201,668 rail and bus passengers, the highest number ever carried in its corporate history, and 2.1 times the 250,293,626 passengers carried in 1940. From 1933 to 1943, the number of CTC street cars increased from 703 to 895 and the number of buses increased from 214 to 1,249. On April 27, 1942, construction began on a new underground loop at the Bureau of Engraving for route 50 cars which was placed in service on February 8, 1943. The last new street cars for Washington, DC, were 50 PCC cars Nos. 1540-1589 ordered from St. Louis Car Company on June 27, 1944. These were delivered beginning November 21, 1945, and the last car was delivered February 6, 1946.

The first transit strike on the CTC occurred on November 6, 1945. Lasting two days, both sides agreed to a fourteen-day cooling off period. There was little progress at the end of the period, thus another strike began at 3:10 a.m. on November 21, 1945. At 3:10 p.m. on November 21, 1945, United States President Harry S. Truman ordered the Federal Government to seize and operate the CTC. On January 2, 1946, the Labor Arbitration Board granted CTC operators a 12 cent per hour increase making their wage $1.14 per hour. President Truman returned the CTC to civilian control on January 8, 1946.

In 1946, the CTC had a total of 852 street cars, of which 489 were PCC cars. On January 6, 1948, all street car service was now one-man operated. The last two-man operated cars –Nos. 736-749 – were scrapped during 1948. The building of large housing projects along the Benning street car line resulted in adding more service. With a shorter time interval between street cars, there were delays for plow changes at the Benning Road and 16th Street plow pit during peak periods, which was a factor in the decision to convert the line to bus operation. Car No. 1520 was the last car to leave Seat Pleasant at 3:21 a.m., ending street car operation on the Benning line on May 1, 1949. The three-mile route 84 Branchville-Beltsville shuttle was abandoned on July 31, 1949, which eliminated some more private right-of-way and ended the use of conventional double ended cars. Car No. 369 left Beltsville at 1:35 a.m. for the last run. All service was now provided by PCC cars and the 20 early streamliners. With the completion of the Dupont Circle underpass during 1949, Washington, DC, had a modern, well-maintained street car system.

Washington, DC, had the fifth largest PCC car fleet (489 cars) in North America. Toronto was first with 744, Chicago second with 683, Pittsburgh third with 666, and Philadelphia fourth with 559. There were almost 5,000 PCC cars built, with 10 percent of them in Washington, DC. PCC cars for Washington, DC, were equipped for overhead operation, but were the only PCC cars in the world equipped with plows

for conduit operation. Ranging in length from 43.5 to 44 feet long, the PCC cars for Washington, DC, were about two feet shorter in length, or one less window, than most PCC cars, because of short clearances in car house transfer tables.

Under the Public Utility Holding Company Act passed by the United States Congress, the North American Company had to divest itself of either Capital Transit Company or PEPCO. They chose to sell Capital Transit Company. On August 12, 1949, controlling interest in CTC was bought by Louis Wolfson, a Florida financier. As fares increased, ridership declined, service was reduced, and public relations deteriorated. On September 10, 1950, only PCC cars and 1000 series streamliners were in service. With an increase in power costs and declining revenues, CTC increased the quarterly dividend from 50 cents to $1.00 a share on August 24, 1950. A three-day strike occurred from July 1, 1951 to July 4, 1951 that was settled by a 15 cent per hour increase plus an increase in fringe benefits. The company requested a fare increase to cover the increased labor costs, and the DCPUC on January 4, 1952 granted CTC a 10 cent increase in the weekly pass to $2.10 effective January 20, 1952. There was a reduction in employees, but the system continued to be maintained. By September 1953, the 1000 series streamliners were no longer in regular service.

On July 1, 1955 at 12:40 a.m., operators and maintenance employees went on strike for higher wages and improved pensions. The company would not settle without agreement from the DCPUC for a fare increase. In response, the United States Congress passed Public Law 389 signed by President Dwight D. Eisenhower on August 14, 1955, which gave the District Commissioner the right to settle the strike, revoke the company's franchise, and the new operator would be required to have an all bus system. The strike was settled on August 21, 1955 with wage and fare increases. Track crews had to remove debris from the conduit slot plus cut down weeds and realign track on the private right-of-way sections. Service was restored for the August 22, 1955 morning rush hour. Bids to replace CTC had been requested from prospective purchasers to operate an all bus system.

On October 5, 1955, a consultant hired by CTC testified before the DCPUC against immediate conversion of the street car system in favor of a seven-year phase out because the cars were in excellent condition, were more comfortable than a bus, and would cost $11 million to $16 million to bus the street car lines. Six bids were received by the DCPUC to replace CTC by the October 10, 1955 deadline. The DCPUC rejected the bids on December 20, 1955.

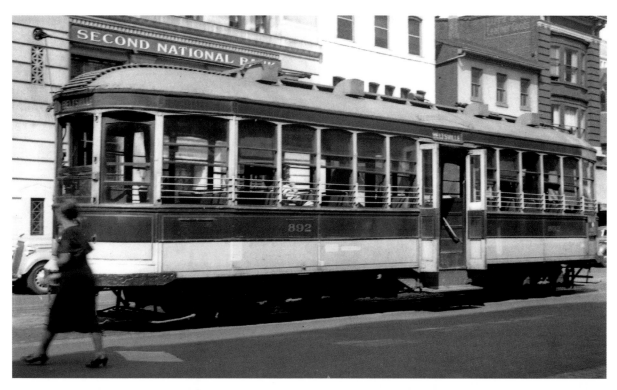

Center door CTC car No. 892 is at 14th and G Streets NW on August 30, 1936. This was one of 10 cars Nos. 651-660 built by Southern Car Company for WERCO in 1912-1913. The 41.7-foot-long cars were transferred to CTC in 1933 and were renumbered 885-894. Equipped with 30-inch diameter wheels and powered by four General Electric type 200 A motors, the cars weighed 40,400 pounds and seated 48 passengers. Car No. 892 was scrapped in 1939; all of these cars were scrapped by 1944. (Bob Hadley photograph - C. R. Scholes collection.)

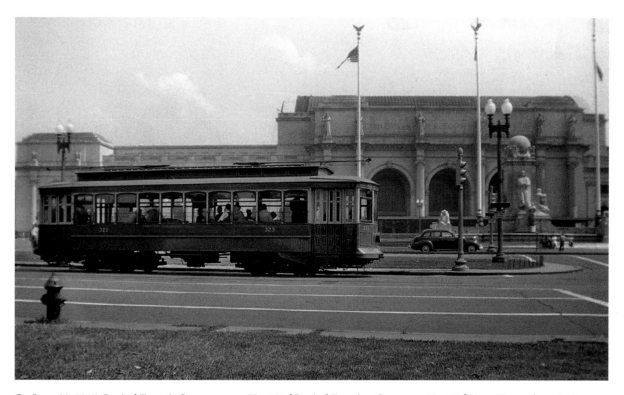

On June 22, 1947, Capital Transit Company car No. 323 (Capital Traction Company No. 737) is on Massachusetts Avenue NW at Union Station Plaza. Powered by two Westinghouse type 306 motors and weighing 33,857 pounds, this was one of 50 cars Nos. 701-750 built by Jewett Car Company in 1912 for the Capital Traction Company. These cars became Capital Transit Company (CTC) cars Nos. 287-336 in 1933 and were scrapped by 1947. (C. R. Scholes collection.)

WASHINGTON D.C. STREETCAR LINES
NOT TO SCALE

30 FRIENDSHIP HEIGHTS-
17TH & PENNSYLVANIA AVE. S.E.

50 14TH & COLORADO-
BUREAU OF ENGRAVING

54 14TH & COLORADO-
NAVY YARD

1943 TRACK MAP

40 MT. PLEASANT - LINCOLN PARK
42 MT. PLEASANT- 13TH & D N.E.

90 CALVERT BRIDGE VIA NEW JERSEY AVE.-
17TH & PENNSYLVANIA AVE. S.E.
92 CALVERT BRIDGE VIA FLORIDA AVE.-
NAVY YARD

10 ROSSLYN - KENILWORTH

12 WASHINGTON CIRCLE - SEAT PLEASANT

20 CABIN JOHN - UNION STATION

Capital Transit Company street car lines are shown west of 11ᵗʰ Street in this 1943 track map.

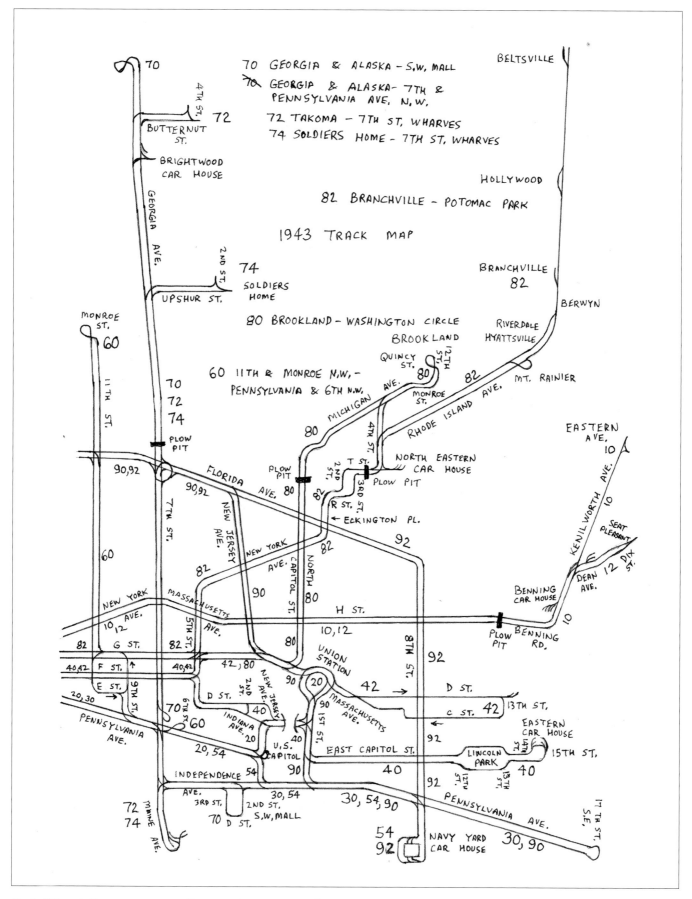

Capital Transit Company street car lines are shown east of 14th Street in this 1943 track map.

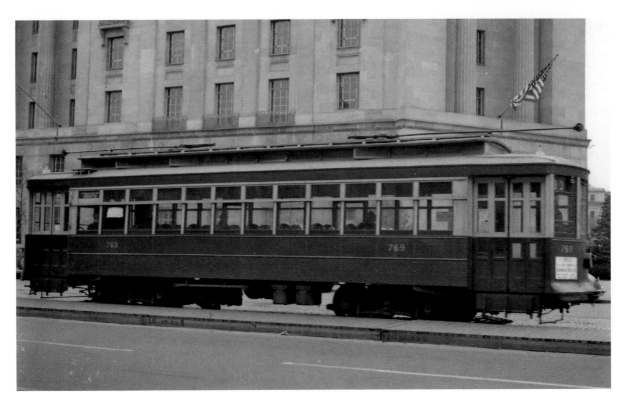

Pennsylvania Avenue at 10th Street NW is the location of CTC car No. 769 on February 22, 1941. This was one of 20 cars Nos. 26-45 built in 1918 by G. C. Kuhlman Car Company. Powered by four General Electric type 247 motors (car No. 765 had four General Electric type 200K motors), each car seated 48 passengers and weighed 44,800 pounds. In 1933-1935 the cars were renumbered 765-784. Car No. 769 was scrapped in 1952. (C. R. Scholes collection.)

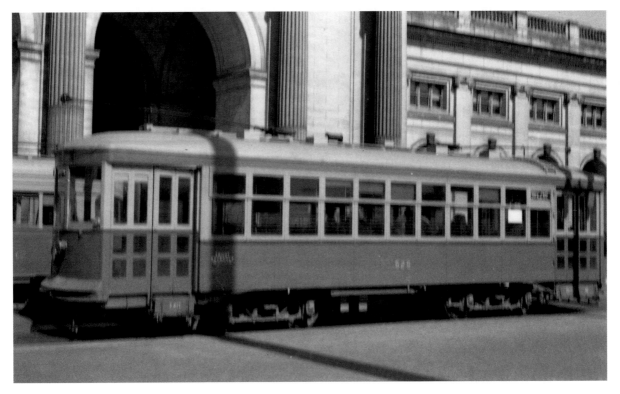

On March 18, 1941, CTC car No. 526 is at the Union Station Plaza. This was originally car No. 2091, one of 150 cars built in 1922-1923 by Osgood Bradley Car Company for United Electric Railways Company of Providence, Rhode Island. CTC purchased 50 of these cars in 1935 (the only second hand cars ever purchased) and renumbered them 501-550. Powered by four General Electric type 265A motors, the car was scrapped in 1950. (C. R. Scholes collection.)

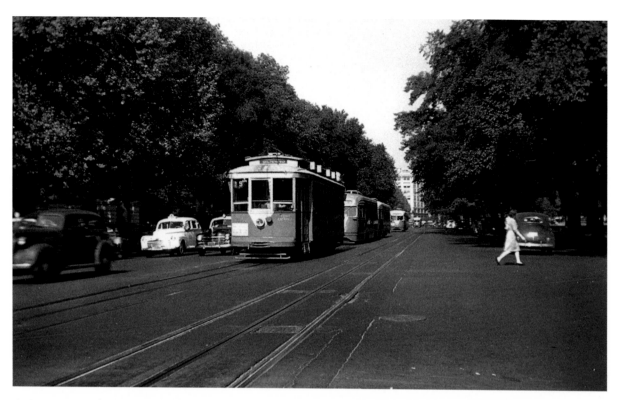

CTC car No. 947 (originally WERCO No. 170) is on Pennsylvania Avenue NW on May 24, 1947. Powered by four General Electric type 200C motors, this was one of 27 cars Nos. 160-186 built in 1927-1928 by J. G. Brill Company for WERCO. They were transferred to CTC in 1933, upgraded with four General Electric type 1198E1 motors, renumbered 937-963, and scrapped in 1952. (C. R. Scholes collection.)

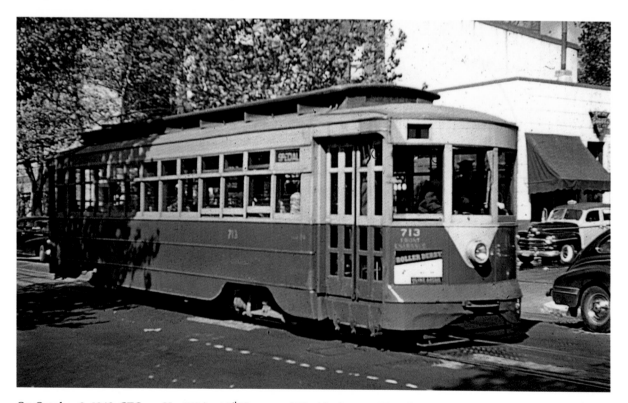

On October 2, 1949, CTC car No. 713 is at 7th Street and Florida Avenue NW. This was one of 50 cars Nos. 700-749 built by G. C. Kuhlman Car Company in 1918-1919 for WERCO. Cars Nos. 700-744 were powered by four General Electric type 200K motors. Cars Nos. 745-749 were powered by four Westinghouse type 101B motors. The cars were transferred to CTC in 1933. Car No. 713 was scrapped in 1950. (Bob Crockett photograph - C. R. Scholes collection.)

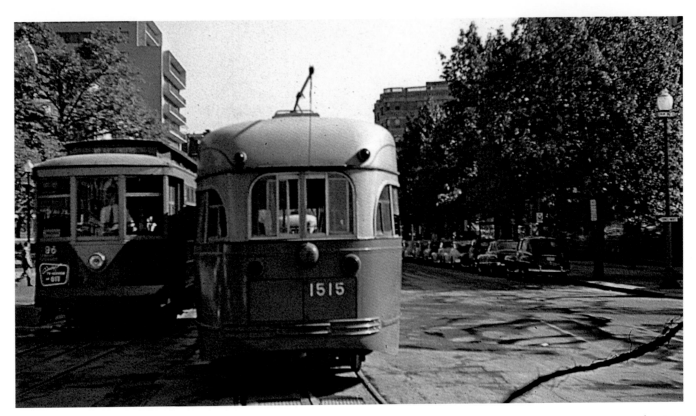

CTC car No. 796 (originally car No. 56 built by J. G. Brill Company in 1919 and scrapped in 1952) is passing PCC car No. 1515 (built in 1944 by St. Louis Car Company in 1944 and scrapped in 1962) on Pennsylvania Avenue at Washington Circle on October 2, 1949. (Bob Crockett photograph - C. R. Scholes collection.)

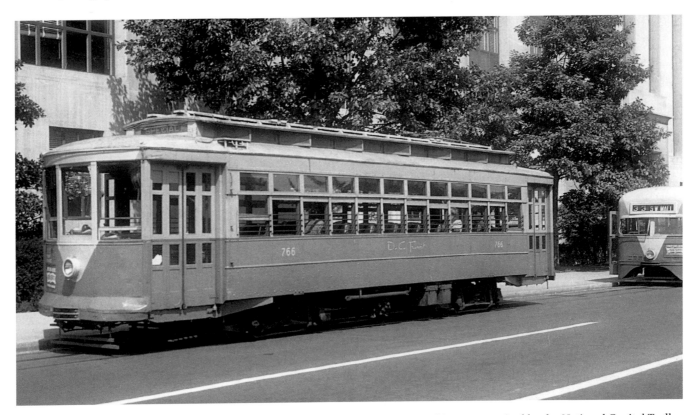

In 1950, CTC car No. 766 (originally No. 27 built by G. C. Kuhlman Car Company and in 1970 acquired by the National Capital Trolley Museum) and streamliner No. 1056 (built by St. Louis Car Company in 1935 and scrapped in 1959) are at 3rd and C Streets SW. (C. R. Scholes collection.)

Chapter 2

DC Transit System

In a March 1, 1956 Capital Transit Company advertisement in the Washington, DC, newspaper *The Evening Star*, titled "De-Bunking the Bunk About Street Car Conversion," it was noted, "that street car income per mile is almost 100 percent greater than bus income per mile. And that bus lines as a whole lost in excess of $1,049,000 in 1955 while the street car lines showed a profit of $1,573,000." The company did its best to retain street car service.

On June 30, 1956, the DC Commissioners and CTC Directors approved the purchase of CTC by Oscar Roy Chalk, President of Trans-Caribbean Airways and Morris Fox of B & F Transportation, a Washington, DC-area trucking company. The House-Senate Conferees approved the purchase on July 17, 1956. The House passed the bill on July 19, 1956 and Senate on July 20, 1956. It was signed by President Dwight D. Eisenhower on July 24, 1956. CTC stockholders approved the sale on August 3, 1956. DC Transit System (DCTS) officially took over on August 15, 1956. Chalk tried to get a bill through Congress to preserve the street car lines. However, the district commissioners would not change their mind. Street cars and buses were re-lettered to show DC Transit System as an affiliate of Trans-Caribbean Airways.

On August 26, 1956, route 80 PCC car No. 1229 made the last trip from Rosslyn, Virginia, over the Key Bridge to Washington, DC. Route 80 was the last street car line in Virginia and was cut back as part of a repaving project on the Key Bridge to Washington Circle during base periods and weekends. The street car line was replaced by a shuttle bus service. During weekday rush hours, the western terminus of route 80 was changed to 19th and F streets NW with some runs extended via route 20 trackage to 36th and Prospect Streets NW. During off-peak periods, route 80 terminated at Washington Circle. A new color scheme was adopted beginning with car No. 1575 in January 1957. The white painted roof extended down to the upper belt rail in the rear. A Mercury Green (light warm green) was used on the upper window section, with a Deluxe Banner Green (darker green) on the sides below the windows, and Persimmon (orange-red) car striping. On June 24, 1957 at 10:08 a.m., car No. 1512 – refurbished as the *Silver Sightseer* – began operating over a special route, which left the Southern Division carhouse on Maine Avenue to run from Potomac Park up to Pennsylvania Avenue, past the White House, to loop around the Peace Monument at 1st and Pennsylvania Avenue NW, and in front of the capitol, for the regular 20 cent fare (40 cents for the round trip). This was a short, low cost, comfortable ride around many of the most important buildings in the United States. The exterior was painted in two tones of green. Chrome wings were added around the front headlight. There were metal flags at each end of the car proclaiming "Silver Sightseer." The words "air conditioned" were on the front, back, and both sides of the car. Windows were sealed and the bars were removed. The car had a public address system used by a hostess to point out the scenic attractions along the route. There was a small rack for literature, and the standard advertising signs were removed. The car interior had light green sides with a white ceiling. Seats had foam rubber cushions in aqua-green colors. DC Transit System, Inc. advertised in a leaflet, "a guided tour of Washington, DC, in America's only air conditioned luxury streetcar-THE SILVER SIGHTSEER" which featured fluorescent lighting and glare-proof windows for luxury riding at regular fares. By the end of 1957, only 379 PCC cars remained on the active list compared to the 508 street cars including the 20 streamliners that DCTS had when it acquired CTC.

A 14-inch snow on February 15, 1958 resulted in a number of street cars stranded at the route 20 plow pit at 36th and Prospect Streets. In the city, where there was conduit operation, the street cars pulled a plow (current collector) through a slot that was about one inch wide. If the slot was packed with ice or an object was lodged in the slot, the plow could not go through and was separated from the street car and arcing occurred, the car was stuck.

September 7, 1958 was the last day of street car operation on routes 80 (Washington Circle-North Capitol Street-Brookland) and 82 (Potomac Park-Mt. Rainier-Riverdale-Branchville) which released 67 street cars. There were now 200 surplus PCC cars. This was the first step in the forced conversion of all Washington, DC, street car routes. Highway improvement plans for Rhode Island Avenue, Michigan Avenue, and North Capital Street were also a factor.

On September 7, 1958, PCC car no. 1589 made the last run on route 80 and PCC car No. 1574 made the last run on

route 82 as both lines were converted to bus operation. A new standard gauge street car system in Sarajavo, Yugoslavia (Gradsko Saobracatno Preduzege) agreed to purchase 50 PCC cars from DCTS for $175,000. The contract required all of the cars to be completely overhauled and repainted in the DCTS paint scheme by DCTS. On March 14 and March 15, 1959, the first two cars were shipped to Yugoslavia. The Southern car house and 4th Street shops were sold by DCTS to the Redevelopment Land Agency on January 14, 1959. Even with the conversion to bus operation, the oldest PCC cars continued to be maintained. In September 1959, the first PCC car No. 1101 was completely repainted.

During 1960, operators were issued a stylish dark green uniform with a pale green shirt, black tie, and pilot type peak hat featuring the DCTS winged emblem. The $42.85 uniform cost was deducted from wages at $4.00 per week. This was part of the company's goal to create the image of a modern company providing quality public transit service.

On Sunday January 3, 1960, routes 20 (Cabin John), 30 (Wisconsin Avenue), 70 (Georgia Avenue), 72 (Takoma), and 74 (Soldier's Home) were replaced by bus service. PCC car No. 1225 was the last regular service car leaving Friendship Heights at 1:51 a.m. The last regular service route 20 PCC car No. 1540 left Union Station at 12:15 a.m. and arrived at Cabin John where it left at 1:05 a.m. with arrival back at Union Station at 2:18 a.m. Route 20 was the last DCTS street car line that had private right-of-way. These were the last overhead wire lines in the District of Columbia. Only the conduit lines remained. Street cars no longer passed the White House. Also rush hour lines 49 (Mt. Pleasant to Potomac Park), route 53 (14th & Colorado to the Southwest Mall), and route 63 (11th & Monroe to the Southwest Mall) street car service ended. Routes 53 and 63 were abandoned without replacement. These abandonments resulted in 113 fewer PCC cars required. Only 152 PCC cars were required for service, and the active fleet was reduced to 174 cars. The *Silver Sightseer* was rerouted to operate from Mt. Pleasant to Union Station.

Although DCTS was noted for its well-kept cars, the DCPUC did not permit the company to make the investment needed to renew the aging conduit system because the street car system was going to be completely converted to bus operation. Washington, DC, received 27 inches of snow during 1960-1961, which halted street cars because of shorts in the conduit that occurred because of slush and road salt. Crews had to drill out frozen plows, which damaged the conduit. Buses had to replace the stranded street cars. In March 1961, Transvias de Barcelona (Barcelona, Spain) agreed to purchase 100 PCC cars from DCTS. PCC cars 1243 (powered by four General Electric type 1198F1 motors) and 1258 (powered by four Westinghouse type 1432D motors) were sent to Barcelona in June 1961 for testing.

Street car routes 40, 42, and 60 were converted to bus operation on December 3, 1961. PCC car No. 1123 left Mt. Pleasant at 1:45 a.m. on a route 44 trip that was the last street car to use the Dupont Circle underpass. The last route 60 PCC car left the 11th and Monroe loop at 1:35 p.m. Only 96 PCC street cars remained, operating out of the Navy Yard carbarn, for routes 50, 54, 90, and 92. A rush hour route 91 operated from Navy Yard via Bureau of Engraving to Union Station, and then operated as route 45 to the Bureau of Engraving via G Street. The *Silver Sightseer* was rerouted to operate between the Navy Yard and 14th and Colorado loop. This left Navy Yard as the only operating car house serving the 14th Street lines 50, 52, and 54 and the Calvert Bridge lines 90 and 92, plus a rush hour line from the Navy Yard to Bureau of Engraving that ran as route 91 to Union Station and then over G Street, and the Bureau of Engraving as route 45. On December 14, 1961, DCTS petitioned the DCPUC to end street car service on January 28, 1962 because the track system was no longer able to provide reliable service in a severe snow and ice storm. That request was approved on December 27, 1961.

Early Sunday morning January 28, 1962, car No. 1500 made the last public street car trip leaving at 2:17 a.m. from the 14th and Colorado loop and arrived at the Navy Yard carbarn at 3:05 a.m. Three cars of rail enthusiasts made the final trip: car No. 1101, the first PCC car used in Washington; followed by 1053, the only survivor of 20 pre PCC cars; and 766, the deck roof street car, which was the final car to arrive back at the Navy Yard at 4:45 p.m. Washington had the distinction of running the last conduit operated street cars in the world using a plow that made contact with a rail lying in an underground vault. One of the finest street car systems in the United States had ended street car service.

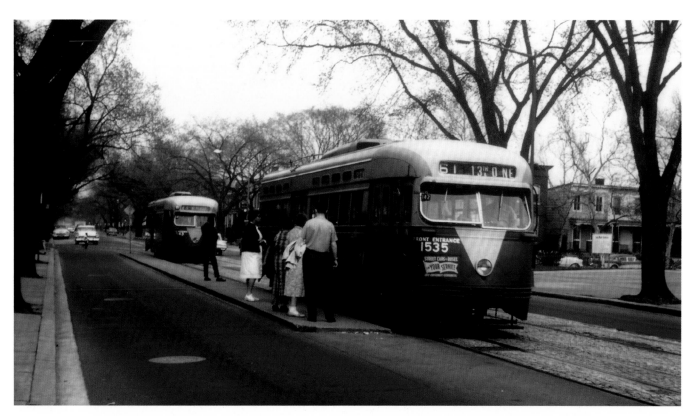

On a cloudy April 15, 1960, DC Transit System (DCTS) PCC car No. 1535 (one of 38 cars Nos. 1502-1539 delivered March 31, 1945 – July 21, 1945) is on E. Capital Street at 12th Street NE followed by PCC car No. 1543 (one of 25 cars Nos. 1540-1564 delivered November 21, 1945 – February 6, 1946). Powered by four General Electric type 1220A1 motors, both cars were built by St. Louis Car Company. (Kenneth C. Springirth photograph.)

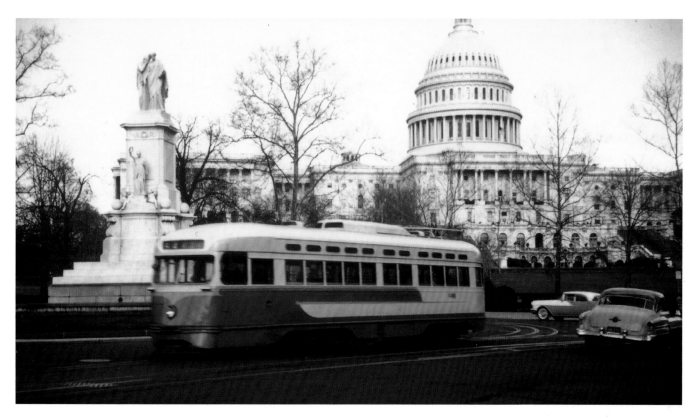

With the United States Capitol in the background, route 54 PCC car No. 1481 is on Pennsylvania Avenue at 1st Street NW on April 16, 1961. This car was scrapped in 1963. (Kenneth C. Springirth photograph.)

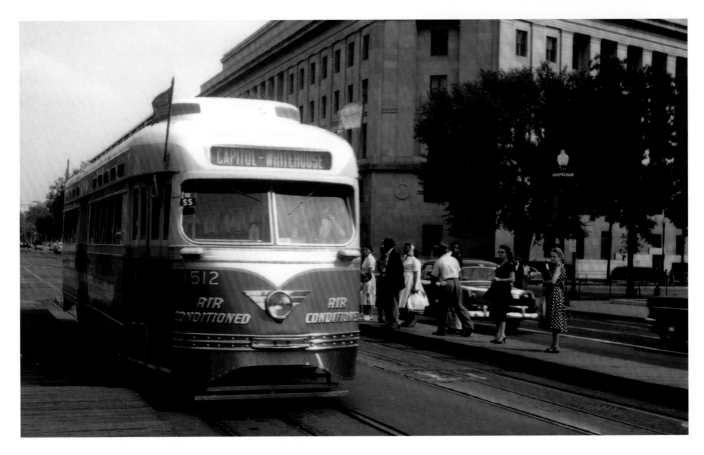

Above: On June 9, 1959, DCTS *Silver Sightseer* PCC car No. 1512 is traveling along Pennsylvania Avenue. This was one of 75 cars Nos. 1465-1539 built by St. Louis Car Company and delivered in 1945. It was rebuilt as the air conditioned *Silver Sightseer,* making its official preview on June 24, 1957. DCTS requested permission from the DCPUC to air condition nine more PCC cars, which was denied on August 13, 1957. (Kenneth C. Springirth photograph.)

Left: The Silver Sightseer PCC car No. 1512 is on 1st Street at E. Capital Street in this view taken from the steps of the United States Supreme Court Building on August 28, 1960. Wooden doors replaced the steel doors, which sweated with the air conditioning. Using modified B-2 trucks, the car was the quiet and smooth running. (C. Abel photograph - C. R. Scholes collection.)

Chapter 3

Routes 10/12 Kenilworth/Seat Pleasant

After the 1933 merger of Washington Railway & Electric Company (WRECO) and Capital Traction Company into the Capital Transit Company (CTC), the east end of the Pennsylvania Avenue line of Capital Traction was combined with the Columbia line of WRECO during 1936. This created a long line from Rosslyn, Virginia, to Seat Pleasant, Maryland, that operated as two routes: 10 (Rosslyn-Kenilworth) and 12 (15th and New York Avenue-Seat Pleasant). Route 10, the only CTC line that operated into Virginia, operated from Rosslyn, crossing the Key Bridge into Washington, DC, and used M Street, Pennsylvania Avenue, New York Avenue, Massachusetts Avenue, H Street, Benning Road NE, and Kenilworth Avenue to Eastern Avenue. Route 12 operated from Washington Circle and used Pennsylvania Avenue, New York Avenue, Massachusetts Avenue, H Street, Benning Road NE, Kenilworth Avenue, Deane Avenue, private right-of-way and Dix Street to Seat Pleasant at the District Line. The two lines shared trackage between Washington Circle and the Kenilworth Avenue-Deane Avenue intersection.

With completion of a wye in March 1945, at Kenilworth and Eastern Avenues NE, route 10 began receiving PCC cars. A new loop and terminal opened in July 1945 for route 12 at Dix and 62nd Street in Seat Pleasant which permitted the operation of PCC cars. In March 1946, routes 10 and 12 carried a total of 3,320,525 passengers. On May 1, 1949, routes 10 and 12 were replaced by buses because of the costly job of repairing the conduit portions of these lines. Route 80 (Brookland) was extended to Rosslyn, Virginia, to replace the western ends of discontinued routes 10 and 12.

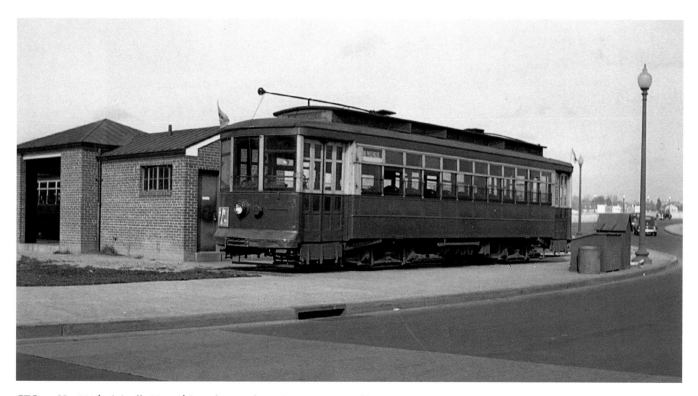

CTC car No. 821 (originally No. 82) is at the Rosslyn, Virginia, terminal loop in 1942. This was one of 40 cars Nos. 46-85 built by J. G. Brill Company in 1919 for Capital Traction Company. These cars were transferred to CTC in 1933 and were renumbered 785-824. Powered by four Westinghouse type 514 motors (car No. 824 had four General Electric type 200k motors), each car weighed 44,800 pounds. Car No. 821 was scrapped in 1952. (Bill Stevenson photograph - C. R. Scholes collection.)

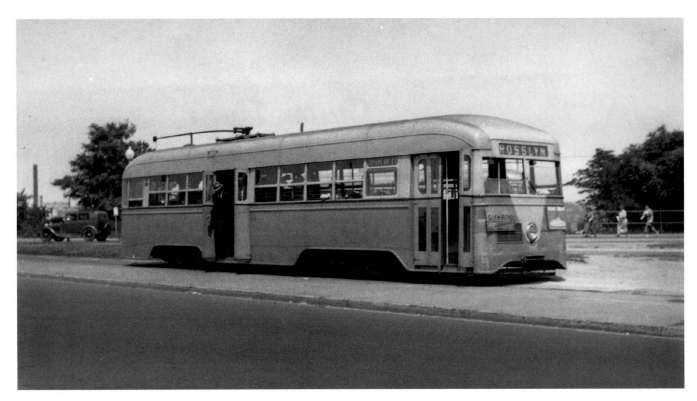

CTC streamliner car No. 1002 is at the Rosslyn, Virginia, terminal loop on June 7, 1936. This was one of ten cars Nos. 1001-1010 built by J. G. Brill Company in 1935 and with their leather upholstered seats represented the first modern street cars for Washington, DC. Powered by four Westinghouse type 1426L motors, each car weighed 35,000 pounds and seated 49. These cars were scrapped in 1959. (Bob Hadley photograph - C. R. Scholes collection.)

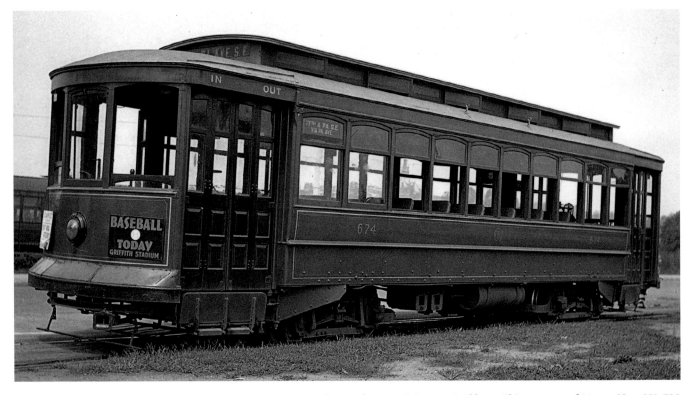

On August 26, 1934, Capital Traction Company car No. 674 is at the Rosslyn, Virginia, terminal loop. This was one of 80 cars Nos. 621-700 built by Jewett Car Company in 1911. Powered by two Westinghouse type 306 motors, each car weighed 33,857 pounds and seated 40. These cars were transferred to CTC in 1933 and were later renumbered 207-286. Car No. 674 became No. 260 and was scrapped in 1945. (Bob Hadley photograph - C. R. Scholes collection.)

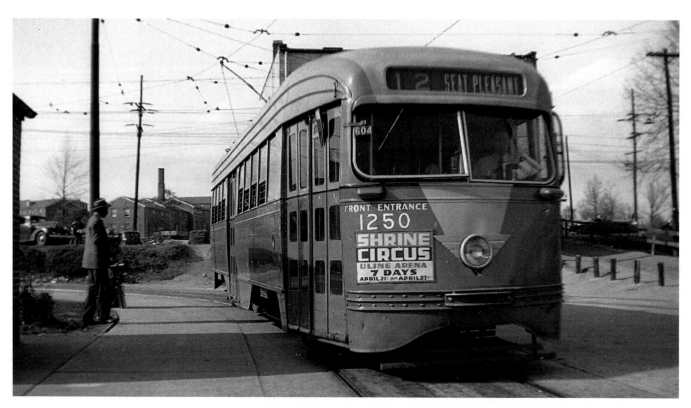

Seat Pleasant loop is the location of Capital Transit Company (CTC) route 12 PCC car No. 1250 on April 20, 1947. Powered by four General Electric type 1198F1 motors, this was one of 17 cars Nos. 1234-1250 built by St. Louis Car Company in 1940 and was scrapped in 1963. Washington, DC, was the first North American city to operate its entire base service (except for Benning line short turns) by PCC cars. (C. R. Scholes collection.)

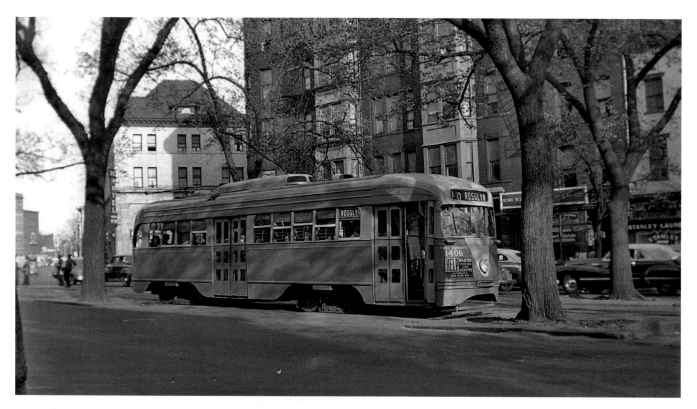

On April 20, 1947, CTC route 10 PCC car No. 1406 is on New York Avenue at 9th Street NW heading for Rosslyn, Virginia. Powered by four General Electric type 1198F3 motors and weighing 36,360 pounds, this was one of 32 cars Nos. 1400-1431 built in 1944 by St. Louis Car Company. The car was scrapped in 1962. (C. R. Scholes collection.)

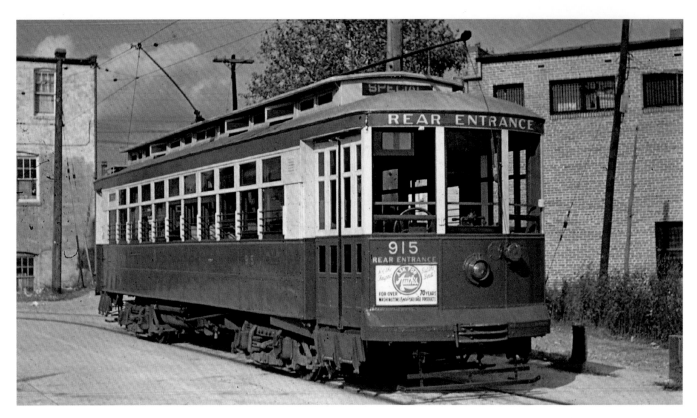

Car No. 915 is at Seat Pleasant loop on October 19, 1947. This was originally WERCO trailer car No. 1073 built in 1912 by J. G. Brill Company. It was transferred to CTC in 1933. In 1937 it was rebuilt as a double end motor car powered by four Westinghouse type 101B motors. The car weighed 51,000 pounds and seated 48. (Bob Crockett photograph - C. R. Scholes collection.)

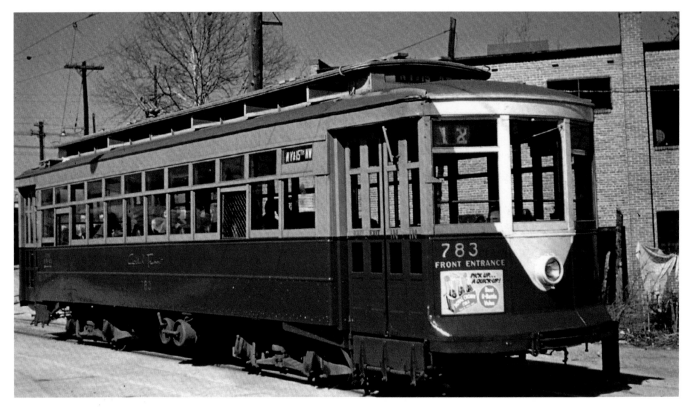

On April 4, 1948, Capital Transit Company car No. 783 is at the Seat Pleasant loop. This was originally Capital Traction Company car No. 44 built in 1918 by G. C. Kuhlman Car Company. After it was transferred to Capital Transit Company in 1933, it became car No. 783. The car was scrapped in 1952. (Bob Crockett photograph - C. R. Scholes collection.)

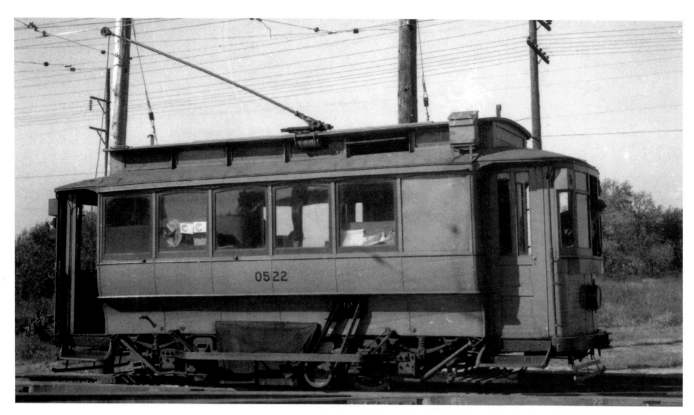

Benning car house is the location of single truck double ended rail grinder No. 0522 in October 1941. This car was built in 1898 as car No. 222 by American Car Company for Capital Traction Company. It was withdrawn from passenger service on January 31, 1913 and placed in storage. This car was transferred to Capital Transit Company in 1933 and was converted into rail grinder No. 0522 in 1937. DC Transit System donated this car to the National Capital Trolley Museum in 1962. (C. R. Scholes collection.)

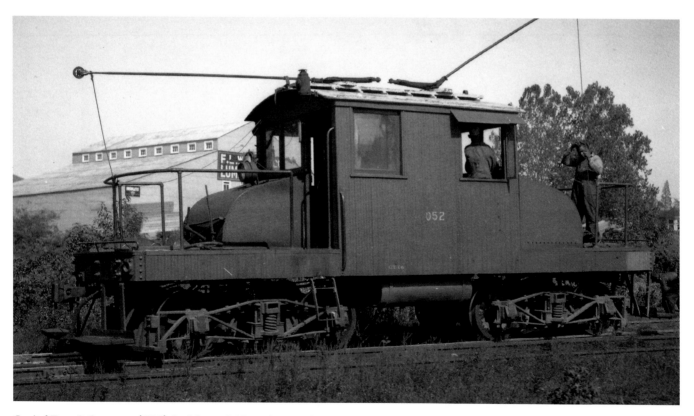

Capital Transit Company (CTC) double truck 35-ton locomotive No. 052 is at Benning car house in October 1940. Powered by four General Electric type 214A motors, this locomotive was built by the WRECO shops in 1914. It was scrapped in 1955. (C. R. Scholes collection.)

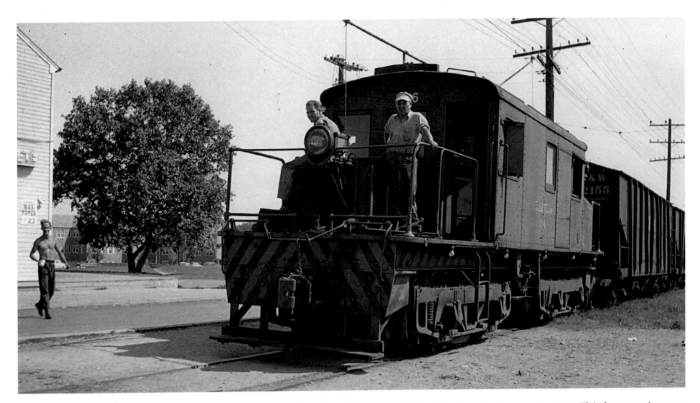

CTC locomotive No. 056 is heading a coal train along the right of way parallel to Kenilworth Avenue in 1950. This locomotive was originally No. 6 built for the New Haven Railroad by Baldwin Westinghouse in 1924. It was acquired in 1949 to handle delivery of coal to the Benning Power plant of PEPCO. The operation was sold to the East Washington Railway and dieselized in 1955. (Bill Stevenson photograph - C. R. Scholes collection.)

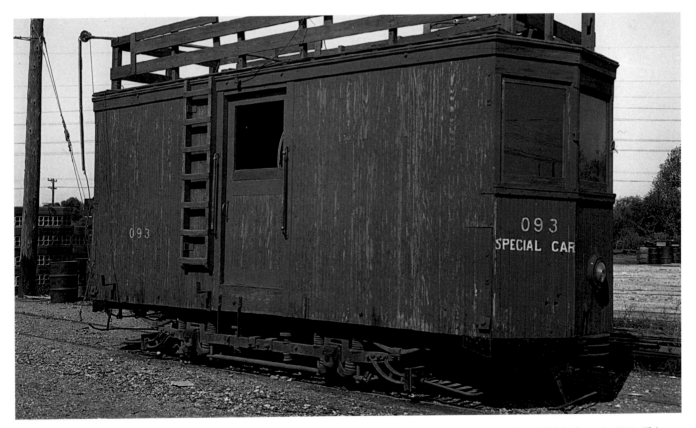

In October 1940, CTC single truck line car No. 093 is at the Benning car house. This car was built by the WERCO shops in 1914. This car was scrapped in 1946. (C. R. Scholes collection.)

Chapter 4

Route 20 Cabin John

The Glen Echo Railroad, opened on June 10, 1891, operated to Glen Echo on April 1, 1896, and reached Cabin John in May 1896. On August 3, 1896, it became the Washington & Glen Echo Railroad Company. The line was abandoned in the fall of 1900, except for the section from Glen Echo to Cabin John, which became part of the Washington & Great Falls Electric Railway. On February 4, 1902, it became the Washington & Electric Railway Company. At Georgetown, cars shifted from plow to overhead wire for the 6-mile run along the Potomac River through the woods and terminating just past Glen Echo Amusement Park at Cabin John, Maryland. PCC cars were introduced to route 20 on September 8, 1940.

A new loop opened at Glen Echo on April 10, 1943. Route 20 operated from Cabin John via private right-of-way, eastbound to Prospect Street, 35th Street (westbound P Street, 36th Street),

O Street, Wisconsin Avenue, M Street, Pennsylvania Avenue, 15th Street, Pennsylvania Avenue, 1st Street, C Street, and 1st Street NE to Union Station. In addition to passengers, route 20 street cars also carried mail sacks to and from Cabin John and Glen Echo to 36th Street and Prospect Avenue NW in Washington, DC, where mail was transferred to trucks. On April 9, 1954, the Glen Echo loop, which was rarely used, was removed. Beginning May 31, 1955, route 20 no longer carried mail.

The March 1946 ridership for route 20 was 854,023. In 1957, route 20 had an average weekday ridership of 9,400. Although the line was scenic, in later years its light ridership resulted in service every 20 minutes. On January 3, 1960, route 20 was replaced by bus service. This was the last DCTS street car line that operated on private right-of-way and served Maryland. Car 099 was scrapped in April 1960 on the Cabin John line for which it had finished dismantling.

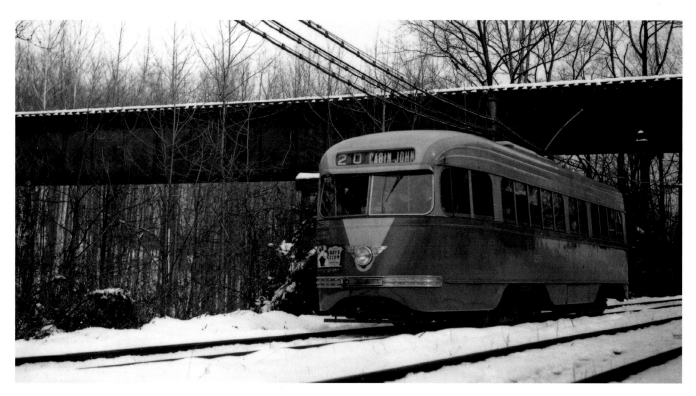

On March 15, 1941, CTC route 20 PCC car No. 1255 is passing under the Baltimore & Ohio Railroad trestle on its way to Cabin John. This was one of 17 cars Nos. 1251-1267 built in 1940 by St. Louis Car Company. Powered by four Westinghouse type 1432D motors, each car seated 49. (C. R. Scholes collection.)

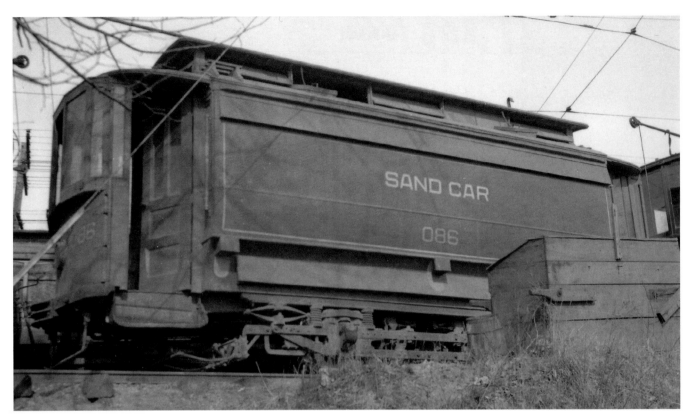

CTC sand car No. 086 is at the Falls car house in 1939. Powered by two General Electric type 1000 motors, this car was built by Laclede Car Company in 1895 and converted to a sand car by 1911. It was scrapped in 1941. (Dave McNeil photograph - C. R. Scholes collection.)

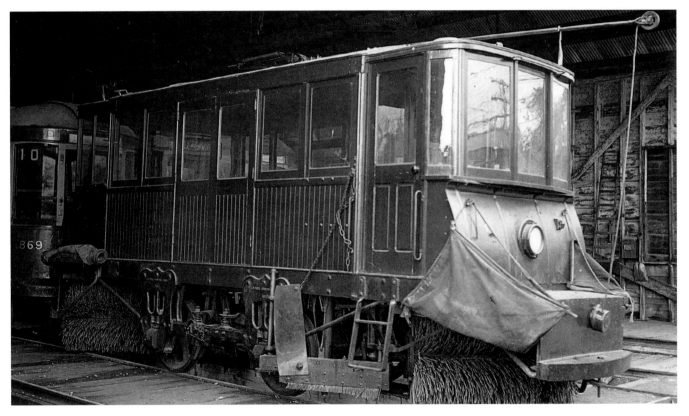

Snow sweeper No. 03 is inside the Falls car house in October 1940. Powered by two Westinghouse type 306 motors, this car was built by J. G. Brill Company in 1895. It was scrapped in January 1962. (C. R. Scholes collection.)

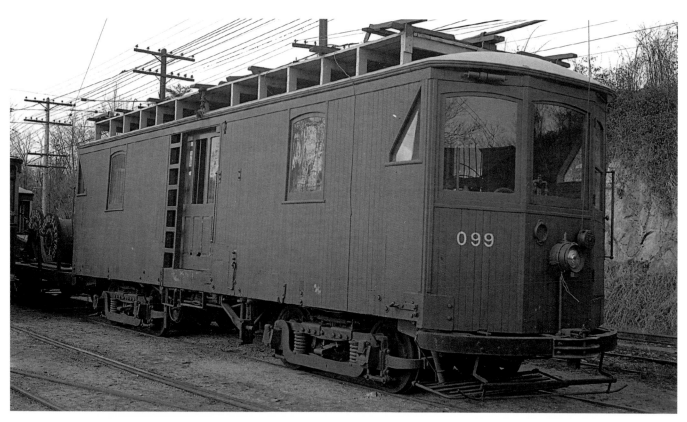

On March 1, 1941, CTC line car No. 099 is outside the Falls car house. Powered by four Westinghouse type 306 motors, this car was built by J. G. Brill Company as a freight motor in 1910. It later had four Westinghouse type 101B motors and was converted to a line car in 1921 and was scrapped in 1960. (C. R. Scholes collection.)

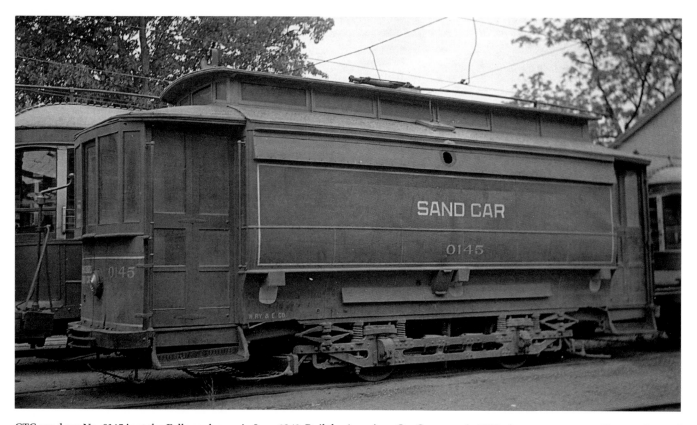

CTC sand car No. 0145 is at the Falls car house in June 1941. Built by American Car Company in 1896, the car was powered by two General Electric type 1000 motors. The car was converted to a sand car in 1923 and scrapped in 1941. (C. R. Scholes collection.)

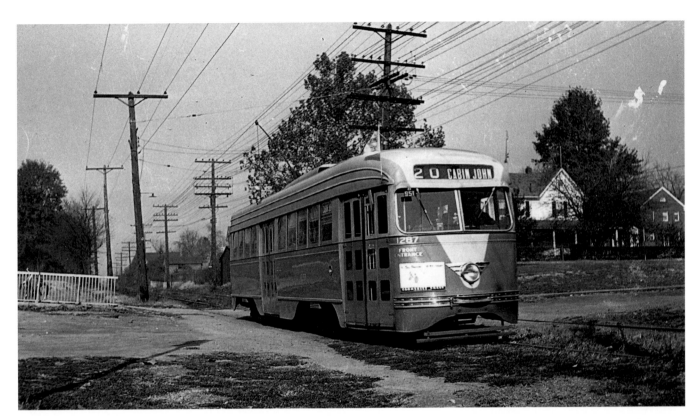

In 1942, CTC route 20 PCC car No. 1287 is crossing Foxhall Road. This car one of 18 cars Nos. 1285-1302 built in 1940 by St. Louis Car Company. Powered by four Westinghouse type 1432D motors, the car weighed 35,020 pounds and had headlight wings. PCC cars were quiet, fast, comfortable, and operated without exhaust fumes. The car was scrapped in 1966. (Bill Stevenson photograph - C. R. Scholes collection.)

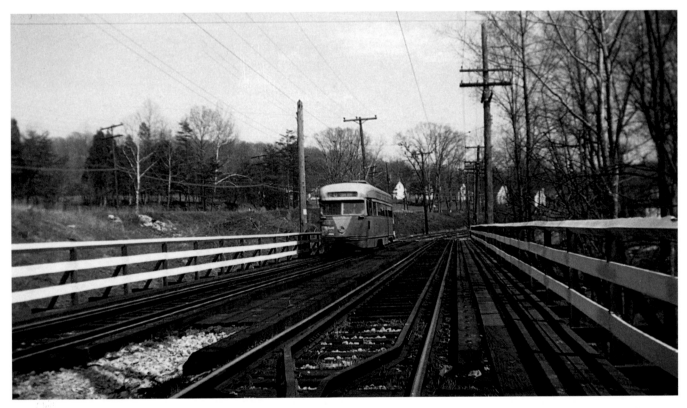

On May 24, 1947, CTC route 20 PCC car No. 1498 is crossing the bridge over the Baltimore & Ohio Railroad. This car was scrapped in 1963. Suburban routes to Cabin John, Seat Pleasant, and Branchville provided comfortable transit service through the Maryland countryside. (C. R. Scholes collection.)

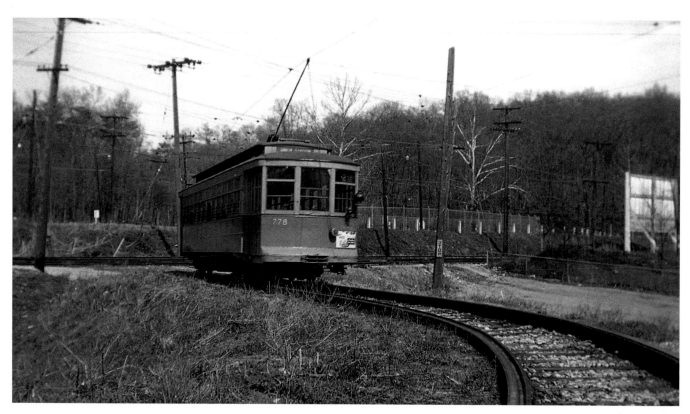

Route 20 CTC car No. 778 is rounding the curve at Glen Echo loop on April 20, 1947. This car was originally Capital Traction Company car No. 39. It was transferred to Capital Transit Company in 1933, became No. 778, and was scrapped in 1952. (C. R. Scholes collection.)

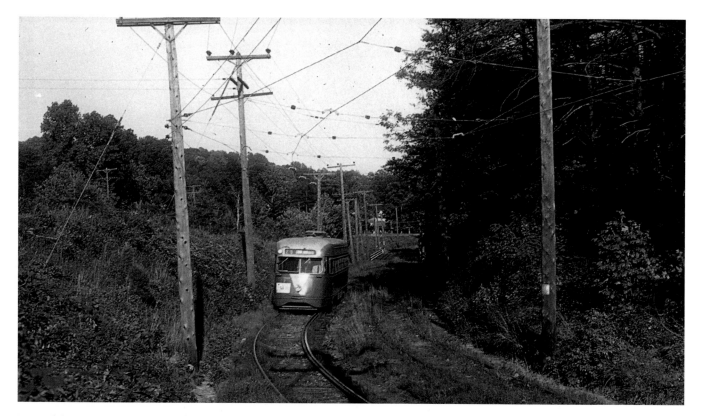

West of the Baltimore & Ohio Railroad bridge finds CTC route 20 PCC car No. 1533 in 1948. This car was delivered in 1944 by St. Louis Car Company and was sold to Tranvias de Barcelona (Barcelona, Spain) in 1963. (C. R. Scholes collection.)

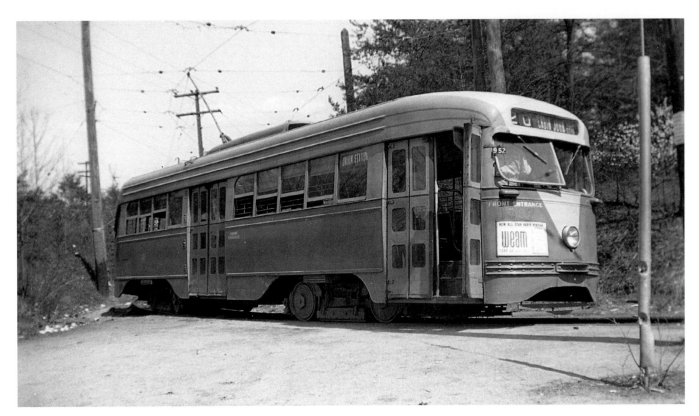

On May 24, 1947, CTC route 20 PCC car No. 1397 is at the Cabin John loop. This was one of 33 cars Nos. 1367-1399 built in 1942 by St. Louis Car Company at a cost of $18,362 per car and powered by four Westinghouse type 1432D motors. The car was sold to Gradsko Saobracatno Preduzege (Sarajevo, Yugoslavia). (C. R. Scholes collection.)

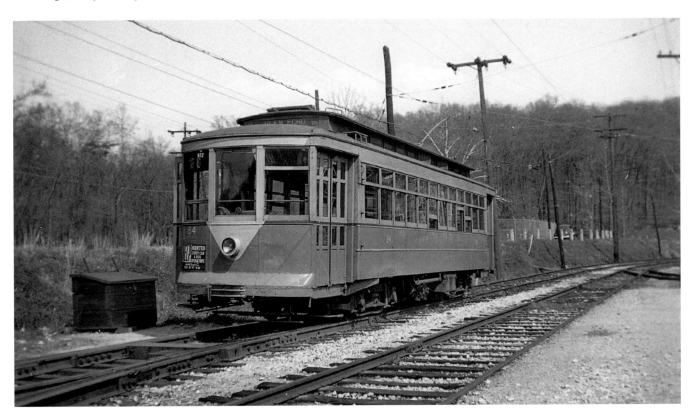

Route 20 car No. 784 is at the switch for the Glen Echo loop on April 20, 1947. This car was originally car No. 45 built in 1918 by the G. C. Kuhlman Car Company for Capital Traction Company. It was transferred to Capital Transit Company in 1933 and became No. 784. It was scrapped in 1952. (C. R. Scholes collection.)

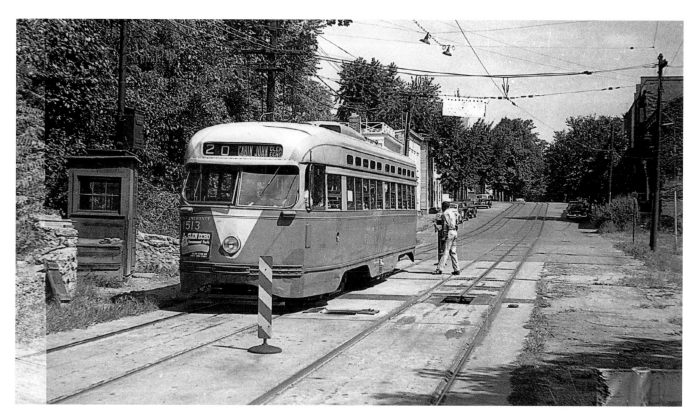

CTC route 20 PCC car No. 1513 is at the Prospect Avenue plow pit west of 37th Street NW in 1954. Weighing 35,740 pounds and seating 50, this car was built in 1944 and scrapped in 1962. (Joe Kepler photograph - C. R. Scholes collection.)

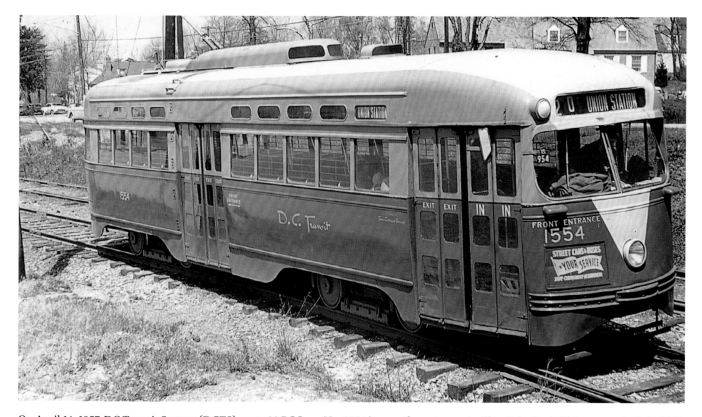

On April 14, 1957, DC Transit System (DCTS) route 20 PCC car No. 1554 is near the entrance to Glen Echo Park. This car was built in 1945, weighed 35,640 pounds, seated 50, and in 1963 went to Tranvias de Barcelona. (C. Abel photograph - C. R. Scholes collection.)

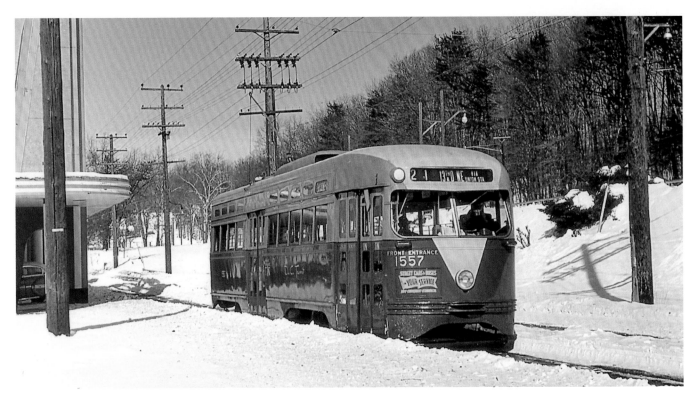

In this February 18, 1958 snow scene, DCTS route 21 (the odd number second digit indicated rush hour or off-route destination) PCC car No. 1557 is at the entrance to Glen Echo Park. The street car adds to the park's stylish look. Built in 1945, this car was sent to Tranvias de Barcelona in 1963. (C. Abel photograph - C. R. Scholes collection.)

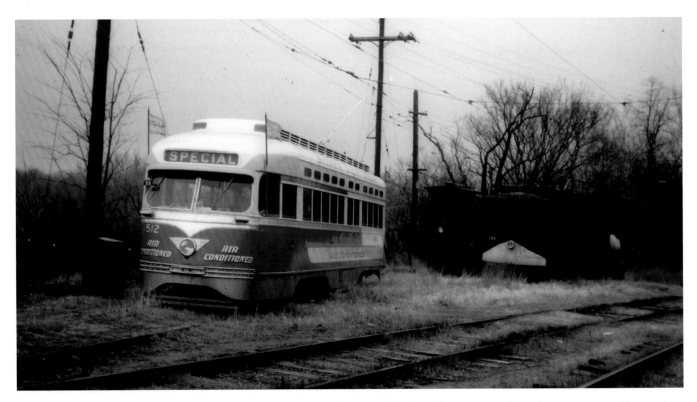

On January 2, 1960, the DCTS luxurious *Silver Sightseer* was parked at the Falls siding along route 20 for a photo stop on a rail excursion. This was the world's first air conditioned street car. (Kenneth C. Springirth photograph.)

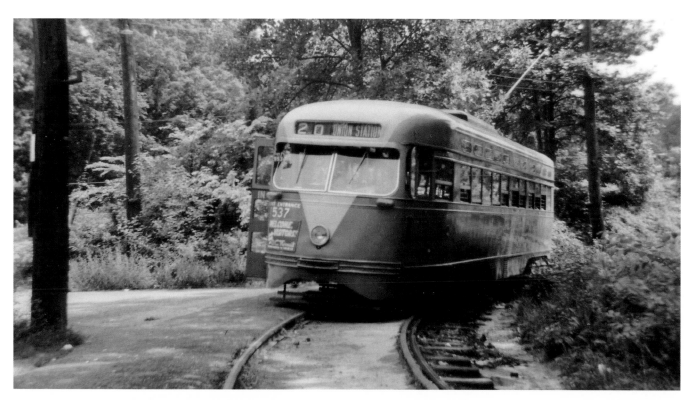

DCTS route 20 PCC car No. 1537 has arrived at the picturesque Cabin John loop on May 29, 1959. The car series Nos. 1465-1539 (delivered March 31, 1945-July 21, 1945) was the first group of Washington, DC, PCC cars to have standee windows. Located over the main windows, the six-inch-high standee windows allowed standing passengers to see outside and read street signs without bending over seated riders. This car went to Tranvias de Barcelona (Barcelona, Spain) in 1963. (Kenneth C. Springirth photograph.)

On June 9, 1959, DCTS route 20 PCC car No. 1553 is passing by Glen Echo Park. This car was built in 1945 at a cost of $19,778 and went to Tranvias de Barcelona (Barcelona, Spain) in 1964. Glen Echo Park opened as an amusement park in 1899 and was purchased by the Washington Railway & Electric Company in 1911. It was acquired by the Federal government in 1968 and is now managed by the Glen Echo Park Partnership for Arts and Culture in cooperation with Montgomery County, Maryland, and the National Park Service. (Kenneth C. Springirth photograph.)

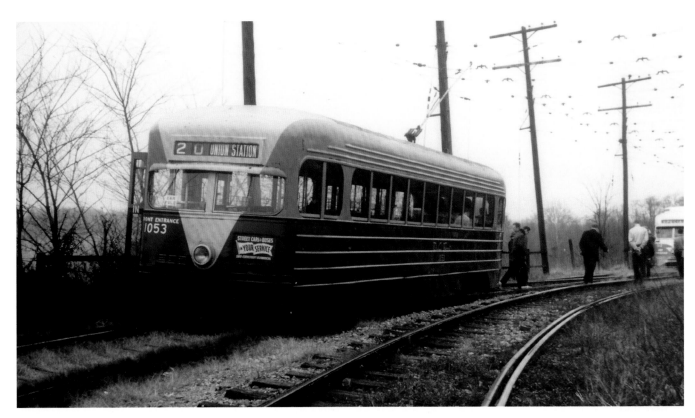

Streamliner No. 1053 is at Falls siding for a photo stop on a January 2, 1960 rail excursion. This was one of 10 cars Nos. 1051-1060 built by St. Louis Car Company in 1935. Powered by four General Electric type 1193 motors, the car weighed 34,750 pounds and seated 49. The car was acquired by the National Capital Trolley Museum in August 1970 and was destroyed in a September 28, 2003 carbarn fire. (Kenneth C. Springirth photograph.)

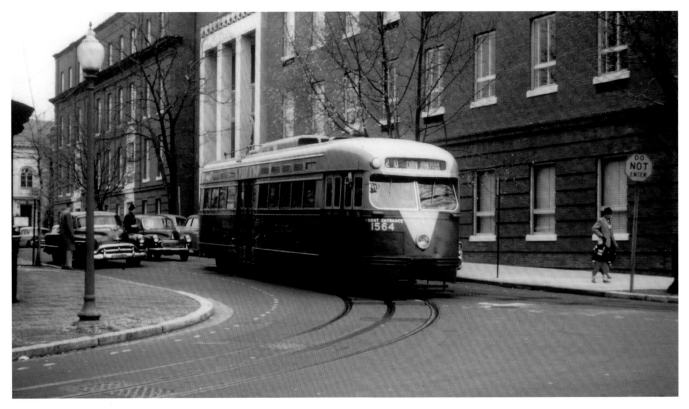

On January 2, 1960, DCTS route 20 PCC car No. 1564 is at 36th and Prospect Streets in the historic Georgetown neighborhood in Northwest Washington, DC. This car was built in 1945 and went to Tranvias de Barcelona in 1963. (Kenneth C. Springirth photograph.)

Chapter 5

Route 30 Friendship Heights

Near the southern end of Wisconsin Avenue, route 20 joined route 30 at M street, and route 10 from Rosslyn joined route 30. Route 30 operated from Friendship Heights via Wisconsin Avenue NW, M Street, Pennsylvania Avenue, 15th Street, Pennsylvania Avenue, 1st Street SW, Independence Avenue, and Pennsylvania Avenue SE to 17th Street. Wisconsin Avenue cars changed to overhead wire at Georgetown. With completion of a large apartment complex called McLean Gardens, the new McLean Gardens loop at Wisconsin and Idaho Avenues was placed in service in July 1943, which served as a cutback for route 30 street cars.

The main route was 30 (Friendship Heights-17th and Pennsylvania Avenue SE). Rush hour routes were 31 (Friendship Heights-Navy Yard), 33 (Friendship Heights-SW Mall), 37 (Friendship Heights-7th Street Wharves), and 39 (Friendship Heights-Potomac Park). Westbound short turn routes from 17th and Pennsylvania Avenue were 39 (19th and F NW), 30 (Washington Circle), 30 (Georgetown), 30 (McLean Gardens), and 30 (Wisconsin and Harrison). Eastbound short turn routes from Friendship Heights were 39 (19th and F NW), 30 (Pennsylvania Avenue and 6th NW), and 30 (Peace Monument). The March 1946 ridership for route 30 was 2,509,865. In 1957, route 30 had an average weekday ridership of 35,200. On Sunday January 3, 1960, route 30 was replaced by bus service.

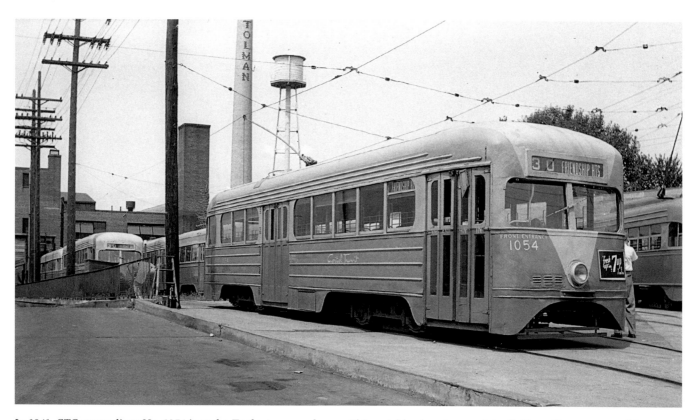

In 1941, CTC streamliner No. 1054 is at the Tenleytown car house. This neighborhood was originally Tennallytown named for tavern owner John Tennally. Over a period of time, it became known as Tenleytown. This car was built in 1935 before the PCC car specifications were finalized. The ten cars Nos. 1051-1060 of this series were the first production of all welded street cars. While these cars could not compete with the later PCC cars, they were reliable and popular with passengers because of their comfortable and smooth ride. This car was scrapped in June 1959. (Bill Stevenson photograph - C. R. Scholes collection.)

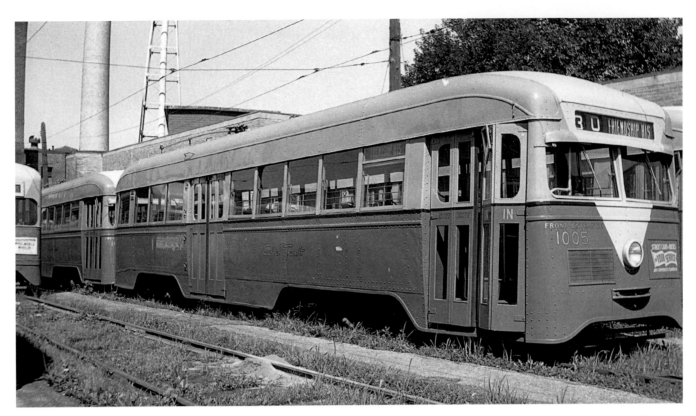

In 1941, streamliner car No. 1005 is in the lineup of cars at the Tenleytown car house. These were the first new cars purchased by CTC and represented an important development in street car vehicles. (Bill Stevenson photograph - C. R. Scholes collection.)

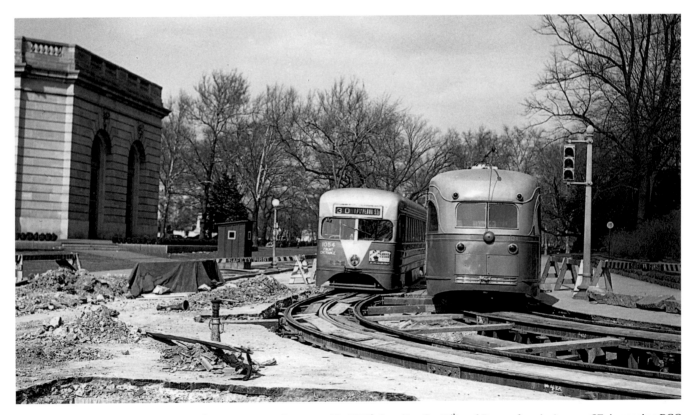

CTC route 30 streamliner car no. 1054 (built in 1935 and scrapped in 1959), heading for 17th and Pennsylvania Avenue SE, is passing PCC car No. 1134 (built in 1937 and scrapped in 1963) on Independence Avenue and 1st Street SE on February 22, 1941 over a rebuilding track and conduit project. (C. R. Scholes collection.)

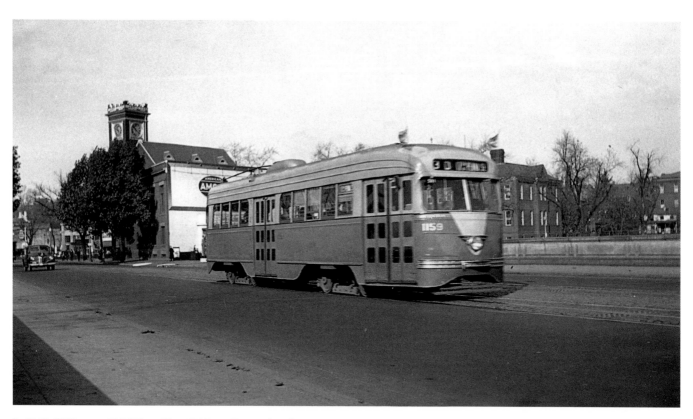

In 1942, CTC route 30 PCC car No. 1159 is on Pennsylvania Avenue NW crossing over the Rock Creek bridge. This was one of 20 cars Nos. 1176-1195 built in 1938 by St. Louis Car Company and each costing $13,552. Powered by four General Electric type 1195F1 motors, each car weighed 34,240 pounds and seated 50. The car was scrapped in 1963. (Bill Stevenson photograph - C. R. Scholes collection.)

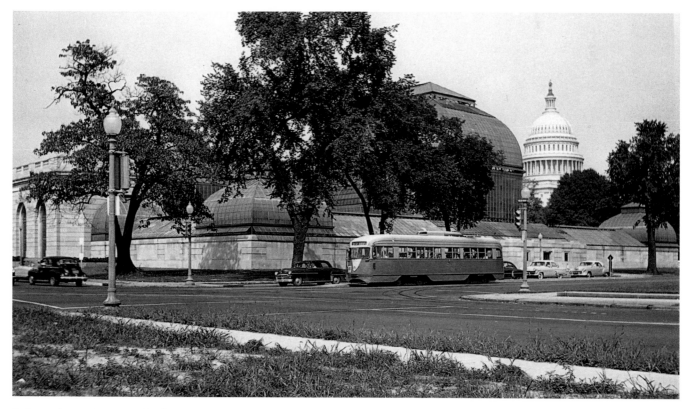

Independence Avenue and 2nd Street SW is the location of PCC car No. 1252 in 1943. This CTC car was built in 1940 and was scrapped in 1962. The broad tree lined avenues of Washington, some with median strips, enabled the PCC cars to demonstrate their rapid acceleration and smooth riding qualities. (Bill Stevenson photograph - C. R. Scholes collection.)

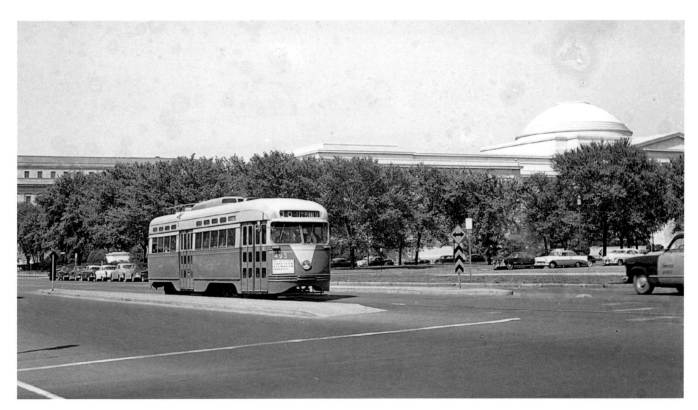

Pennsylvania Avenue at 3rd Street SE is the location of CTC route 30 PCC car No. 1493 heading for 17th and Pennsylvania Avenue SE in 1945. This car was built in 1944, fitted with a sealed beam headlamp in 1958, and scrapped in 1963. Street cars were maintained clean and attractive by CTC. Before Louis Wolfson management took over, CTC repainted street cars every five years. Under Wolfson, street cars were painted on a conditional basis. (C. R. Scholes collection.)

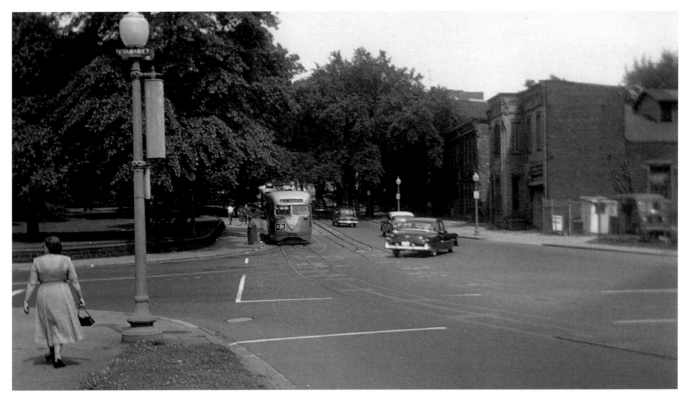

1n 1947, PCC car No. 1454 is at Independence Avenue and 1st Street SW. This was one of 33 cars Nos. 1432-1464 built in 1944 by St. Louis Car Company for CTC each powered by four Westinghouse type 1432D motors. Seating 49, each car cost $18,831. This car went to Gradsko Saobracatno Preduzege (Sarajevo, Yugoslavia) in 1958. (C. R. Scholes collection.)

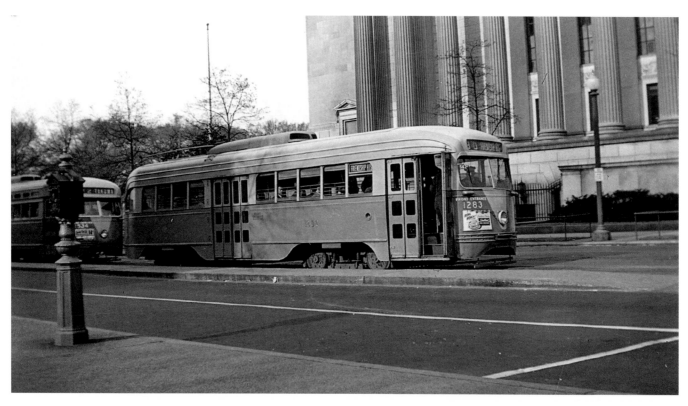

On April 19, 1947, CTC route 30 PCC car No. 1283 (one of 17 cars Nos. 1268-1284 built in 1940 and powered by four General Electric type 1198F3 motors) heading for Friendship Heights followed by PCC car No. 1584 (one of 25 cars Nos. 1565-1589 built in 1945 and powered by four Westinghouse type 1423HE motors) are on Pennsylvania Avenue at 7th Street NW. Both cars were scrapped in 1963. (C. R. Scholes collection.)

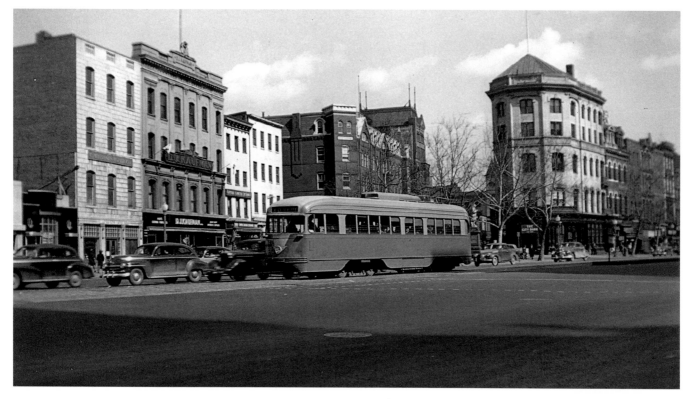

On March 9, 1947, CTC route 30 PCC car No. 1260 is on Pennsylvania Avenue at 11th Street NW. This car was built in 1940, received an experimental automatic pole device in 1953, and went to Gradsko Saobracatno Preduzege (Sarajevo, Yugoslavia) in 1962. (C. R. Scholes collection.)

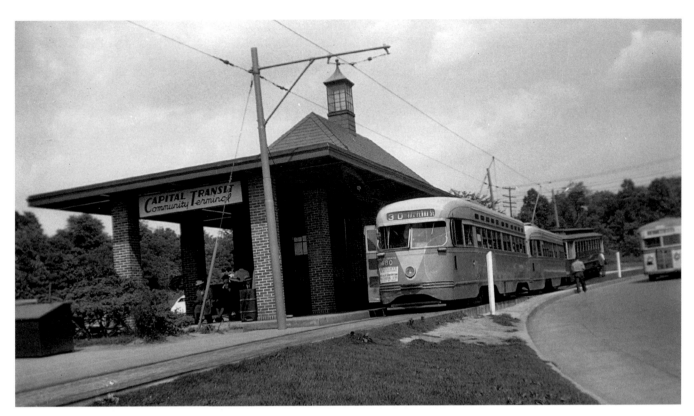

At the Friendship Heights terminal loop building on Wisconsin Avenue at Western Avenue NW, which opened June 11, 1936, CTC route 30 PCC car No. 1480 is awaiting departure time on June 22, 1947 in the Friendship Heights neighborhood of Northwest Washington, DC. This was one of 36 cars Nos. 1466-1501 built in 1944 by St. Louis Car Company, powered by four Westinghouse type 1432HE motors, and scrapped in 1963). Behind it is another PCC car and an 800 type street car. (C. R. Scholes collection.)

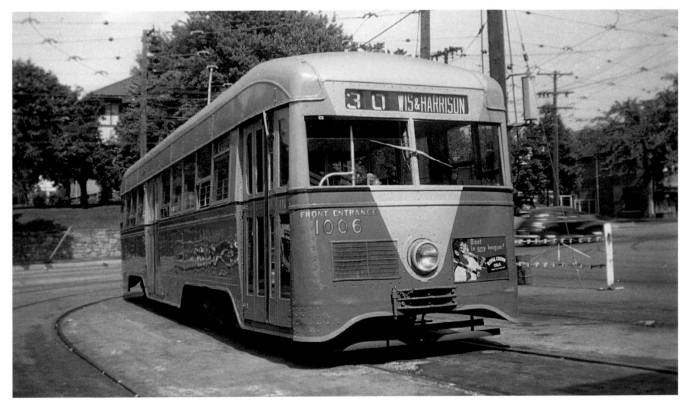

CTC streamliner car No. 1006 (built in 1935 by J. G. Brill Company with riveted construction and scrapped in 1959) is at the Tenleytown car house located at Wisconsin Avenue and Harrison Street NW on June 22, 1947. (C. R. Scholes collection.)

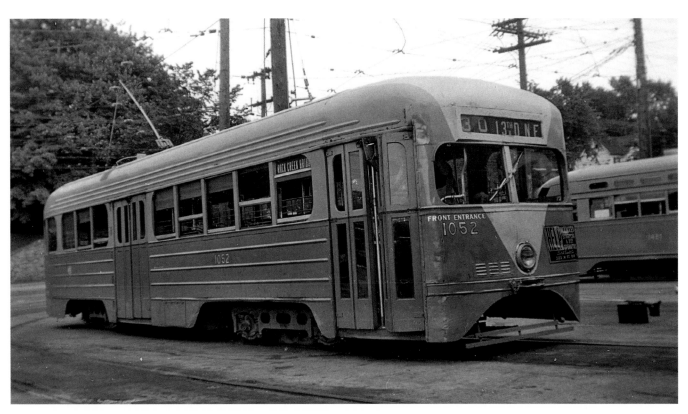

On June 22, 1947, CTC streamliner car No. 1052 (built in 1935 by St. Louis Car Company with all welded construction and scrapped in 1959) is at the Tenleytown car house. (C. R. Scholes collection.)

CTC PCC car 1267 (built in 1940 and scrapped in 1961) followed by PCC car 1538 (built in 1944 and scrapped in 1962) are on Pennsylvania Avenue at 15th Street NW as seen from the United States Treasury Building in 1950. (Bill Stevenson photograph - C. R. Scholes collection.)

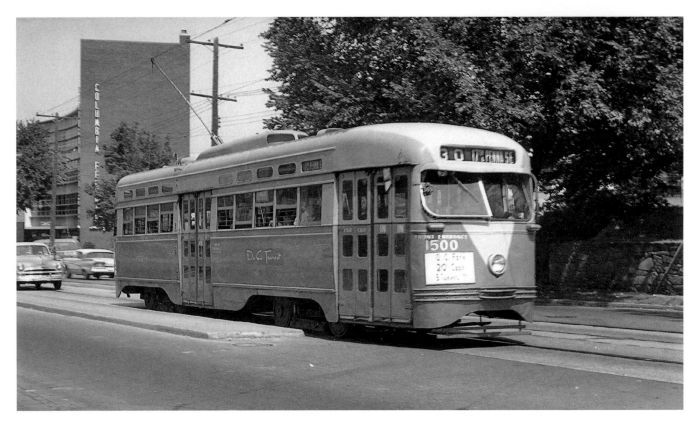

Wisconsin Avenue at Warren Street NW in the Tenleytown neighborhood of Washington, DC, finds southbound CTC route 30 PCC car No. 1500 heading for 17th and Pennsylvania Avenue SE in 1950. This car was built in 1944 and scrapped in 1963. (C. R. Scholes collection.)

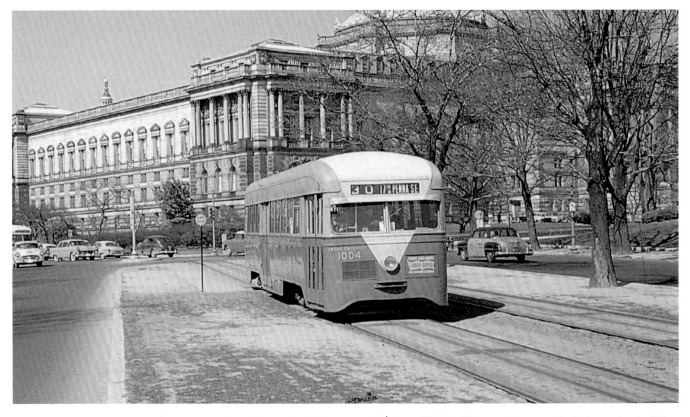

On March 3, 1956, CTC streamliner No. 1004 is on Pennsylvania Avenue at 2nd Street SE. The Library of Congress is the imposing building behind the street car. (Bob Crockett - C. R. Scholes collection.)

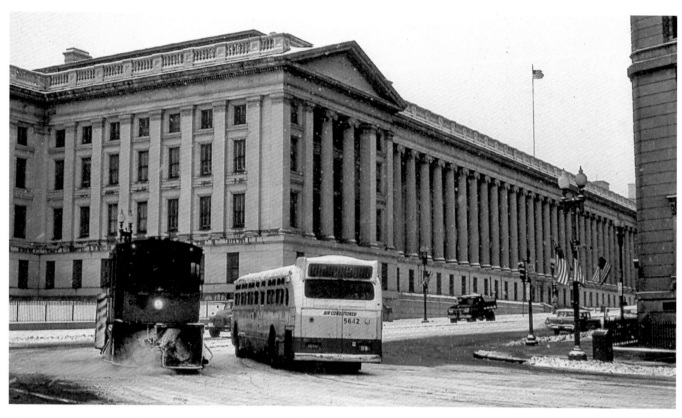

In January 1960, DC Transit System snow sweeper No. 036 (built by J. G. Brill Company in 1901, powered by two Westinghouse type 306 motors, and scrapped in 1962) is turning from 15th Street to Pennsylvania Avenue and passing 1958 General Motors Corporation model TDH5105 bus No. 5642. Historically snow and ice storms have a way of disrupting Washington, DC. (C. R. Scholes collection.)

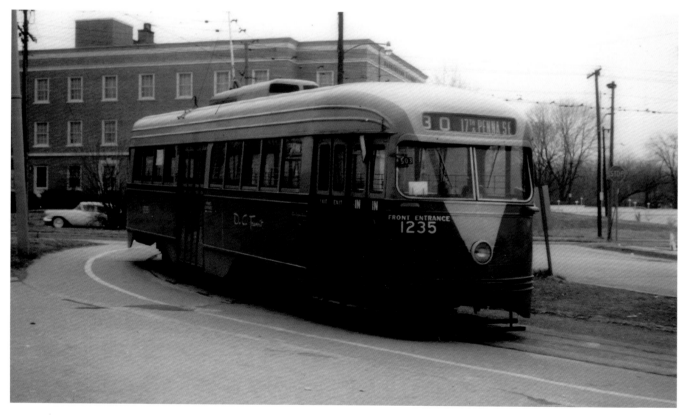

On a cloudy January 2, 1960, DC Transit System PCC car No. 1235 is at the Friendship heights loop. This car was built in 1940 and scrapped in 1966. (Kenneth C. Springirth photograph.)

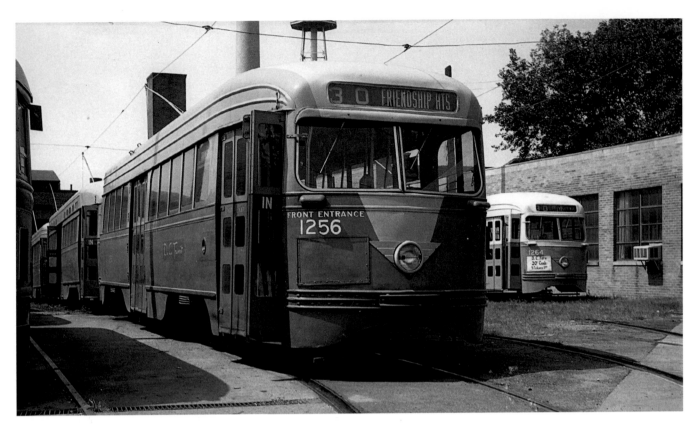

PCC car No. 1256 (built in 1940 and scrapped in 1966) is heading the lineup of cars for the next assignment at Tenleytown car house in 1961. To the right, next to the building, is PCC car No. 1264 (built in 1940 and scrapped in 1962). (C. R. Scholes collection.)

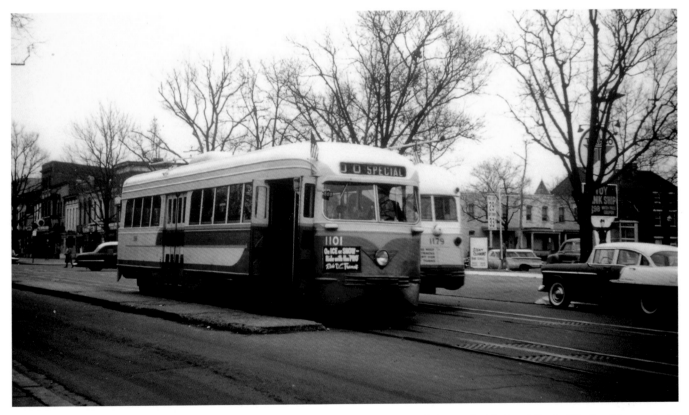

On January 21, 1962, PCC car No. 1101 (built in 1937 and preserved in operating condition at the National Capital Trolley Museum) at a picture stop on 8th Street and Pennsylvania Avenue SE on a rail excursion is being passed by regular service PCC car No. 1179 (built in 1938 and scrapped in 1963). (Kenneth C. Springirth photograph.)

Chapter 6

Routes 40/42 Lincoln Park/13th & D St.

These routes linked the important residential areas in both the Northwest and the area east of the Capitol to the downtown F Street shopping area. Both lines used the underground conduit for their entire length. Route 40 (Mt. Pleasant-Lincoln Park) operated from Lamont and Mt. Pleasant Streets NW, via Mt. Pleasant Street, Columbia Road, Connecticut Avenue, 17th Street, H Street, 14th Street, F Street, 5th Street, D Street, Indiana Avenue (New Jersey Avenue, westbound), C Street, 1st Street NE, and East Capitol Street to 15th Street.

Route 42 (Mt. Pleasant-13th & D Streets) shared the same track with route 40 from Mt. Pleasant to 5th Street and separated going to G Street, Massachusetts Avenue NE, Union Station Plaza, Massachusetts Avenue NE, and D Street to 13th Street and returned using C Street and the same route back to Mt. Pleasant. Rush hour routes were 41 (14th & Colorado-Lincoln Park), 43 (Mt. Pleasant-SW Mall), 45 (Lincoln Park-Union Station-Bureau of Engraving), 47 (Mt. Pleasant-7th Street Wharves), and 49 (Mt. Pleasant-Potomac Park).

The March 1946 ridership for routes 40/42 totaled 4,935,349, making them the heaviest on the system. Routes 40 and 42 used the 0.33 mile Dupont Circle underpass under Connecticut Avenue, construction of which began on March 8, 1948 at a cost of $4 million. The Dupont Circle underpass was opened to northbound street car service with route 42 car No. 1550, making the first northbound trip on November 2, 1949, passing under the circle. The southbound tunnel was opened on December 9, 1949 by car No. 1550. In 1957, routes 40 and 42 had an average total weekday ridership of 54,500 making them the busiest lines on the system. On December 3, 1961, routes 40 and 42 were converted to bus operation.

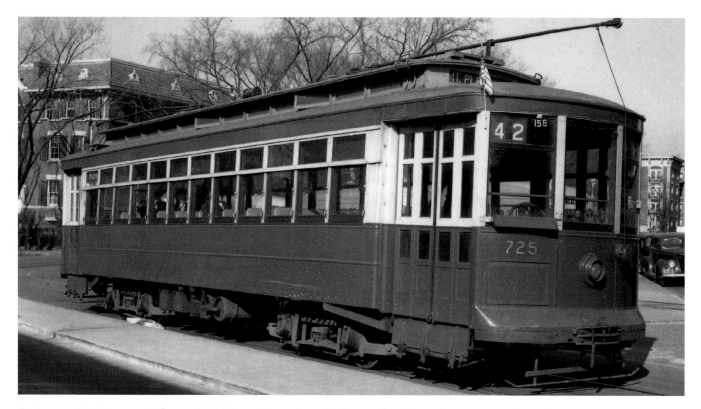

On January 20, 1941, route 42 former WERCO car No. 725 is at Mt. Pleasant loop located at Lamont and Mt. Pleasant Streets NW in the Mt. Pleasant neighborhood in Northwest Washington, DC. This car, transferred to Capital Transit Company (CTC) in 1933, was converted to one-man operation in 1945 and scrapped in 1950. (C. R. Scholes collection.)

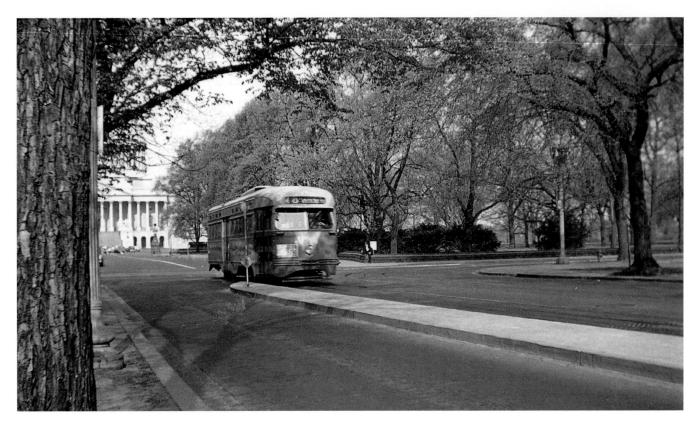

CTC route 40 PCC car No. 1514 is on East Capital Street near 1ˢᵗ Street with the United States Capitol Building in the background on April 19, 1947. This car was built in 1944 and went to Tranvias de Barcelona (Barcelona, Spain) in 1964. (C. R. Scholes collection.)

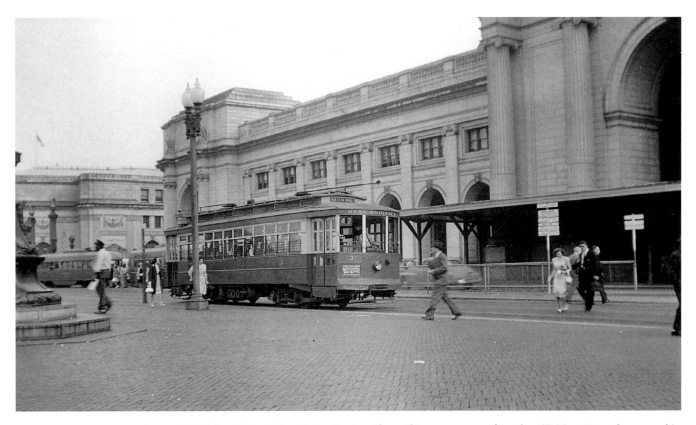

On May 24, 1947, route 42 former WERCO car No. 737 is at Union Station Plaza. This car was transferred to CTC in 1933 and scrapped in 1948. (C. R. Scholes collection.)

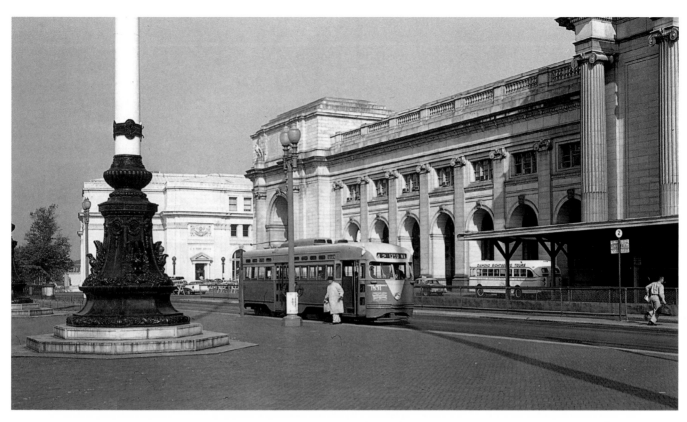

On May 29, 1947, CTC route 42 PCC car No. 1531 is at a passenger stop in front of Union Station for an eastbound trip to 13th and D Streets NE. This car was built in 1944 and went to Tranvias de Barcelona (Barcelona, Spain) in 1964. (C. R. Scholes collection.)

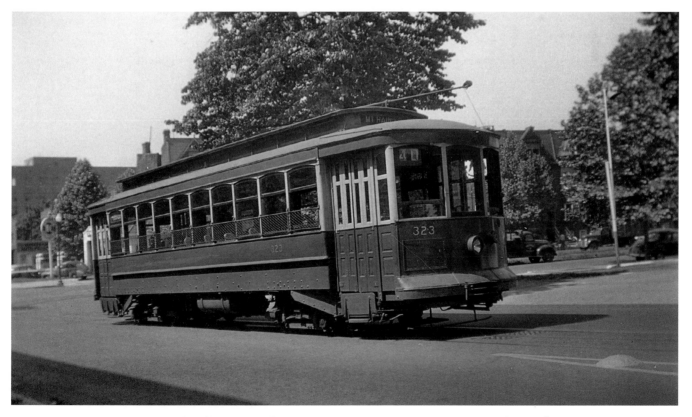

Route 40 Capital Transit Company (CTC) car No. 323 (originally Capital Traction Company car No. 737) is at 2nd Street and Indiana Avenue NW on June 22, 1947. This car weighed 33,857 pounds and seated 40. The 50 cars Nos. 701-750 of this series (later renumbered 287-336) were obtained from Jewett Car Company at a total cost of $228,762 in 1912. (C. R. Scholes collection.)

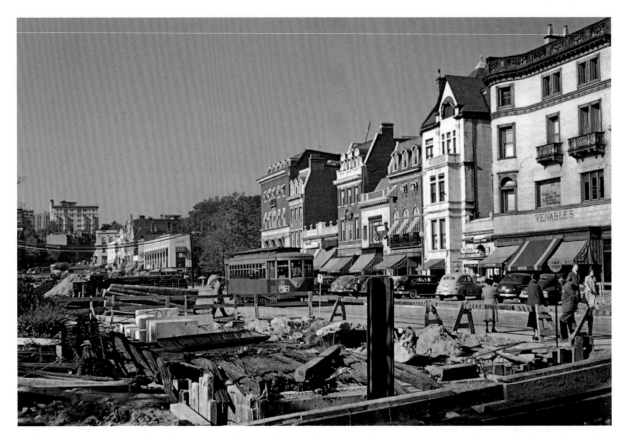

Capital Transit Company (CTC) car No. 722 (originally Capital Traction Company car No. 308) passes by the construction of the Dupont Circle underpass on Connecticut Avenue at Massachusetts Avenue, P Street, 19th Street, and New Hampshire Avenue NW on October 1, 1949. Construction began on March 8, 1948 and the street car portion opened on December 9, 1949. A separate automobile tunnel opened on May 1, 1950. (Bob Crockett photograph - C. R. Scholes collection.)

In 1949, PCC car No. 1564 is entering the 15th Street side of the CTC Eastern or Lincoln Park car house. This car was built in 1945 and in 1963 went to Tranvias de Barcelona (Barcelona, Spain). The brick structure was built in 1896 by the Metropolitan Railway Company. (Bill Stevenson photograph - C. R. Scholes collection.)

The 13th and D streets NE terminus of CTC route 42 finds PCC car No. 1563 waiting for departure time in 1950 and another PCC car behind it. This car was built in 1945 and scrapped in 1962. (Bill Stevenson photograph - C. R. Scholes collection.)

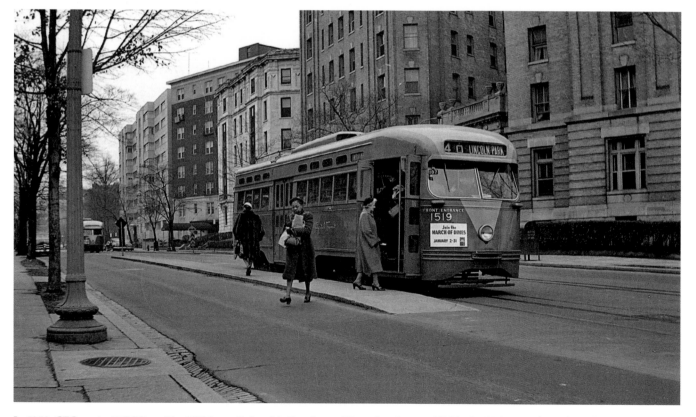

In 1950, CTC route 40 PCC car No. 1519 is on Columbia Road near Wyoming Avenue NW in the Kalorama (translates from the Greek as fine view) section in Northwest Washington, DC. This car was built in 1944 and went to Tranvias de Barcelona (Barcelona, Spain) in 1963. (Bill Stevenson photograph - C. R. Scholes collection.)

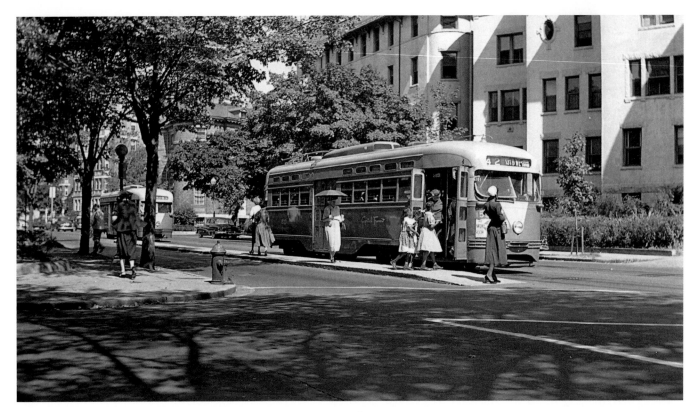

In 1950, CTC route 42 PCC car No. 1506 is on Columbia Road at 19th Street NW in the Adams Morgan neighborhood of Northwest Washington, DC. This car was built in 1944 and went to Leonard's Department Store in Fort Worth, Texas, in 1962. (Bill Stevenson photograph - C. R. Scholes collection.)

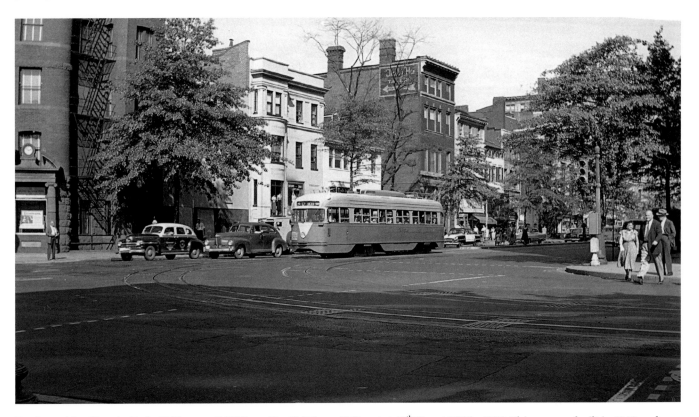

Eastbound for Lincoln Park, CTC route 40 PCC car No. 1349 is on H Street at 17th Street NW in 1950. This car was built in 1942 and was scrapped in 1962. (Bill Stevenson photograph - C. R. Scholes collection.)

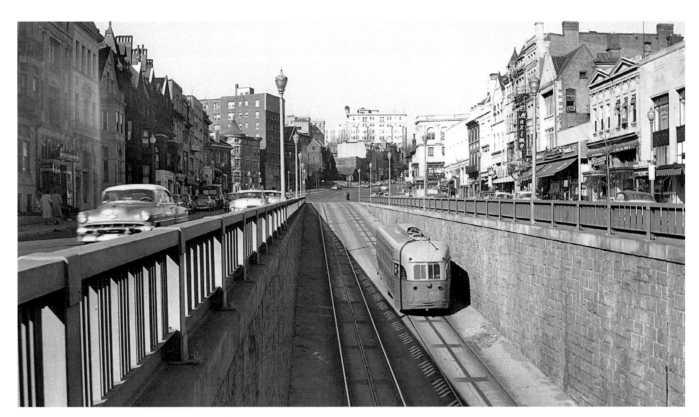

PCC car No. 1521 is emerging from the Dupont Circle underpass to Connecticut Avenue NW in 1950. This CTC car was built in 1944 and went to Tranvias de Barcelona (Barcelona, Spain) in 1964. The Dupont Circle neighborhood of Northwest Washington, DC, is centered around the traffic circle. (Bill Stevenson photograph - C. R. Scholes collection.)

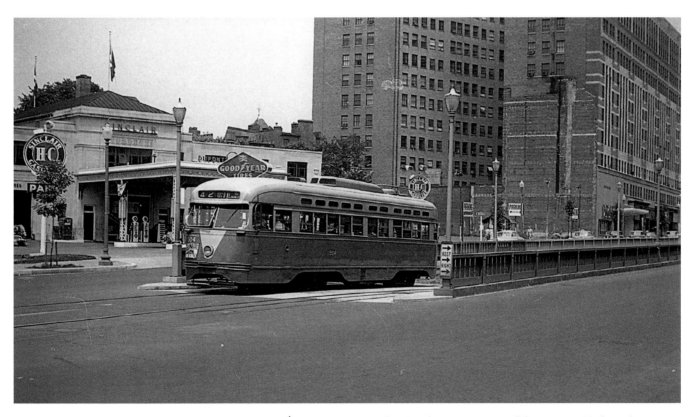

In 1954, CTC route 42 PCC car No. 1504, heading for 13th & D Streets NE, is leaving the entranceway of the Dupont Circle underpass on Connecticut Avenue at N Street NW. This car was built in 1944 and went to Tranvias de Barcelona (Barcelona, Spain) in 1964. (Joe Kepler photograph - C. R. Scholes collection.)

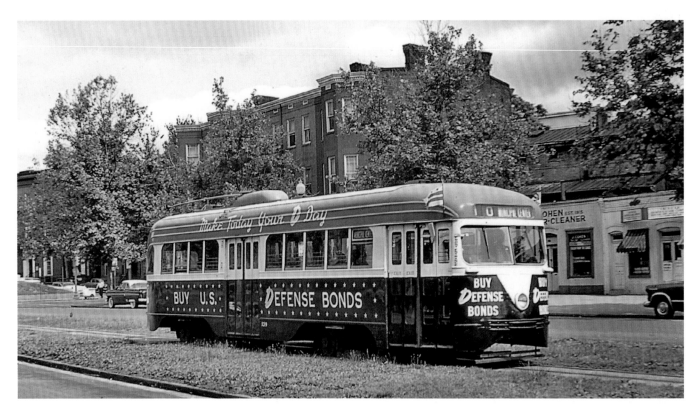

"Make Today Your D Day Buy U.S. Defense Bonds" is prominently displayed on red, white, and blue painted PCC car No. 1139 on Indiana Avenue and 2nd Street NW on June 3, 1956. CTC placed this repainted car in service at a ceremony at the Peace Monument on September 4, 1951 to advertise a city-wide $9 million bond drive. This car, built in 1937, was rotated on various routes and scrapped in 1963. (C. Abel photograph - C. R. Scholes collection.)

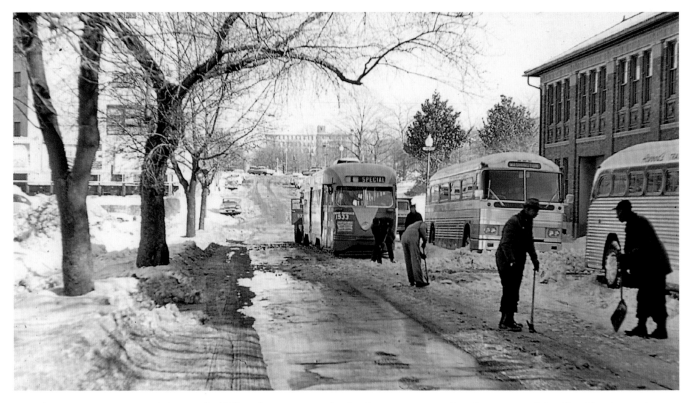

On February 5, 1961, DC Transit System (DCTS) workers are removing ice from route 40 track and center conduit rail on New Jersey Avenue and D Street NW so that PCC car No. 1533 can proceed. The 1960-1961 winter brought twenty-seven inches of snow with ice jamming the conduit slot halting street car service. Buses temporarily replaced the street cars. (C. Abel photograph - C. R. Scholes collection.)

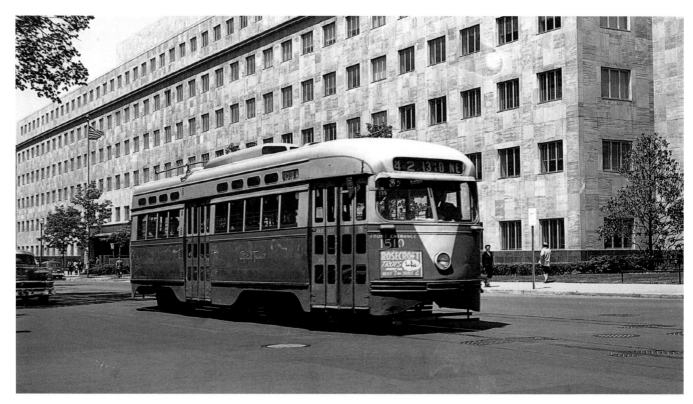

DCTS route 42 PCC car No. 1510, eastbound for 13th and D streets NE, is at G and 4th Streets NW in 1961. This car was built in 1944, later received the DC Transit paint scheme, and went to Tranvias de Barcelona (Barcelona, Spain) in 1963. (C. R. Scholes collection.)

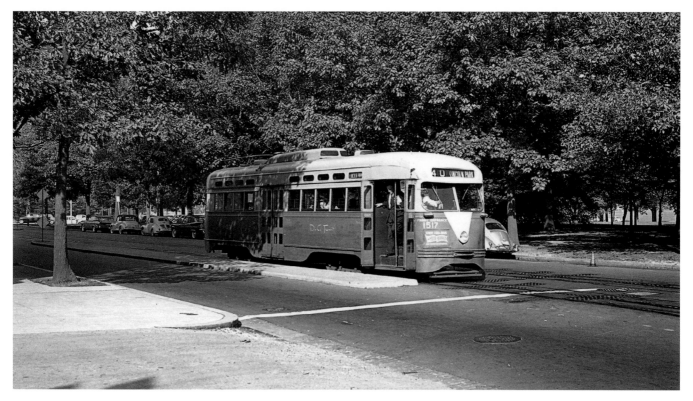

On September 4, 1961, DCTS route 42 PCC car No. 1517 is at a passenger stop on East Capital Street near 2nd Street for an eastbound trip to Lincoln Park. This car was built in 1944 and went to Tranvias de Barcelona (Barcelona, Spain) in 1963. (C. R. Scholes collection.)

Eastbound for Lincoln Park, DCTS route 40 PCC car No. 1534 is on 1st Street at Constitution Avenue NE in 1961. This car was built in 1944 and went to Tranvias de Barcelona (Barcelona, Spain) in 1964. (C. R. Scholes collection.)

Vintage car No. 303 with trailer 1512 (on a rail excursion) is on the left track and route 42 regular service PCC car No. 1505 (built in 1944 and went to Tranvias de Barcelona at Barcelona, Spain in 1964) is on the right track at DCTS Mt. Pleasant loop on April 16, 1961. (Kenneth C. Springirth photograph.)

Routes 50/54 Bureau of Engraving/Navy Yard

Route 50 (14th & Colorado-Bureau of Engraving) operated entirely on 14th Street between Colorado Avenue and the Bureau of Engraving. Route 54 (14th & Colorado-Navy Yard) was the other main route that operated from 14th and Colorado Avenue NW via 14 Street, Pennsylvania Avenue, 1st Street SW, Independence Avenue, Pennsylvania Avenue SE, and 8th Street to the Navy Yard. Rush hour routes were 51 (14th & Colorado via 11th-Navy Yard) and 53 (14th & Colorado-SW Mall). Southbound short turns from 14th & Colorado were 52 (9th & E NW) and 54

(Peace Monument). Northbound short turns from the Navy Yard or Bureau of Engraving were 50 (14th & Decatur) and 51 (14th & Decatur via 11th). A new terminal loop opened at 14th and Colorado Avenue on May 2, 1937. On February 2, 1943, an underground loop and station opened at the Bureau of Engraving below 14th and C Street SW. The March 1946 ridership for routes 50/52/54 totaled 4,125,634. In 1957, routes 50 and54 had an average total weekday ridership of 41,400. Routes 50 and 54 were converted to bus operation on Sunday morning January 28, 1962.

In 1939, Capital Transit Company (CTC) car No. 327 (originally Capital Traction Company No. 741) is at 14th Street and Maine Avenue SW. This was the original Bureau of Engraving loop before the underground loop was built. With graceful arched windows and mahogany-paneled interiors, this car was one of 50 reliable cars Nos. 701-750 built by Jewett Car Company (renumbered 287-336 in 1933). (Dave McNeil photograph – C. R. Scholes collection.)

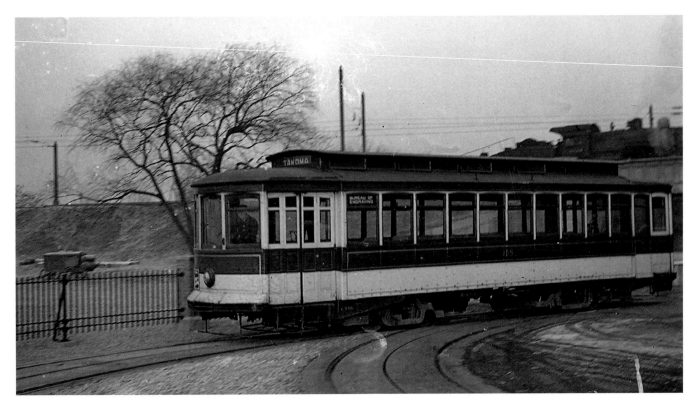

Capital Transit Company (CTC) car No. 155 is at 14th and Water Streets SW in 1940. This was one of 36 cars Nos. 151-186 built in 1909 by Cincinnati Car Company for Capital Traction Company and were transferred to CTC in 1933. Cars Nos. 151-154 had two Westinghouse type 101B motors while the remainder had two Westinghouse type 306 motors. Each car, weighing 36,621 pounds, was scrapped in 1945. (Dave McNeil photograph - C. R. Scholes collection.)

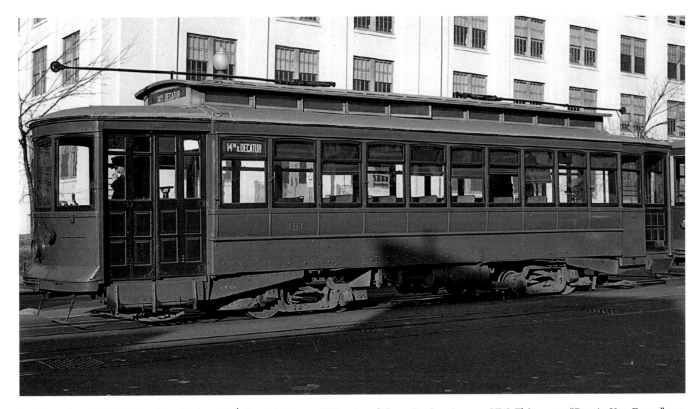

In December 1940, CTC car No. 181 is on 14th Street between E Street and Constitution Avenue NW. This was a "Pay As You Enter" car, where the conductor was on the rear platform and collected fares as passengers boarded. (C. R. Scholes collection.)

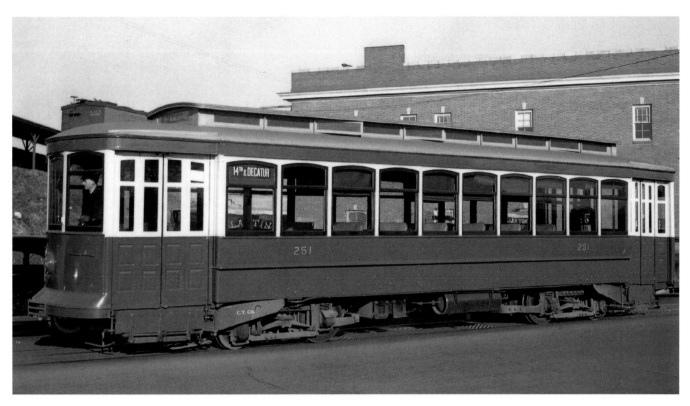

Capital Transit Company car No. 251 (originally Capital Traction Company car no. 665) is at 14th Street and Maine Avenue SW on February 18, 1941 for a north bound trip to 14th and Decatur Streets. (C. R. Scholes collection.)

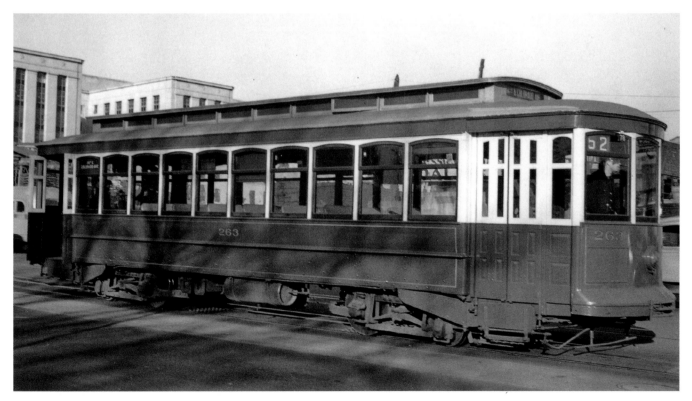

In February 1941, Capital Transit Company (CTC) car No. 263 (originally Capital Traction Company car No. 677) is at 14th Street and Maine Avenue SW for a route 52 northbound trip to Park Road in the Columbia Heights neighborhood of Northwest Washington, DC. (C. R. Scholes collection.)

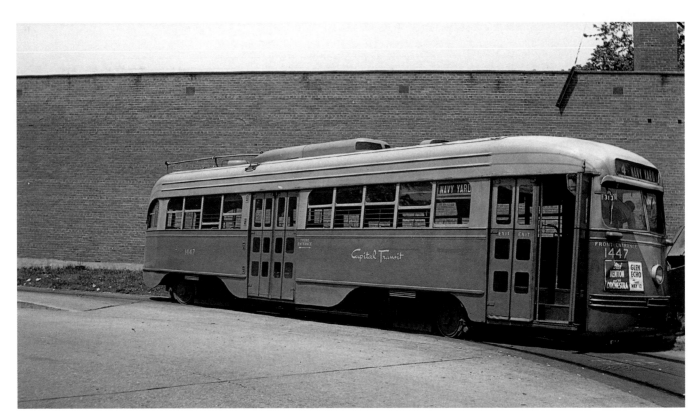

CTC route 54 PCC car No. 1447 is at the 14th Street and Colorado NW loop in the Brightwood neighborhood in the Northwest quadrant of Washington, DC, waiting for departure time to the Navy Yard in 1947. This car was built in 1944 and went to Gradsko Saobracatno Preduzege (Sarajevo, Yugoslavia) in 1958. (Bill Stevenson - C. R. Scholes collection.)

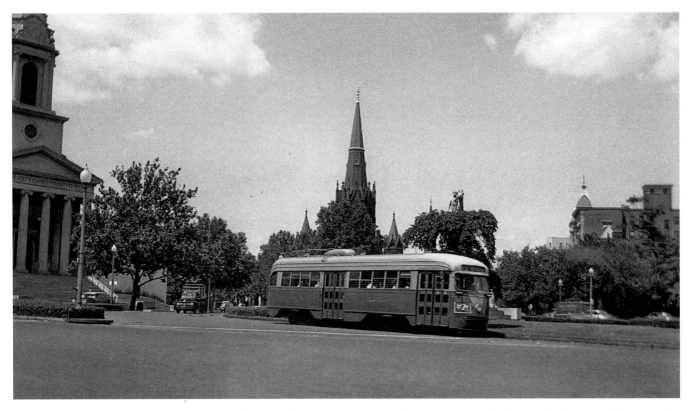

In 1947, CTC PCC car No. 1103 (built in 1937 and scrapped in 1963) is traversing Thomas Circle in Northwest Washington, DC, named for American Civil War Union Army General George Henry Thomas. In the center of the picture behind the street car is the Luther Place Memorial Church built in 1873. The National City Christian Church, completed in 1930, is at the left of the street car. (C. R. Scholes collection.)

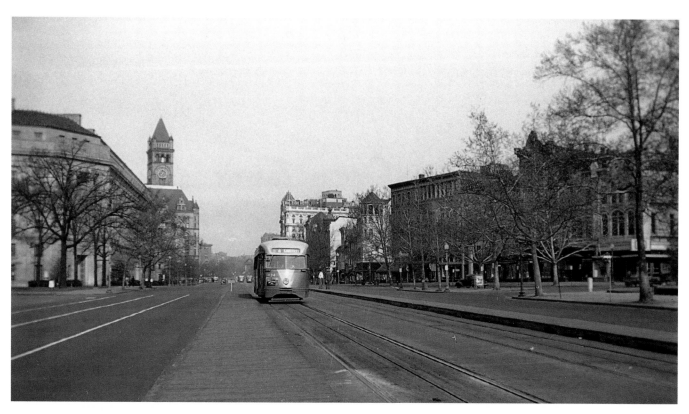

On April 19, 1947, CTC route 54 PCC car No. 1434 is on Pennsylvania Avenue at 7th Street NW. This car was built in 1944 and in 1958 went to Gradsko Saobracatno Preduzege (Sarajevo, Yugoslavia). (C. R. Scholes collection.)

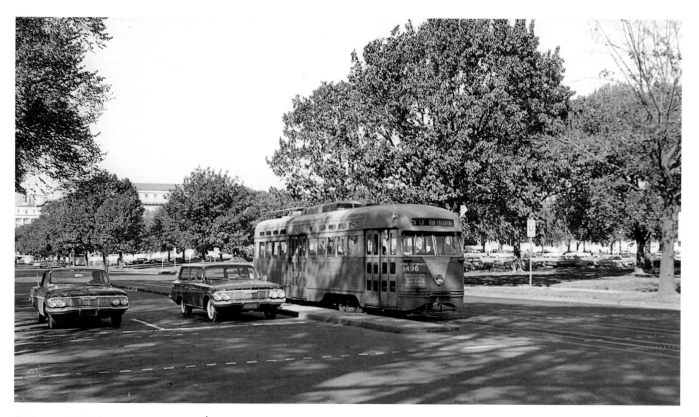

CTC route 50 PCC car No. 1496 is on 14th Street at Independence Avenue SW on June 21, 1947. This car was built in 1944 and was scrapped in 1963. (C. R. Scholes collection.)

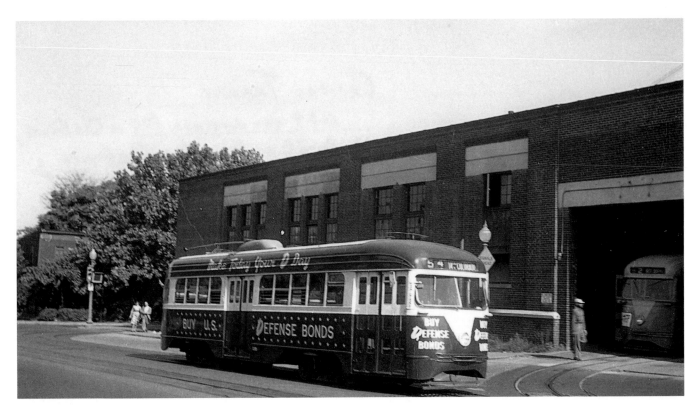

Patriotically painted and lettered "Buy U.S. Defense Bonds," CTC route 54 PCC car No. 1139 is on M Street SE at the Navy Yard car house. This photo from 1951 shows the car ready for the next trip to the northern terminus at 14th Street and Colorado Avenue. (C. R. Scholes collection.)

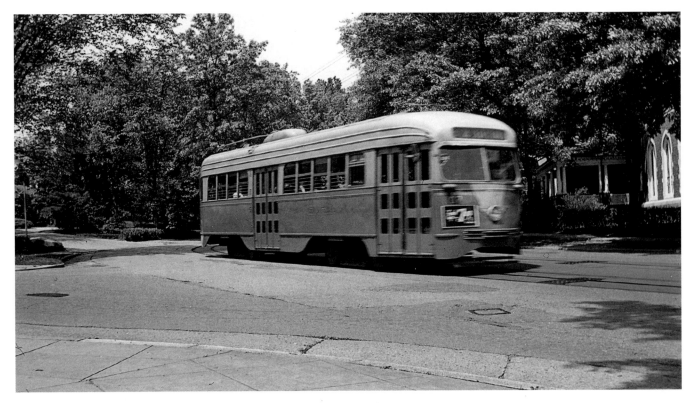

In 1952, CTC PCC car No. 1177 (built in 1938 and scrapped in 1963) is on 14th Street near Decatur Street NW in the Sixteenth Street Heights neighborhood of Washington, DC. It is bounded by 16th Street on the west, Missouri Avenue on the north, Georgia Avenue on the east, and Upshur Street on the south. Street car lines on 14th Street and nearby Georgia Avenue contributed to the growth of this area. (Bill Stevenson photograph - C. R. Scholes collection.)

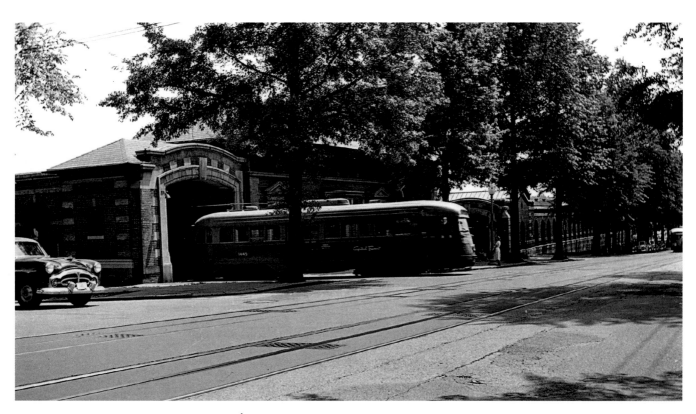

CTC PCC car No. 1445 is coming out of the 14th Street and Decatur NW car house in 1952. The car was built in 1944 and went to Gradsko Saobracatno Preduzege (Sarajevo, Yugoslavia) in 1958). This stylish looking car house was built in 1907 by Capital Traction Company and became a bus garage in 1959. (Bill Stevenson photograph - C. R. Scholes collection.)

In 1952, CTC route 54 PCC car No. 1438 on the right is at the 14th Street and Colorado NW loop. This car was built in 1944 and went to Gradsko Saobracatno Preduzege (Sarajevo, Yugoslavia) in 1958. On the left is another PCC car. (Bill Stevenson photograph - C. R. Scholes collection.)

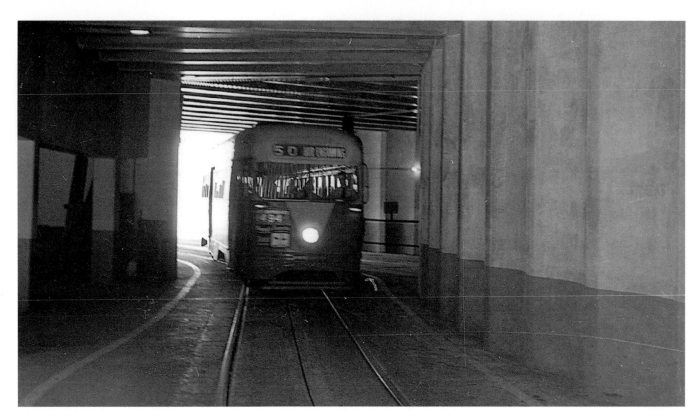

CTC route 50 PCC car No. 1494 (built in 1944 and scrapped in 1963) is entering the underground ground Bureau of Engraving loop in September 1954. This underground loop and station below 14th and C Streets SW was placed in service on February 8, 1943 to eliminate severe traffic congestion at 14th Street and the Bureau of Engraving. (Joe Kepler photograph - C. R. Scholes collection.)

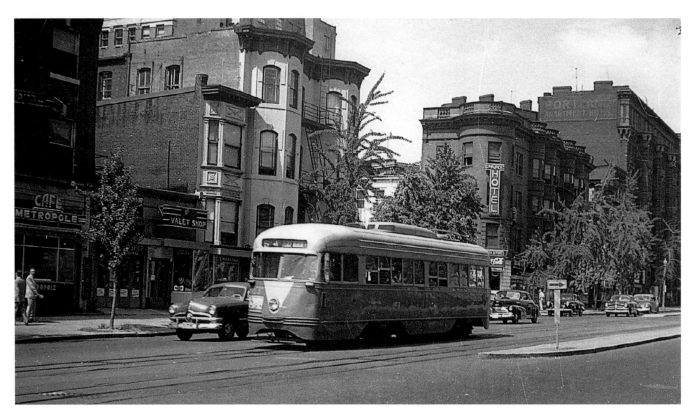

In 1954, CTC route 54 PCC car No. 1253 is at 14th and U Streets NW. This car was delivered in 1940 and was scrapped in 1966. (Joe Kepler photograph - C. R. Scholes collection.)

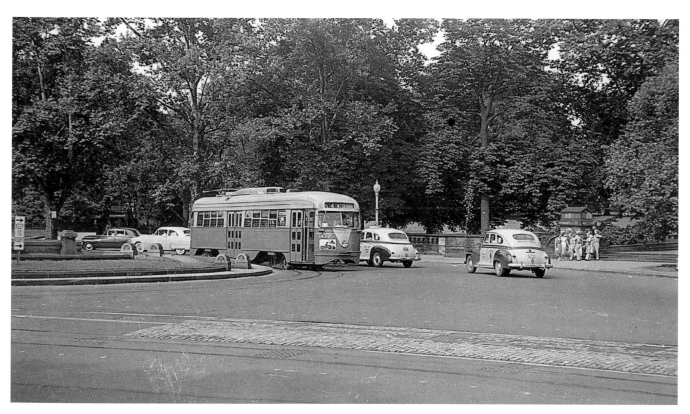

In 1954, CTC route 54 PCC car No. 1427 (built in 1944 and scrapped in 1962) is at the Peace Monument loop on Pennsylvania Avenue at 1st Street. At this circle is a 44-foot-high white marble monument completed in 1878 to commemorate the naval deaths at sea during the American Civil War. (Joe Kepler photograph - C. R. Scholes collection.)

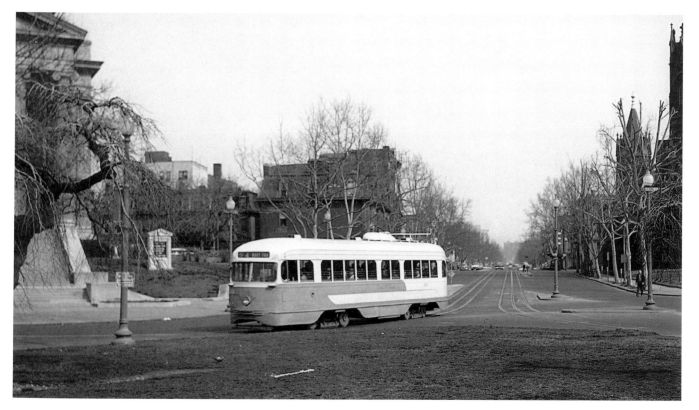

On April 2, 1960, DC Transit System (DCTS) PCC car No. 1131 is on 14th Street at Massachusetts Avenue passing through Thomas Circle NW. This was one of 23 cars Nos. 1123-1145 built by St. Louis Car Company in 1937 and powered by four General Electric type 1198F1 motors. The car was repainted in the DCTS paint scheme and was scrapped in 1966. (Charles Griffin photograph - C. R. Scholes collection.)

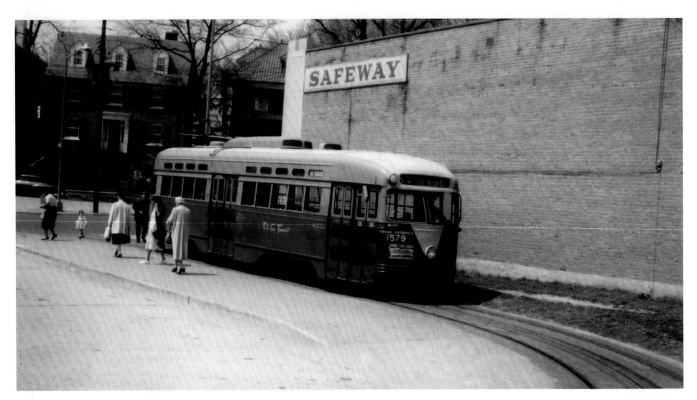

On April 15, 1960, DCTS route 50 PCC car No. 1579 is on a layover at the 14th Street and Colorado Avenue NW northern terminus and at the appointed time will head south to the Bureau of Engraving. This car was built in 1945 and was scrapped in 1963. (Kenneth C. Springirth photograph.)

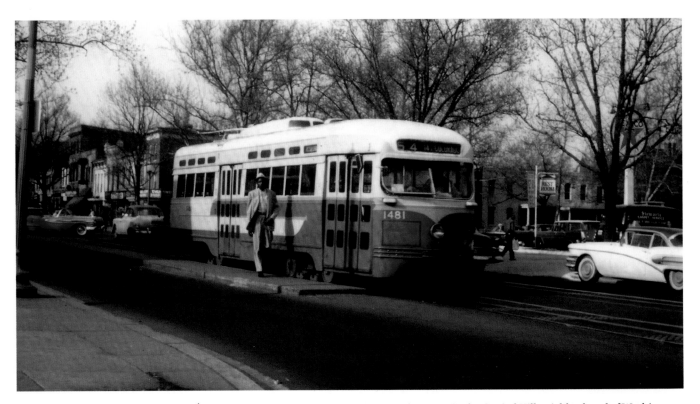

DCTS route 54 PCC car No. 1481 is at 8th Street and Pennsylvania Avenue SE on April 15, 1960 in the Capital Hill neighborhood of Washington, DC. It is bounded by F street NE on the north, 14th Street NE on the east, Virginia Avenue on the south, and South Capitol Street on the west. The car was built in 1944, was repainted in the DCTS paint scheme, and was scrapped in 1963. (Kenneth C. Springirth photograph.)

Snow sweeper No. 07 is on 14th and E Streets NW in December 1960. This was one of ten double end snow sweepers Nos. 06-015 (powered by two Westinghouse type 101B motors) built in 1899 by McGuire Cummings Manufacturing Company for Washington Traction & Electric Company which became part of WERCO in 1902. It was owned by CTC from 1933 to 1956 and DCTS after 1956. In August 1966 it went to the National Capital Trolley Museum where it was destroyed by a car barn fire on September 28, 2003. (C. R. Scholes collection.)

On April 16, 1961, DCTS route 54 PCC car No. 1220 is at the Navy Yard car house. Powered by four Westinghouse type 1432B motors, this was one of 20 cars Nos. 1214-1233 built by St. Louis Car Company in 1939. The car went to Transvias de Barcelona (Barcelona, Spain) in 1963. The Navy Yard car house was built by the Washington & Georgetown Railroad Company around 1892 and used until as a street car facility until 1962. (Kenneth C. Springirth photograph.)

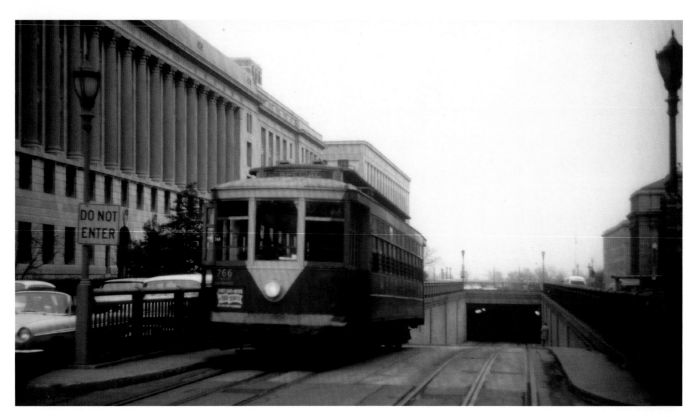

On January 21, 1962, ex Capital Traction Company car No. 27, transferred to Capital Transit Company in 1933 and renumbered 766, is emerging from the underground Bureau of Engraving loop for a photo stop on a rail excursion. DCTS donated this car to the National Capital Trolley Museum where it arrived in March 1970. (Kenneth C. Springirth photograph.)

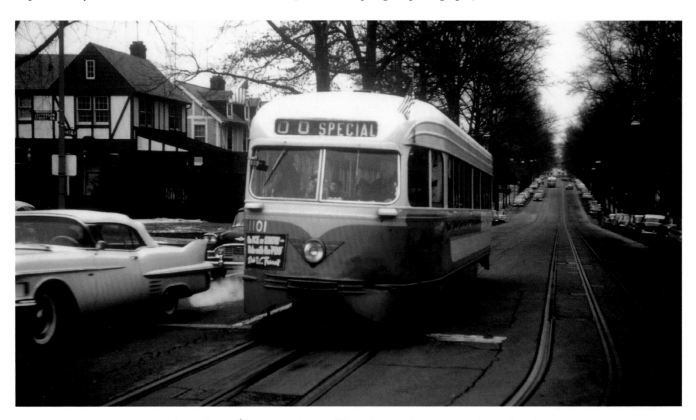

DCTS PCC car No. 1101 is northbound on 14th Street ready to pull into the northern terminal at Colorado Avenue NW on January 21, 1962 on a rail excursion. Street car service ended in Washington, DC, one week later on January 28, 1962. It was a delight to ride this car fifty-four years later, on April 17, 2016, at the National Capital Trolley Museum. (Kenneth C. Springirth photograph.)

Route 60 Eleventh St. – 6th Pennsylvania Ave.

A new loop was completed in the spring of 1942 for route 60 at 11th and Monroe Streets, and PCC cars were placed in service on the line. Route 60, the shortest on the DC Transit system, operated from 11th and Monroe via 11th Street, E Street, 9th Street, Pennsylvania Avenue, 7th Street, C Street, and 6th Street. It returned via Pennsylvania Ave., 9th Street, G Street, and 11th Street to Monroe Street. Rush hour routes were 61 (11th & Monroe NW-Lincoln Park), 63 (11th & Monroe NW-SW mall), 67 (11th & Monroe NW-7th Street Wharves), and 69 (11th & Monroe NW-Potomac Park). The March 1946 ridership for route 60 was 720,566 making it the lightest on the system. In 1957, route 60 had an average weekday ridership of 8,000. The line was converted to bus operation on December 3, 1961.

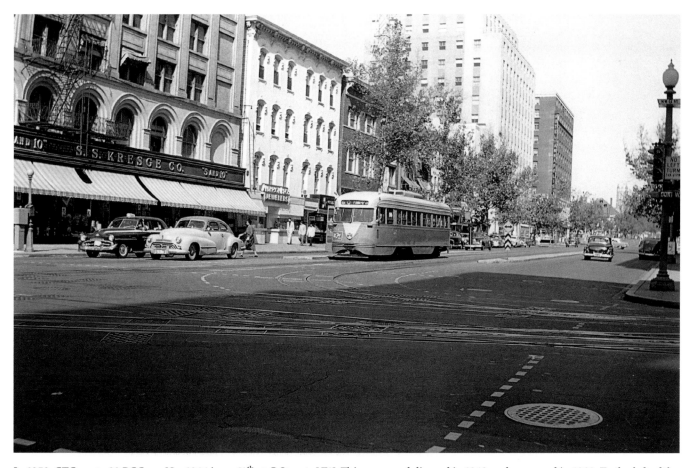

In 1950, CTC route 60 PCC car No. 1244 is on 11th at G Streets NW. This car was delivered in 1940 and scrapped in 1963. To the left of the street car was the S. S. Kresge Company Five and Dime Store. The store was founded by Sebastian Spering Kresge and by 1935 there were 745 of these stores, which – like the street car – were a life saver to the communities they served. They carried a variety of items including transit passes. (Bill Stevenson photograph - C. R. Scholes collection.)

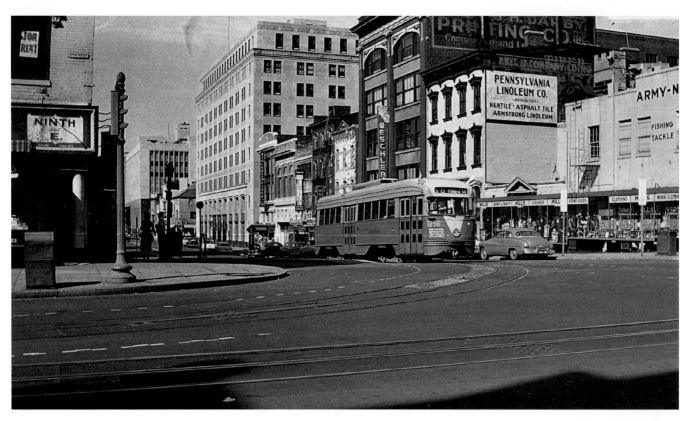

CTC route 60 PCC car No. 1238 is at E and 9th Streets NW in 1950. This car was delivered in 1930 and scrapped 1963. (Bill Stevenson photograph - C. R. Scholes collection.)

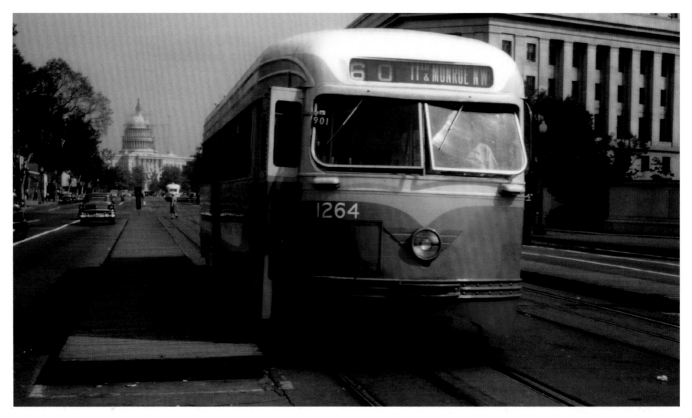

DC Transit System (DCTS) route 60 Presidents' Conference Committee (PCC) car No. 1264 is on Pennsylvania Avenue with the United States Capitol in the distance in this June 9, 1959 scene. This car was built in 1940 and was sold to Gradsko Saobracatno Preduzage (Sarajevo, Yugoslavia). (Kenneth C. Springirth photograph.)

Chapter 9

Routes 70/72/74 Georgia Ave.–7th St.

There were three lines that handled Georgia Avenue-7th Street service. Route 70 operated from Georgia & Alaska Avenue via Georgia Avenue, 7th Street, Independence Avenue, 3rd Street, D Street at the Southwest Mall and left via 2nd Street, returning over the same route. Route 72 operated from 4th and Cedar Street in Takoma via 4th Street, Butternut Street, Georgia Avenue, 7th Street, and Maine Avenue SW to P Street. Route 74 operated from 2nd and Upshur Streets via Upshur Street, Georgia Avenue, 7th Street, and Maine Avenue to P Street. Rush hour routes were 75 (Georgia & Alaska-Bureau of Engraving), 75 (Takoma-Bureau of Engraving), 75 (Soldiers Home-Bureau of Engraving), 79 (Georgia & Alaska-Potomac Park), 79 (Takoma-Potomac Park), and 79 (Soldiers Home-Potomac Park). On March 16, 1941, PCC cars began to be used on route 72. Route 70, 72, and 74 changed to overhead wire at the plow pit on Georgia Avenue just south of W Street NW. A new loop and terminal opened at Georgia and Alaska Avenue on April 28, 1940. The March 1946 ridership for routes 70/72/74 totaled 4,674,535. In 1957, routes 70/72/74 had an average total weekday ridership of 44,600. These lines were converted to bus operation on January 3, 1960.

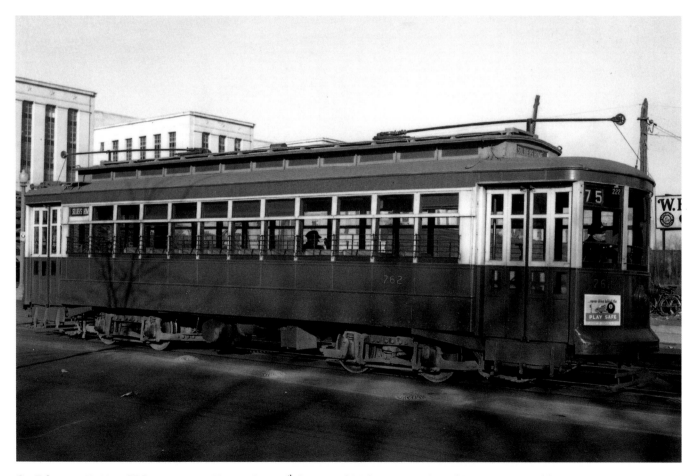

On February 18, 1941 CTC route 75 car No. 762 is at 14th Street and Maine Avenue SW. This car was one of five cars Nos. 760-764 built by J. G. Brill Company in 1919-1920 for WERCO. Powered by four Westinghouse type 101B motors, this car weighed 47,060 pounds and seated 48. All five cars were scrapped in 1948. (C. R. Scholes collection.)

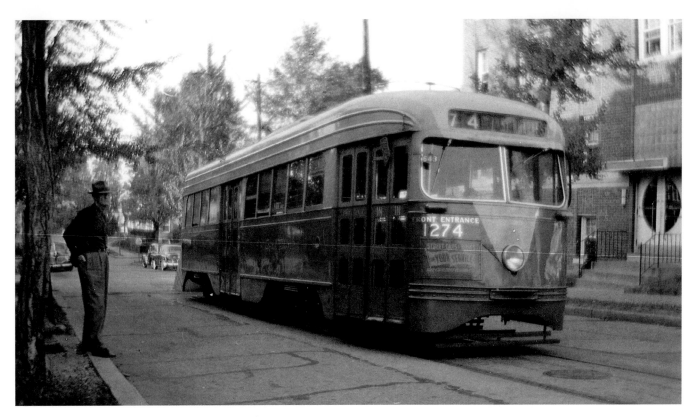

In 1941, CTC route 74 PCC car no. 1274 is at the 2nd Street and Upshur Avenue NW terminus waiting for departure time. This car was built in 1940 and was scrapped in 1962. (Bill Stevenson photograph - C. R. Scholes collection.)

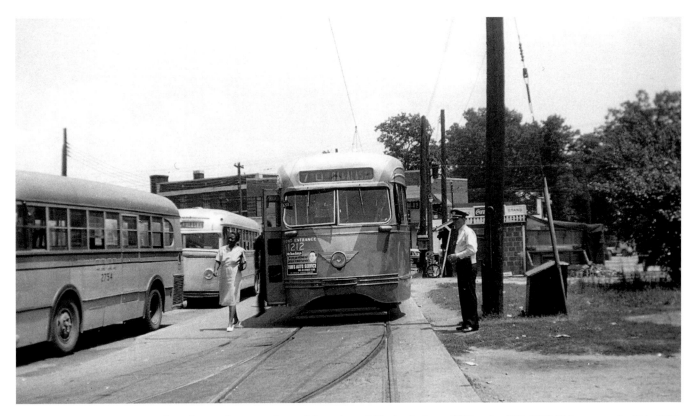

CTC route 70 PCC car No. 1212 is at the northern terminus of Georgia and Alaska Avenues NW on April 19, 1947. This car was built in 1939, was later repainted in the DCTS paint scheme, and was scrapped in 1966. (C. R. Scholes collection.)

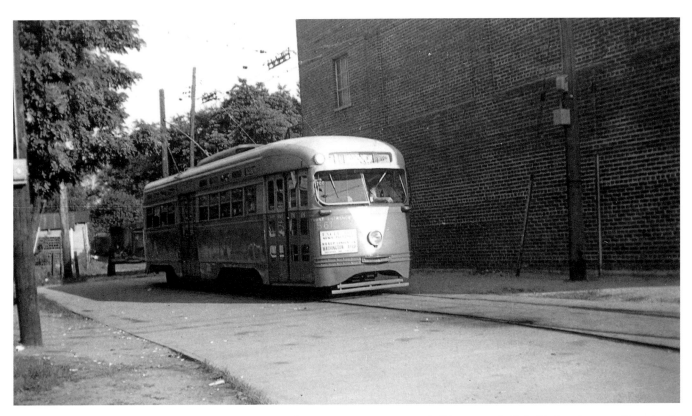

On May 24, 1947, CTC PCC car No. 1561 is on the wye at 4th and Butternut Streets NW. This car was built in 1945 and went to Tranvias de Barcelona (Barcelona, Spain) in 1964. (C. R. Scholes collection.)

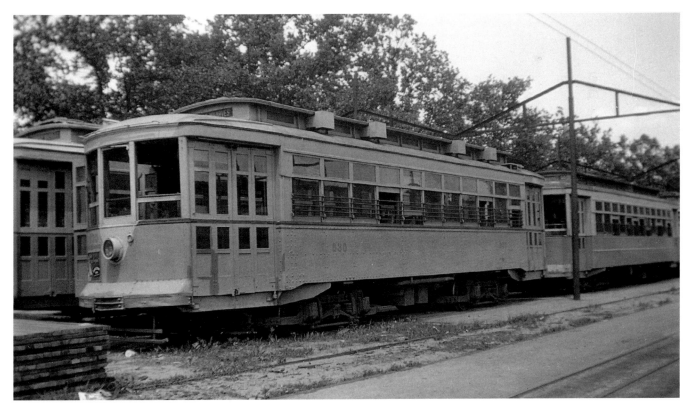

CTC car No. 830 (originally car No. 146 powered by four General Electric type 200 K motors and weighing 41,800 pounds) is in the lineup of other 800 series cars at the 7th Street carhouse on May 24, 1947. This was one of six cars originally Nos. 141-146 built in 1924 for WERCO by J. G. Brill Company. These cars were transferred to Capital Transit Company in 1933, were renumbered as cars Nos. 825-830, and were scrapped in 1952. (C. R. Scholes collection.)

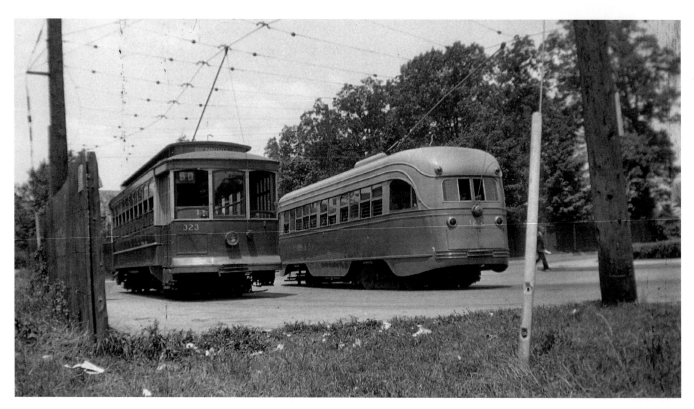

On May 25, 1947, CTC cars No. 323 (built in 1912 and scrapped in 1947) and PCC car No. 1212 (built in 1939 and scrapped in 1966) are at the Georgia Avenue and Alaska Avenue NW terminal loop waiting for their next assignments. (C. R. Scholes collection.)

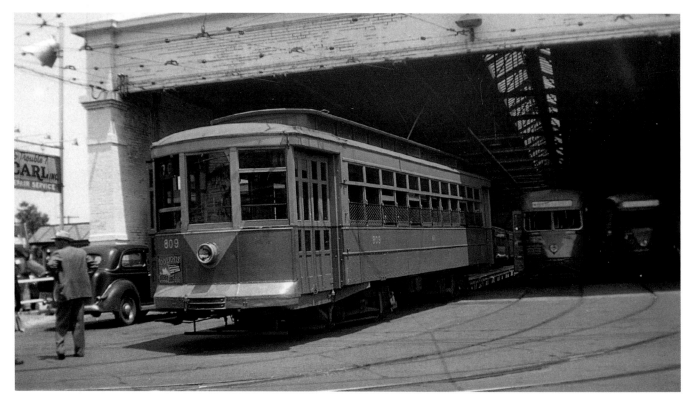

Brightwood car house on Georgia Avenue near Peabody Street NW is the location of CTC car No. 809 on June 22, 1947. This was originally car No. 69 built for Capital Traction Company by J. G. Brill Company in 1919. It was transferred to Capital Transit Company in 1933, was renumbered as car No. 809, and was scrapped in 1952. (C. R. Scholes collection.)

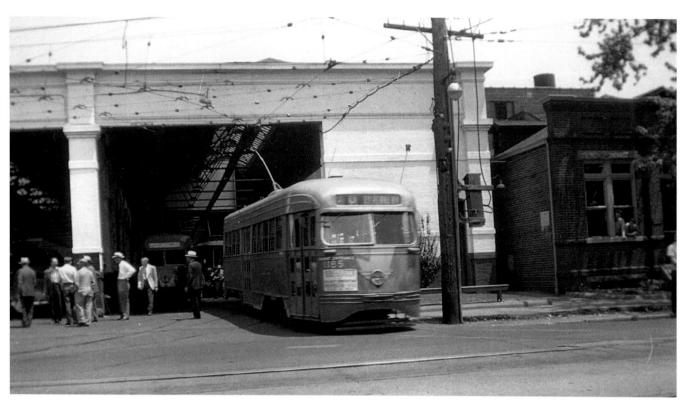

On June 22, 1947, CTC PCC car No. 1185 is outside the Brightwood car house. This car was built in 1938 and went to Transvias de Barcelona (Barcelona, Spain) in 1964. The original car house was built by the Brightwood Railway Company on Georgia Avenue between Gallatin and Farragut Streets and was destroyed in the January 24, 1895 car house fire. The above replacement car house was built on Georgia Avenue near Peabody Street and was closed in 1950. (C. R. Scholes collection.)

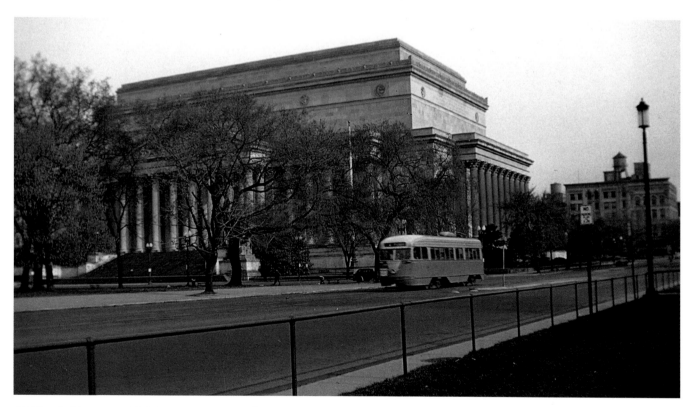

CTC (probably route 72) PCC car No. 1184 is on 7th Street at Constitution Avenue NW on June 25, 1947. The car was built in 1938 and went to Transvias de Barcelona (Barcelona, Spain) in 1964. In the background is the massive National Archives Building, designed by New York Architect John Russell Pope, which was completed in 1937 with 72 Corinthian columns each 53 feet high. (C. R. Scholes collection.)

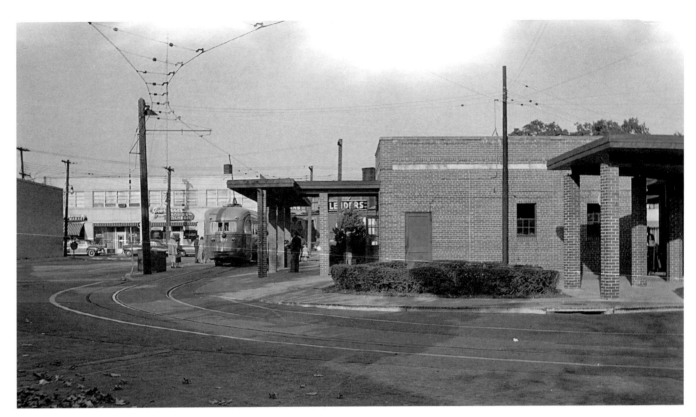

In 1949, CTC route 70 PCC car No. 1177 is at the well-designed Georgia Avenue and Alaska Avenue terminus in the Shepherd Park neighborhood in Northwest Washington, DC. This car was built in 1938 and was scrapped in 1963. (Bill Stevenson photograph - C. R. Scholes collection.)

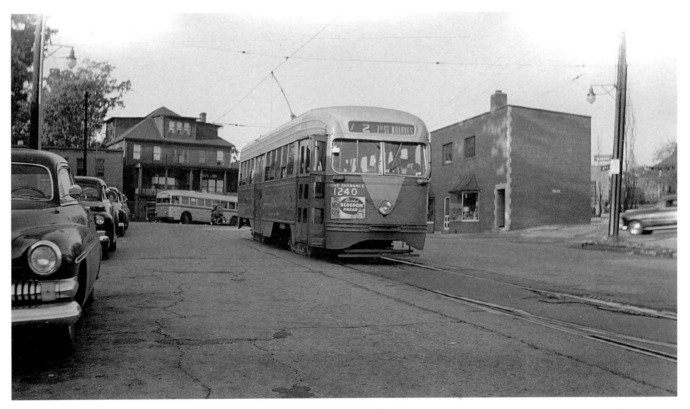

CTC route 72 PCC car No. 1240, with a bus in the background, is at the 4th Street and Butternut Street terminus in the Takoma Park neighborhood in Northwest Washington, DC. The PCC car weighing 35,020 pounds was built in 1940 at a cost of $13,289 and went to Transvias de Barcelona (Barcelona, Spain) in 1961. (Bill Stevenson photograph - C. R. Scholes collection.)

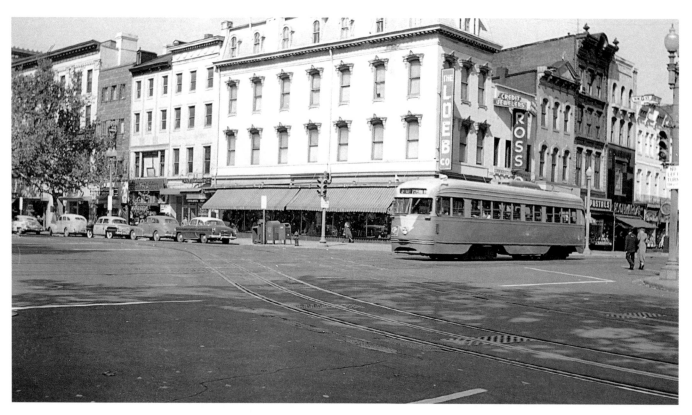

CTC route 70 PCC car No. 1207 is southbound on 7th Street crossing G Street NW in 1950. This car was built in 1939 and scrapped in 1963. (Bill Stevenson photograph - C. R. Scholes collection.)

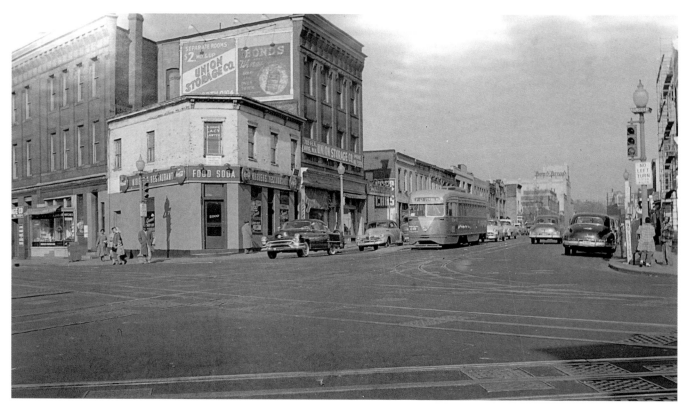

In 1950, southbound CTC route 70 PCC cars No. 1240 is on 7th Street ready to cross the Florida Avenue NW trackage used by routes 90 and 92. This car was built in 1940 and went to Transvias de Barcelona (Barcelona, Spain) in 1961. (Bill Stevenson photograph - C. R. Scholes collection.)

CTC route 70 PCC cars No. 1207 is on Independence Avenue and 7th Street SW in 1950. While the parking lot on the left side of the picture is filled with automobiles, the streets were free of motor vehicular traffic, except for the street car that was built in 1939 and scrapped in 1963. (Bill Stevenson photograph - C. R. Scholes collection.)

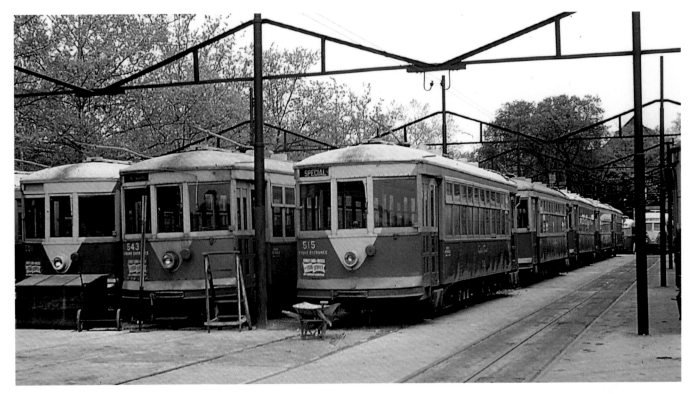

From left to right CTC cars with the original United Electric Railways Company of Providence, Rhode Island, number in parenthesis. Nos. 501 (2056), 543 (2127), and 515 (2088) are in the front rows of 500 series street cars at the 7th Street brick car house that was erected in 1890 at 7th and Water Streets SW by the Washington & Georgetown Railroad Company. The 50 cars Nos. 501-550 were purchased second in 1936-1937 becoming known as the "Providence" cars and were all scrapped by 1950. The car house closed in 1961. (Bob Crockett photograph - C. R. Scholes collection.)

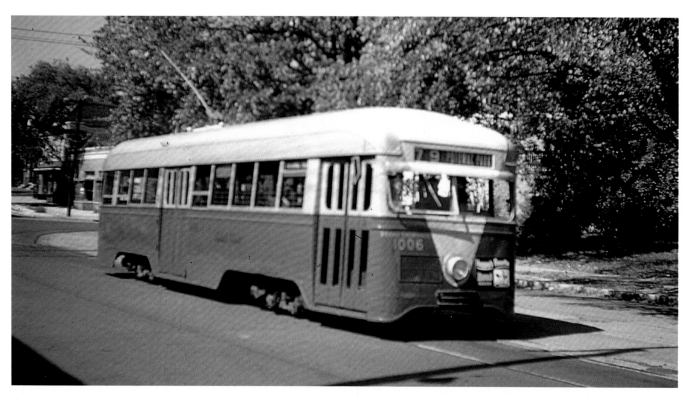

On September 20, 1951, CTC route 79 streamliner car No. 1006 is at Butternut and 4th Streets NW at the Tacoma wye preparing for a rush hour trip to Potomac Park. This series of ten cars Nos. 1001-1010 were built at a total cost of $186,930 in 1935 and were all scrapped in June 1959. (Bob Crockett photograph - (Bob Crockett photograph - C. R. Scholes collection.)

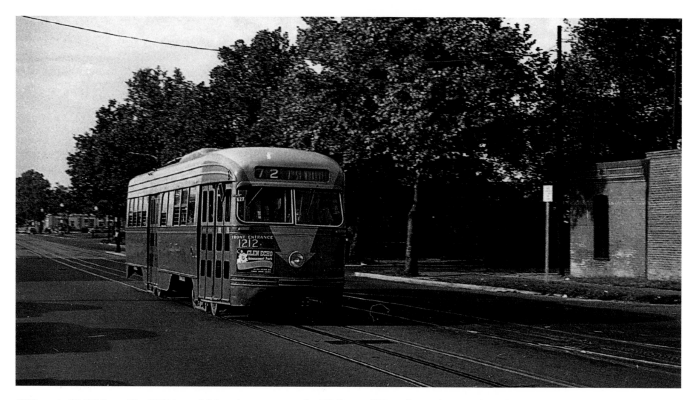

CTC route 72 PCC car No. 1212 is on Maine Avenue near the 7th Street SW car house in 1954. Weighing 34,240 pounds and seating 49, this car was built in 1939, was repainted in the DCTS paint scheme, and in 1963 went to Transvias de Barcelona (Barcelona, Spain). (Joe Kepler photograph - C. R. Scholes collection.)

In 1954, CTC snow sweeper No. 06 (built in 1899 by McGuire Cummings Manufacturing Company for Washington Traction & Electric Company which became part of WERCO in 1902) is to the left of CTC car No. 829 (built originally as car No. 145 for WERCO by J. G. Brill Company in 1924) at the 7th Street SW car house. (Joe Kepler photograph - C. R. Scholes collection.)

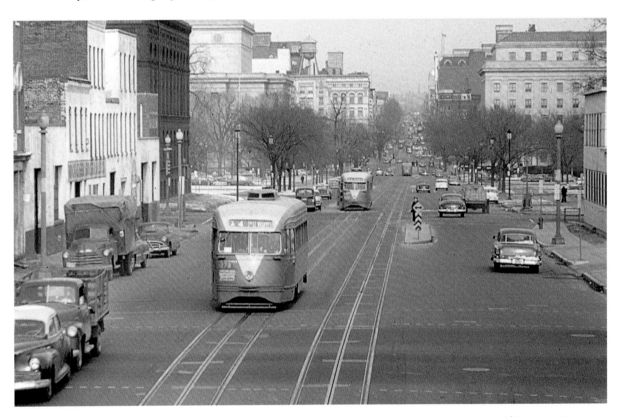

In this scene looking north from a railroad overpass, CTC route 74 PCC car No. 1279 is southbound on 7th Street at Maryland Avenue SW on January 20, 1956. This car was built in 1940 and went to Transvias de Barcelona (Barcelona, Spain) in 1961. This was a busy street car corridor as evidenced by the numerous street cars in view. (C. Abel photograph - C. R. Scholes collection.)

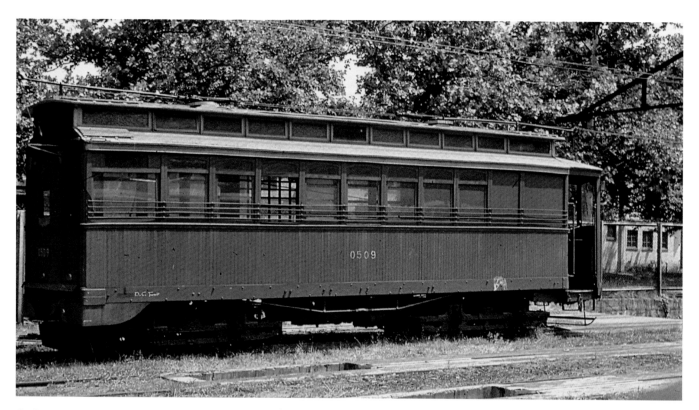

On June 23, 1957, DCTS work car No. 0509 is at the 7th Street car house. This was originally WERCO car No. 509 built by American Car Company in 1899 and powered by two Westinghouse type 101B motors. A 1912 remodeling resulted in four Westinghouse type 101B motors. It was converted to work car 0509 and received four General Electric type 1000 motors from the private car *Columbia* in 1923. The rear end of the car was later rebuilt to haul trucks between the 4th Street shop and the M Street shop. (C. R. Scholes collection.)

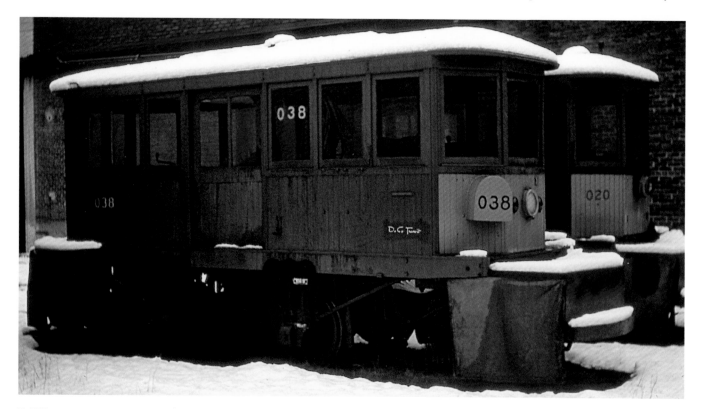

DCTS snow sweepers No. 038 (built by J. G. Brill Company in 1909 and powered by two Westinghouse type 306 motors) and No. 020 (built by J. G. Brill Company in 1906 and powered by two Westinghouse type 101 motors are at the 7th Street car house on February 20, 1958. (C. Abel photograph - C. R. Scholes collection.)

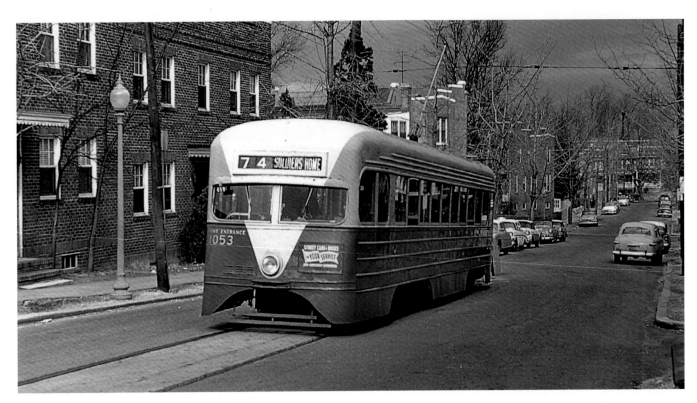

On February 8, 1959, DCTS route 74 streamliner No. 1053 is at the 2nd Street and Upshur Street wye in the Petworth neighborhood in the Northwest quadrant of Washington, DC. This was one of ten cars Nos. 1051-1060 built in 1935 at a total cost of $175,669. Car No. 1053 was restored in February 1959 for use in rail excursions. The other nine cars were scrapped in June 1959. (Bob Crockett photograph - C. R. Scholes collection.)

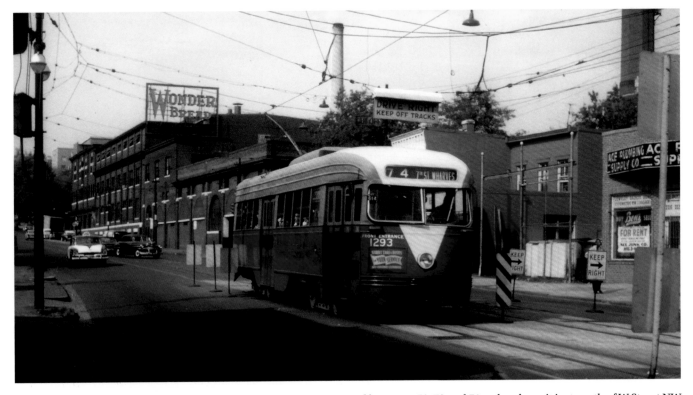

DCTS route 74 PCC car No. 1293 is southbound on Georgia Avenue used by routes 70, 72 and 74 at the plow pit just south of W Street NW on June 9, 1959. The pit, about five feet deep, extended under both tracks. Generally, there was one man in the pit to handle the plow and one man in the street to handle the street car pole. This car was built in 1940 and went to Gradsko Saobracatno Preduzege (Sarajevo, Yugoslavia) in 1962. (Kenneth C. Springirth photograph.)

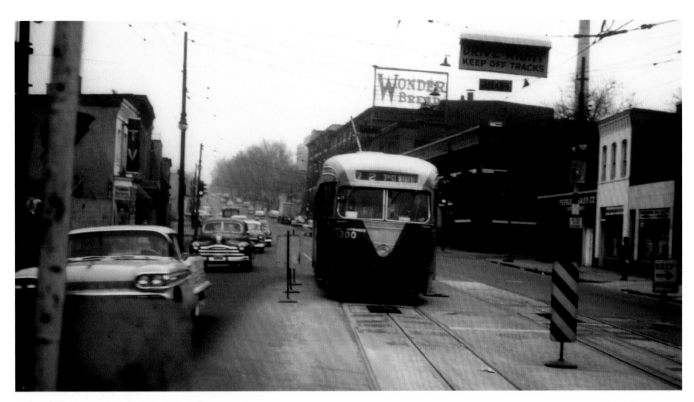

On January 2, 1960, southbound DCTS route 72 PCC car No. 1300 is at the plow pit on Georgia Avenue just south of W Street NW. In going from the overhead to the conduit system, the pitman attached the plow and connected the positive and negative leads to the plow while the pole was pulled down from the wire. This car was built in 1940 at a cost of $13,324 and went to Gradsko Saobracatno Preduzege (Sarajevo, Yugoslavia) in 1962. (Kenneth C. Springirth photograph.)

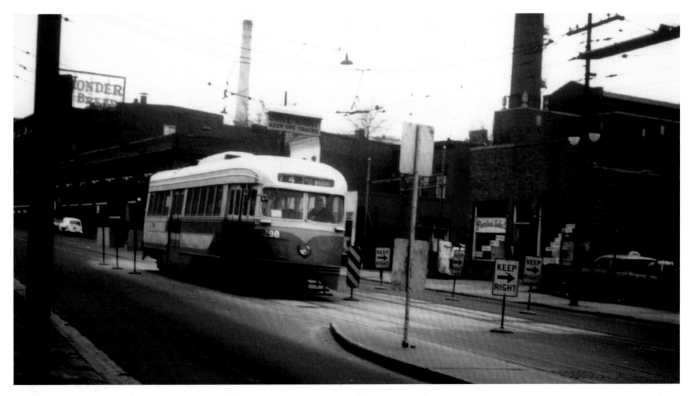

DCTS southbound route 74 PCC car No. 1298, built in 1940, is at the plow pit on Georgia Avenue just south of W Street NW on January 2, 1960. Going from the conduit system to overhead wire, the conduit rail would turn, causing the plow to twist and drop from the hanger into the pit. The pitman connected the leads back to the car while the pole was being raised to the overhead wire. This car was repainted in the DCTS paint scheme and went to Gradsko Saobracatno Preduzege (Sarajevo, Yugoslavia) in 1962. (Kenneth C. Springirth photograph.)

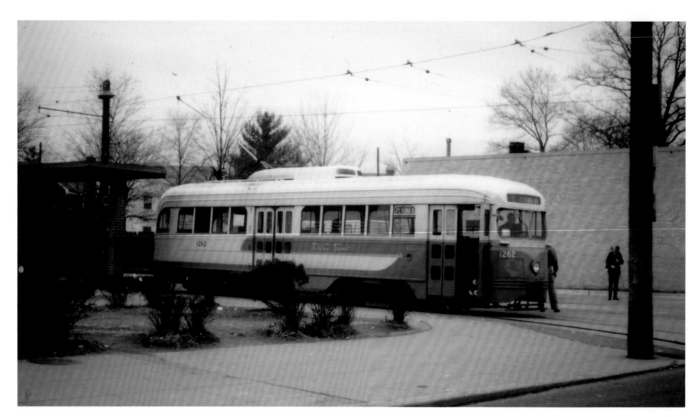

Georgia Avenue and Alaska Avenue NW terminal loop is the location of DCTS route 70 PCC car No. 1262 awaiting departure time on January 2, 1960. This car was built in 1940, was repainted in the DCTS paint scheme, and went to Gradsko Saobracatno Preduzege (Sarajevo, Yugoslavia) in 1962. (Kenneth C. Springirth photograph.)

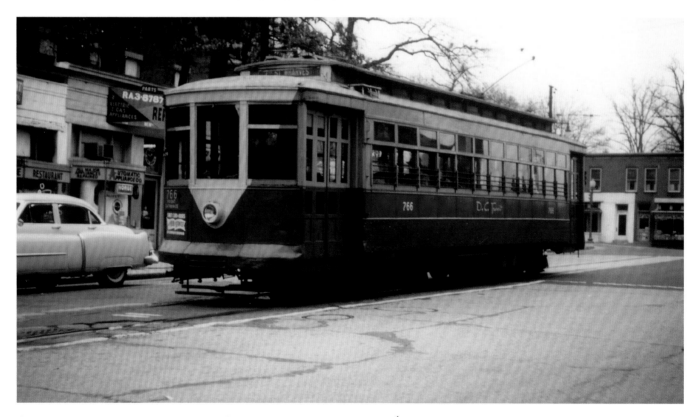

On January 2, 1960, DCTS car No. 766 is at the route 72 northern terminus at 4th and Butternut Streets NW on a rail excursion photo stop. Routes 70, 72, and 74 were converted to bus operation on January 3, 1960. This car was donated by DCTS to the National Capital Trolley Museum where it arrived in March 1970. (Kenneth C. Springirth photograph.)

Chapter 10

Route 80 N. Capital St.

Route 80 operated from 12th Street and Michigan Avenue NE via 12th Street, Monroe Street, Michigan Avenue, North Capitol Street, Massachusetts Avenue NW, G Street, 15th Street, and Pennsylvania Avenue to Washington Circle. The March 1946 ridership for route 80 was 1,996,757. The base service to May 1, 1949 was 80 (Brookland-Potomac Park). After May 1, 1949, it became 80 (Brookland-Rosslyn), 80 (Brookland-36th & Prospect NW), and 80 (Brooklyn-Washington Circle). The March 15, 1958 DC Transit System, Inc. Guide Map showed the base day service for North Capital Street was 80 (Brookland-Washington Circle). The Guide Map showed southbound rush hour service as 80 (19th & F NW), 80 (36th & Prospect), and 89 (Potomac Park). In 1957, route 80 had an average weekday ridership of 16,300. This line was converted to bus operation on September 7, 1958.

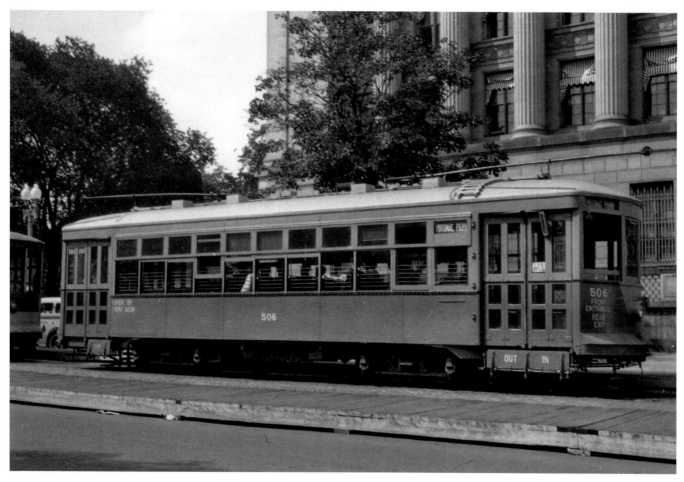

CTC route 80 car No. 506 is at 15th and G streets NW on August 30, 1936. This car was originally No. 2050 as part of 150 cars built by Osgood Bradley Car Company for United Electric Railways Company of Providence, Rhode Island, during 1922-1923. CTC purchased 50 of these cars in 1935 and renumbered them 501-550. Car No. 506 was scrapped in 1950. (Bob Hadley - C. R. Scholes collection.)

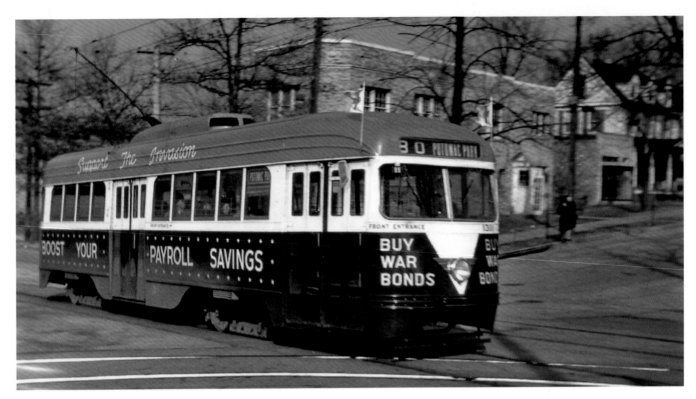

In December 1945, route 80 PCC car No. 1311 (lettered "Buy War Bonds" and "Boost Your Payroll Savings,") is at 12ᵗʰ and Quincy Streets in the Brookland neighborhood in the Northeast quadrant of Washington, DC. This was one of 15 cars Nos. 1303-1317 built by St. Louis Car Company in 1941, powered by four General Electric type 1198F3 motors, and went to Tranvias de Barcelona (Barcelona, Spain) in 1961. (Bob Crockett photograph - C. R. Scholes collection.)

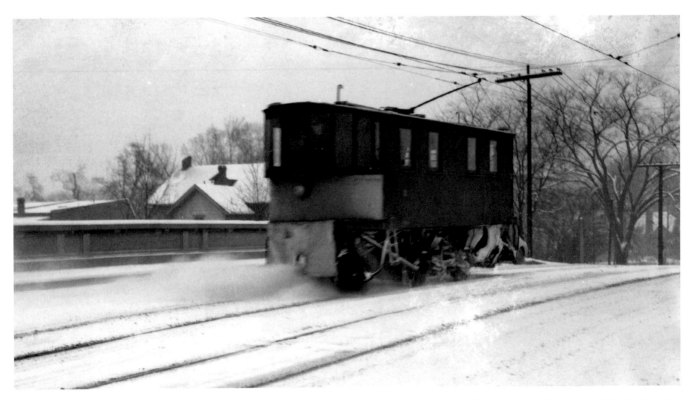

CTC snow sweeper No. 02 is clearing the snow off the track on Michigan Avenue NE at the bridge over the Baltimore & Ohio Railroad in January 1946. This was built by J. G. Brill Company in 1897 and was powered by two Westinghouse type 306 motors. It was scrapped on July 1, 1961. (C. R. Scholes collection.)

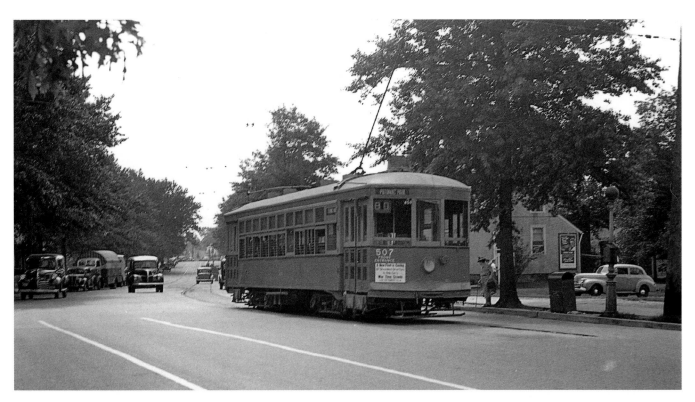

In 1948, CTC route 80 car No. 507 (original No. 2037) is at Michigan Avenue and 12th Street NE. This was one of 50 cars from the series 2001-2150 purchased second hand from United Electric Railways Company of Providence, Rhode Island. The cars, received during 1936-1937, were refurbished including new helical gearing to reduce noise, new lighting, new leather upholstered foam rubber seats, complete repainting, and were renumbered 501-550. (C. R. Scholes collection.)

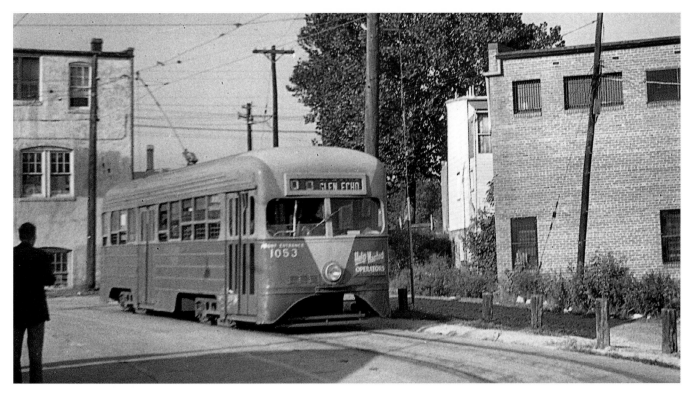

On September 26, 1948, CTC streamliner car No. 1053 is at the 12th and Quincy Streets NE terminal loop. While the roll sign showing Glen Echo may have been a rail excursion, on November 22, 1936, there was a short lived merging of the Cabin John and Maryland lines into route 22 creating the system's longest street car route. This only lasted until April 17, 1937 when route 20 was back to its Cabin John-Union Station routing. (C. R. Scholes collection.)

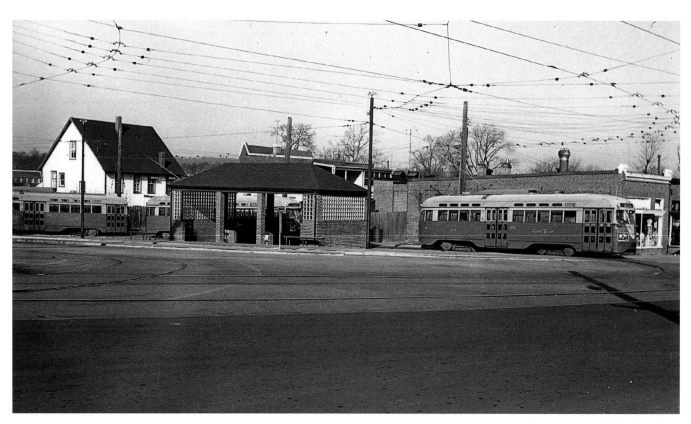

The Brookland loop at 12th and Quincy Streets NE is the location of CTC route 80 PCC car 1574 and other PCC cars in 1949. This car was built in 1945 and went to Tranvias de Barcelona (Barcelona, Spain) in 1963. (Bill Stevenson photograph - C. R. Scholes collection.)

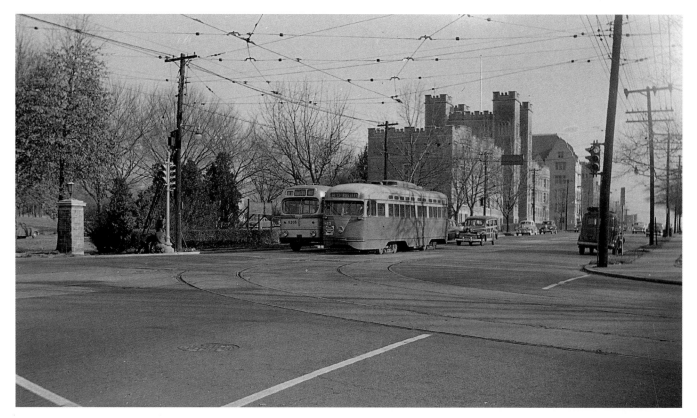

In 1949 at Michigan Avenue and 4th Street NE, CTC route 80 PCC car No. 1485 (built in 1944 and scrapped in 1963) is alongside bus No. 5205, a 1949 model 1144 bus that was part of number series 5200 to 5304 built by the White Motor Company. (Bill Stevenson photograph - C. R. Scholes collection.)

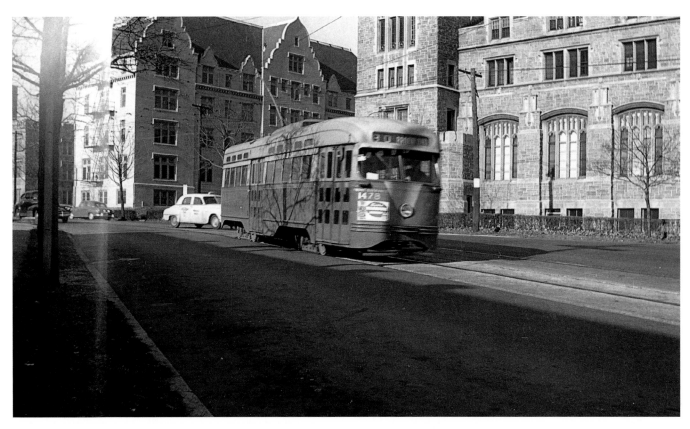

CTC route 80 PCC car No. 1478 is on Michigan Avenue and Monroe Street NE in 1949. This car was built in 1944, was later painted in the DCTS paint scheme, and was scrapped in 1963. (Bill Stevenson photograph - C. R. Scholes collection.)

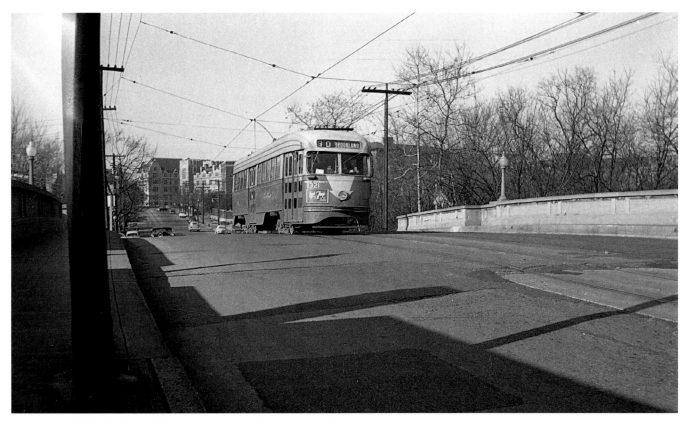

In 1949, CTC route 80 PCC car No. 1321 is on Monroe Street NE on the bridge over the Baltimore & Ohio Railroad heading for Brookland. This car was built in 1941 and went to Gradsko Saobracatno Preduzege (Sarajevo, Yugoslavia). (Bill Stevenson photograph - C. R. Scholes collection.)

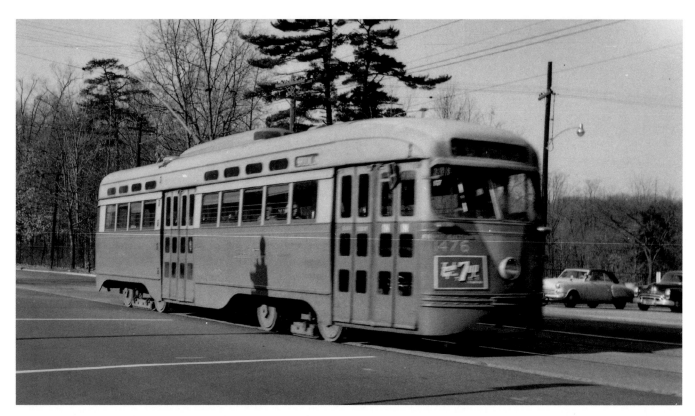

In 1951, CTC PCC car No. 1476 is on Michigan Avenue and 4th Street in the Stronghold neighborhood of Northeast Washington, DC. This car was built in 1944 and went to Tranvias de Barcelona (Barcelona, Spain) in 1963. (Bill Stevenson photograph - C. R. Scholes collection.)

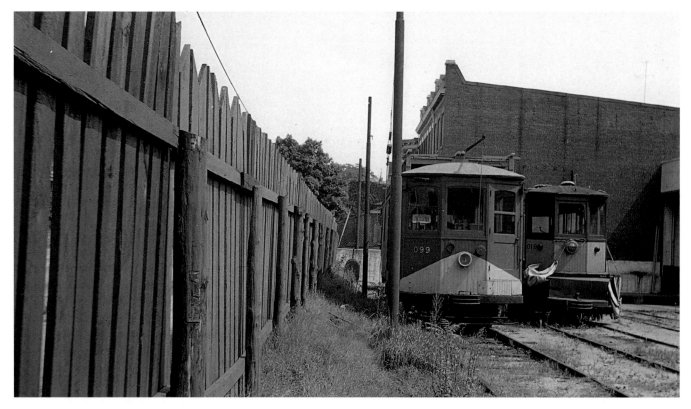

CTC line car No. 099 (built by J. G. Brill Company in 1910 as a freight motor, converted to a line car in 1921, and scrapped in 1960) and snow sweeper No. 019 (one of three Nos. 018-020 built by J. G. Brill Company in 1906 and scrapped in 1961) are at the Eckington car house in 1949. (Bill Stevenson photograph - C. R. Scholes collection.)

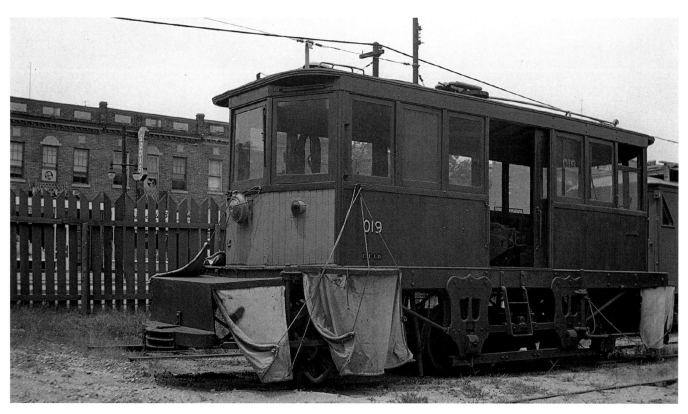

In 1950, CTC snow sweeper No. 019 (built by J. G. Brill in 1906 and scrapped in 1961) is at the Eckington car house located on T Street between 4th and 5th Streets NE built in 1899 by the City & Suburban Railway of Washington. The Eckington car house closed in 1958 with the conversion of street car routes 80 and 82 to bus operation. (Bill Stevenson photograph - C. R. Scholes collection.)

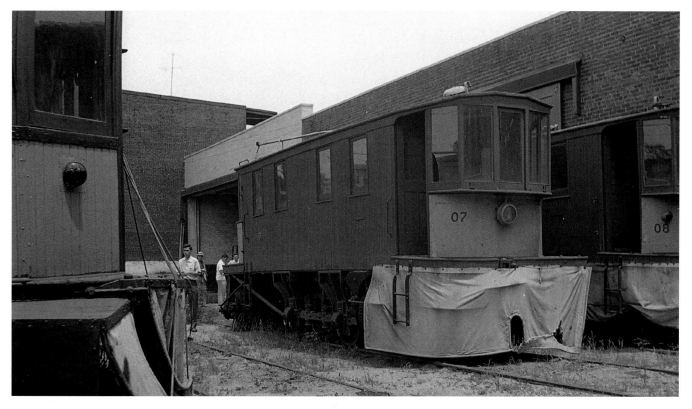

CTC snow sweeper No. 07 (one of ten Nos. 06-015 built by McGuire Cummings Manufacturing Company in 1899) is at the Eckington car house in 1950. This sweeper went to the National Capital Trolley Museum in August 1966 and was destroyed in the September 28, 2003 car barn fire. (Bill Stevenson photograph - C. R. Scholes collection.)

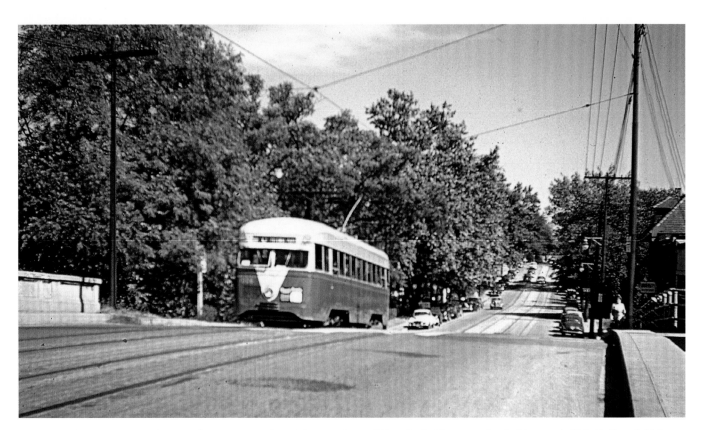

On September 30, 1951, CTC streamliner No. 1006 is on Monroe Street NE at the bridge over the Baltimore & Ohio Railroad. This car was built in 1935 and scrapped in 1959. The 1000 series cars were known as the "Ten Hundreds" by operators and "streamliners" by the public. (Bob Crockett photograph - C. R. Scholes collection.)

On a snow covered February 16, 1958, CTC route 80 PCC car No. 1573 is picking up passengers on Monroe Street at 7th Street NE. This car, built in 1945, went to the DC Recreation Department for a Washington, DC, playground in 1963. (C. Abel photograph - C. R. Scholes collection.)

Chapter 11

Route 82 Branchville

Route 82 operated from 19th and F Streets NW (Potomac Park) via F Street, 18th Street, Pennsylvania Avenue, 15th Street, G Street, 5th Street, New York Avenue, Eckington Place NE, R Street, 3rd Street, T Street, 4th Street, Rhode Island Avenue, and private right-of-way to Branchville. The March 1946 ridership for route 82 was 1,665,026. With completion of new loops at Branchville and Riverdale, a special inspection trip was operated between Mt. Rainier and Branchville on October 5, 1946 with a new PCC car. In 1957, route 82 had an average weekday ridership of 23,800. According to the DC Transit System, Inc. Guide Map Washington, DC, March 15, 1958, the base route was 82 (Branchville-Potomac Park). Rush hour routes were 82 (Eckington-19th & F NW), 82 Mt. Rainer (14th & G NW), and 85 (Branchville-Bureau of Engraving). September 7, 1958 was the last day of street car operation for these lines.

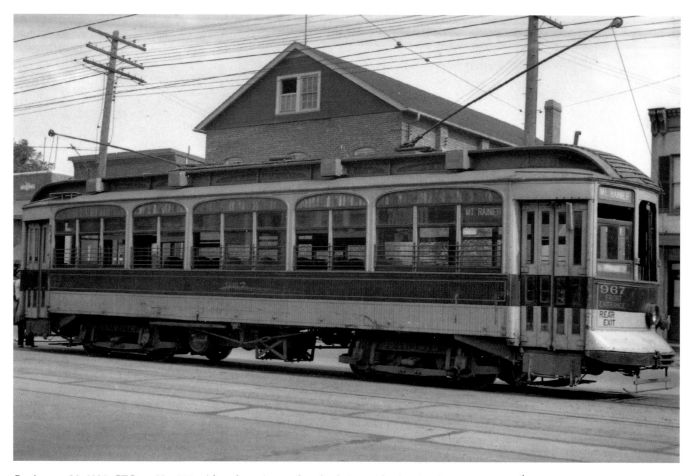

On August 30, 1936, CTC car No. 967, with a classy interurban look, is on Rhode Island Avenue near 34th Street in the city of Mt. Rainier (a street car suburb of Washington, DC, whose growth and development was shaped by the street car line) in Prince George's County, Maryland. This car was originally WERC car No. 597 built by J. G. Brill Company in 1908 and was scrapped in 1939. (Bob Hadley photograph - C. R. Scholes collection.)

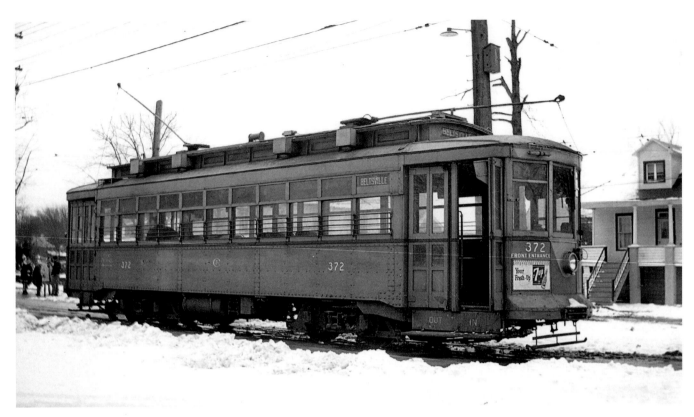

In a 1938 winter scene with a blanket of snow on the ground, CTC car No. 372 (originally WERCO car No. 106) is on Rhode Island Avenue at Beltsville, Maryland. This was one of ten cars Nos. 101-110 built by J. G. Brill Company in 1923 for WERCO powered by two Westinghouse type 93 motors. They were transferred to CTC in 1933 and renumbered 367-376. The cars were scrapped in 1952. (C. R. Scholes collection.)

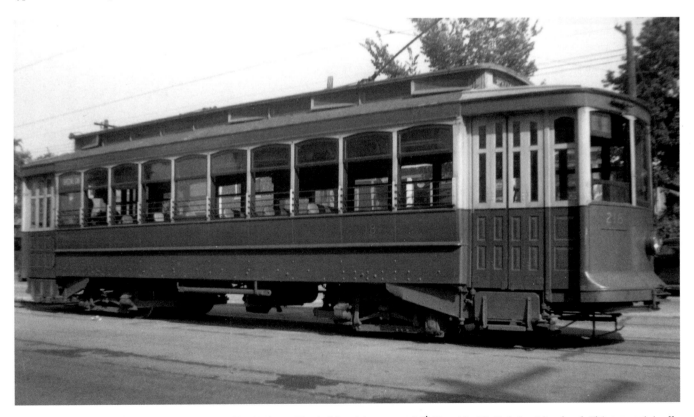

On July 3, 1939, Capital Transit Company car No. 218 is on Rhode Island Avenue at 34th Street in Mt. Rainier, Maryland. This was originally Capital Traction Company car No. 632 one of 80 cars Nos. 621-700 built in 1911 by Jewett Car Company. These cars were transferred to Capital Transit Company in 1933 and were renumbered 207-286. Car No. 218 was scrapped in 1946. (C. R. Scholes collection.)

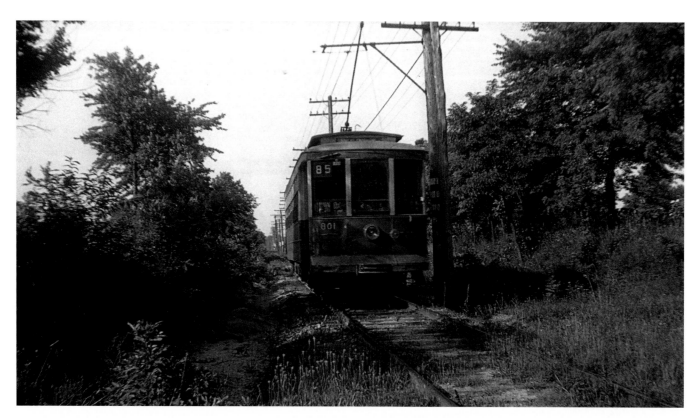

CTC route 85 car No. 801 is along the single track private right-of-way near Hyattsville, Maryland on the Beltsville line on July 3, 1939. This was originally Capital Traction Company car No. 61 one of 40 cars Nos. 46-85 built by J. G. Brill Company in 1919. They were transferred to Capital Transit Company in 1933 and were renumbered 785-824. These cars were scrapped in 1952. (C. R. Scholes collection.)

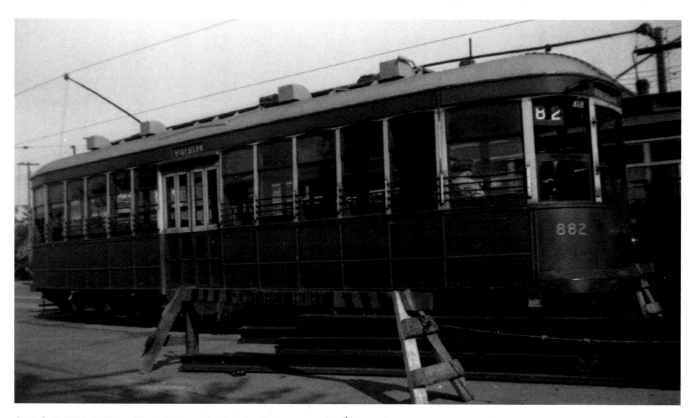

On July 3, 1939, CTC car No. 882 is on Rhode Island Avenue and 34th Street in Mt. Rainier. This was originally WERCO car No. 648 one of 20 cars Nos. 630-649 built in 1912-1913 by St. Louis Car Company. Powered by four General Electric type 200A motors, the car weighed 40,700 pounds, seated 48, and was scrapped in 1945. (C. R. Scholes collection.)

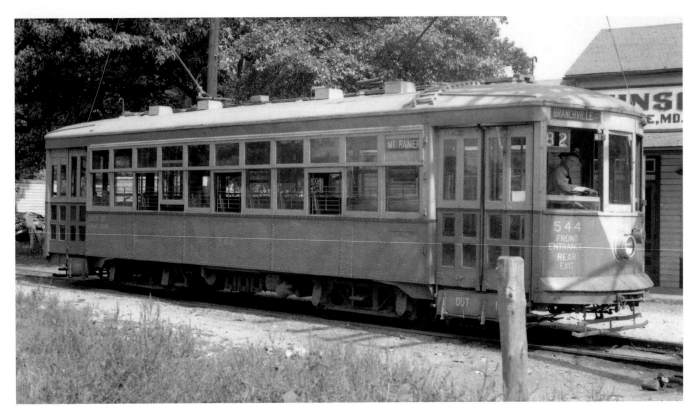

CTC route 82 car No. 544 is at the Branchville, Maryland, station in February 1941. This car was originally car No. 2146 one of a 150 built by Osgood Bradley Car Company built during 1922-1923 for United Electric Railways Company of Providence, Rhode Island. CTC purchased 50 of these cars in 1936-1937, and they were renumbered 501-550. Car No. 544 was scrapped in 1944. (C. R. Scholes collection.)

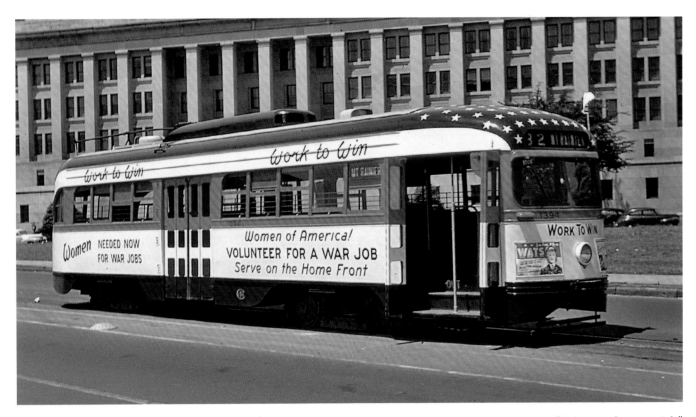

In 1946, CTC route 82 car No. 1394 is at C and 18th Streets NW in a patriotic paint scheme urging women to, "Volunteer for a war job." This car was built in 1937, was repainted in the DCTS paint scheme, and was scrapped in 1963. (Bob Crockett – C. R. Scholes collection.)

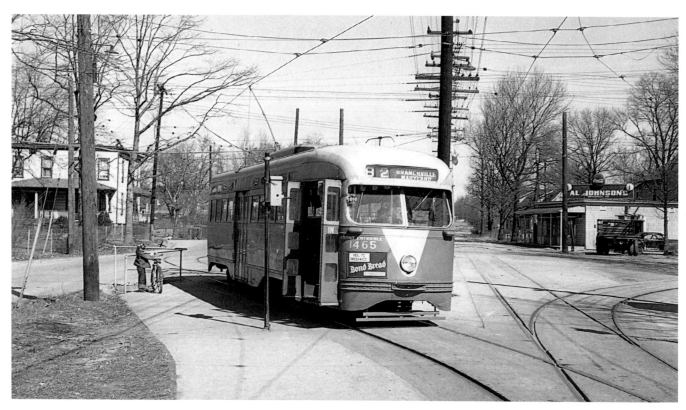

CTC route 82 PCC car No. 1465 is at the Branchville terminal loop in 1947. This car was built in 1944 and was scrapped in 1963. (C. R. Scholes collection.)

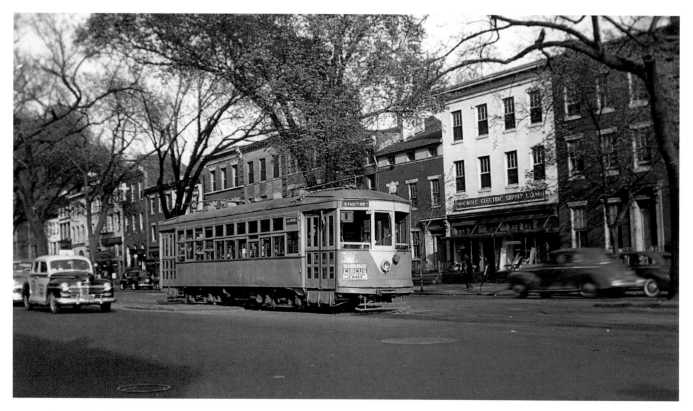

On April 19, 1977, CTC car No. 502 is on New York Avenue NW. This was originally United Electric Railways Company of Providence, Rhode Island car No. 2083, one of 150 cars built by Osgood Bradley Car Company in 1922-1923. CTC purchased 50 of these in 1936. This car was scrapped in 1949. (C. R. Scholes collection.)

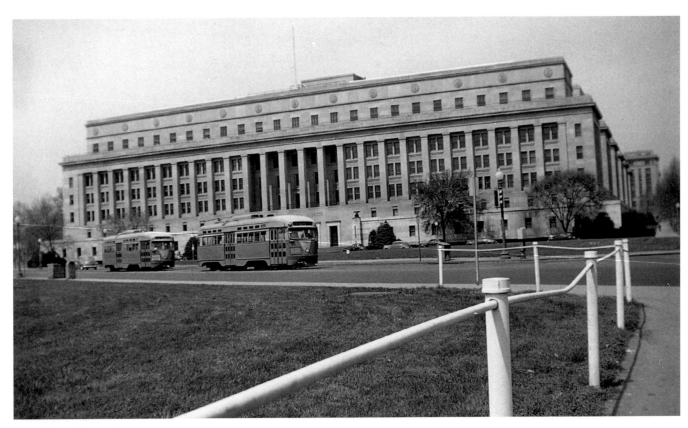

CTC route 82 PCC car No. 1568 (built in 1945 and went to Tranvias de Barcelona (Barcelona, Spain) in 1963) followed by PCC car No. 1465 (built in 1944 and was scrapped in 1963) are at Virginia Avenue and 18th Street NW on June 21, 1947. (C. R. Scholes collection.)

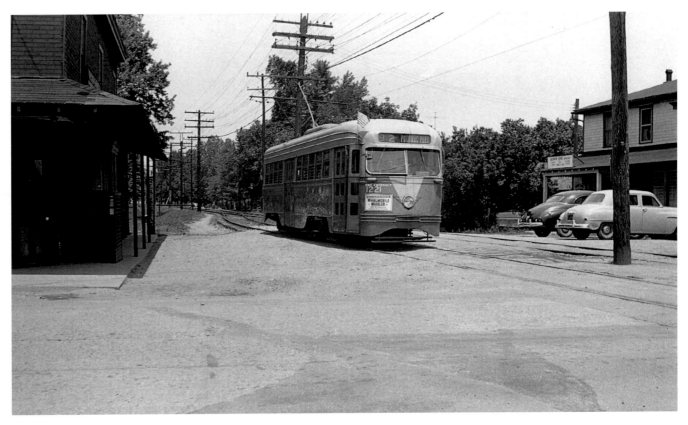

In 1950, CTC route 82 PCC car No. 1221 is at Berwyn, Maryland, on the Branchville line heading for Potomac Park in Washington, DC. This car was built in 1939 and was scrapped in 1963. (Bill Stevenson photograph - C. R. Scholes collection.)

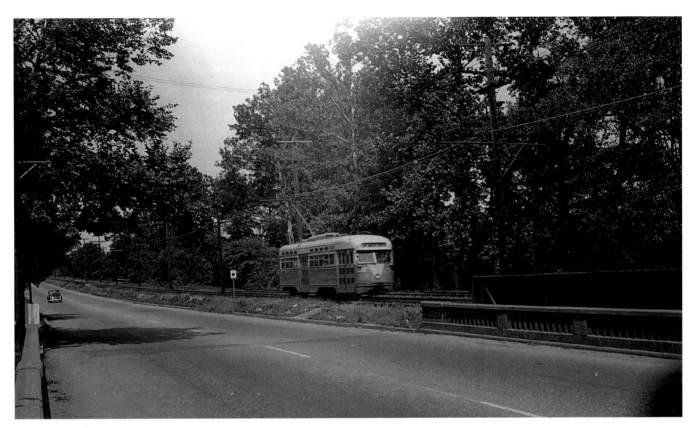

CTC route 82 PCC car No. 1468 is on the rural Branchville line ready to cross a bridge over a branch of the Anacostia River in 1950. This car was built in 1944 and was scrapped in 1963. (Bill Stevenson photograph - C. R. Scholes collection.)

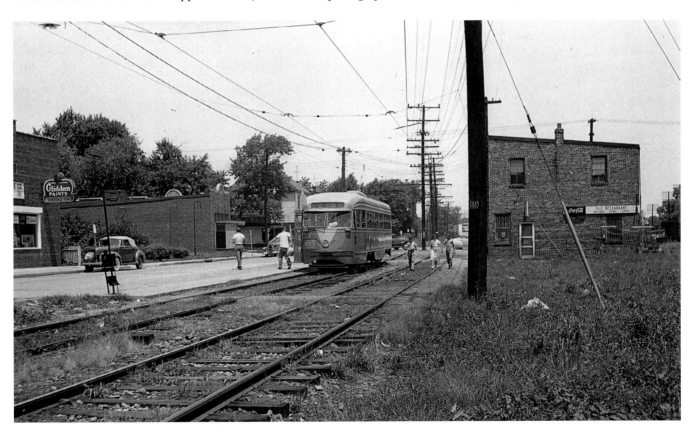

In 1950, CTC route 82 PCC car No. 1217 is at Riverdale, Maryland, heading for Potomac Park in Washington, DC, on the Branchville line. This car was built in 1939 and was scrapped in 1963. (Bill Stevenson photograph - C. R. Scholes collection.)

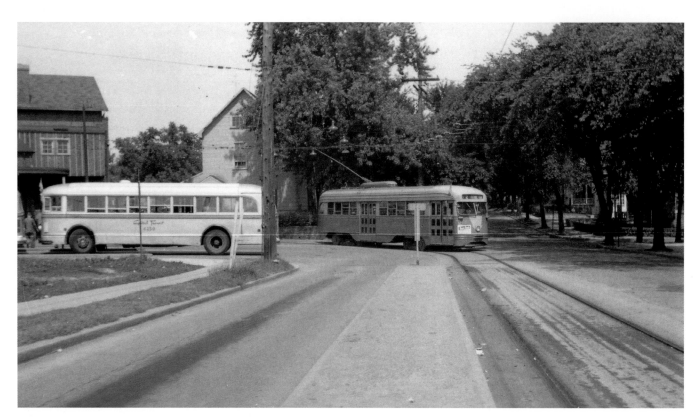

CTC PCC car No. 1220 is at the Mt. Rainier loop at Rhode Island Avenue and 34th Street in 1950. This car was built in 1939, repainted in the DCTS paint scheme, and went to Transvias de Barcelona (Barcelona, Spain) in 1963. Left of the street car is a 1940 model 788 bus No. 4250 built by the built by the White Motor Company as part of number series 4211 to 4262. (Bill Stevenson photograph - C. R. Scholes collection.)

In 1950, across and parallel to the Baltimore & Ohio Railroad tracks finds CTC PCC car No. 1451 at Hyattsville, Maryland. This car was built in 1944 and scrapped in 1962. (Bill Stevenson photograph - C. R. Scholes collection.)

CTC route 82 PCC car No. 1215 is on a short turn loop on the Branchville line in 1950. This car was built in 1939, was repainted in the DCTS paint scheme, and was scrapped in 1966. (Bill Stevenson photograph - C. R. Scholes collection.)

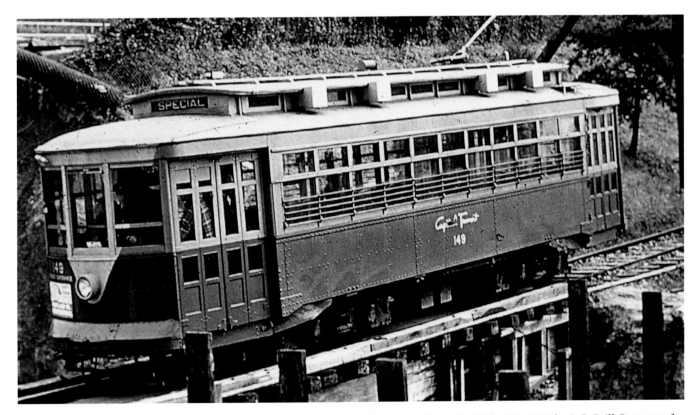

Around 1950, CTC car No. 149 is on the Beltsville line. This was one of four cars Nos. 147-150 built in 1924 by J. G. Brill Company for WERCO powered by two General Electric type 57A motors. The cars were transferred to CTC in 1933, and the motors for each car were replaced by four General Electric type 200A motors from other scrapped cars. These cars were scrapped in 1952. (C. R. Scholes collection.)

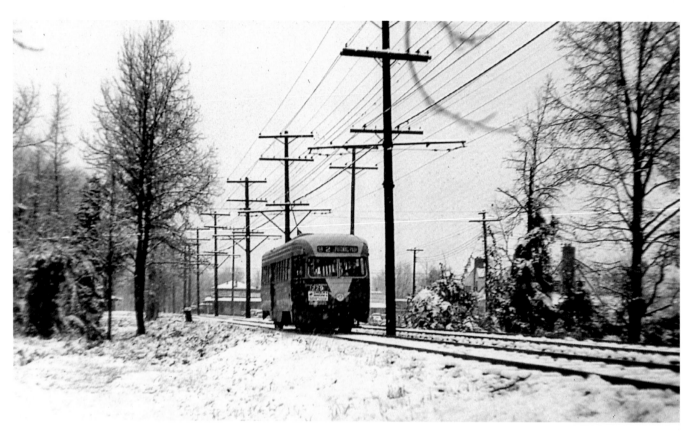

Amid the gentle falling snow flakes of November 19, 1955, CTC PCC car No. 1229 is on the private way portion of the Branchville line. This car was built in 1939 and scrapped in 1963. (C. Abel photograph – C.R. Scholes collection.)

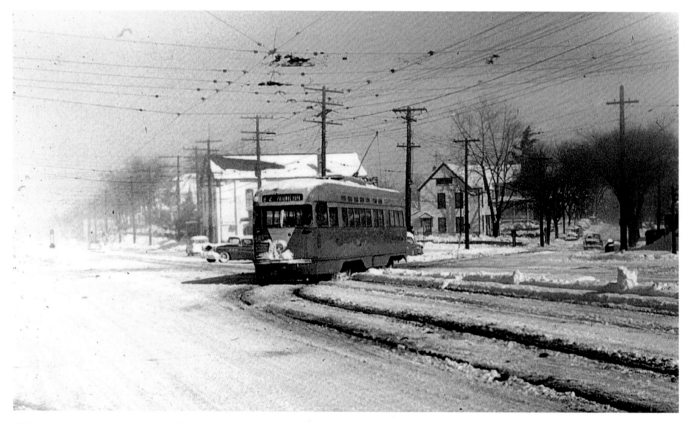

CTC route 82 PCC car No. 1587 is leaving the Mt. Rainier loop for a trip to Potomac Park on a snowy and windy February 16, 1958. This car was built in 1945 and scrapped in 1963. (C. Abel photograph – C. R. Scholes collection.)

Chapter 12

Routes 90/92 New Jersey Ave.–17th Pennsylvania Ave./Florida Ave.–Navy Yard

Routes 90 and 92 had no overhead wire operation. Route 90 operated from the Calvert Bridge via Calvert Street NW, 18th Street, U Street, Florida Avenue, New Jersey Avenue, Massachusetts Avenue, Union Station Plaza, 1st Street NE, Independence Avenue SE, Pennsylvania Avenue, to 17th Street SE. Route 92 operated from the Calvert Bridge via Calvert Street NW, 18th Street, U Street, Florida Avenue, 8th Street to the Navy Yard). The base service routes were 90 (Calvert Bridge via New Jersey-17th & Pennsylvania SE) and 92 (Calvert Bridge via Florida Avenue -Navy yard). Rush hour service was route 91 (Calvert Bridge via New Jersey-Navy Yard). The March 1946 ridership for routes 90/92 totaled 3,491,155. In 1957, routes 90/92 had an average total weekday ridership of 31,400. These lines were converted to bus operation on January 28, 1962.

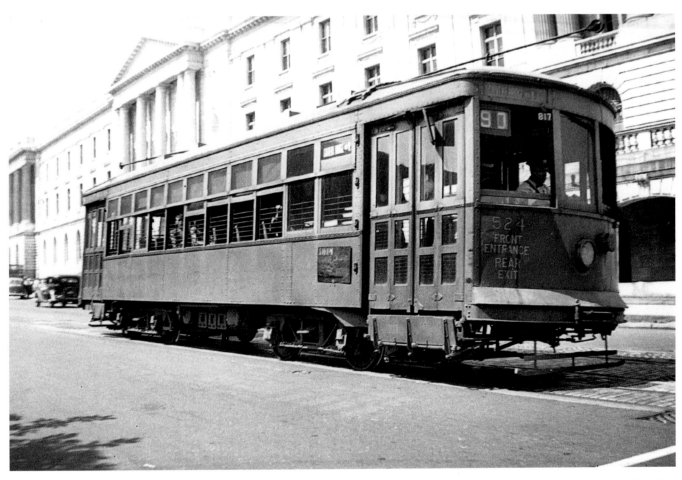

On July 3, 1939, CTC route 90 car No. 524 is at 1st and C streets SE. This originally was car No. 2084, one of 150 cars built by Osgood Bradley Car Company in 1922-1923 for United Electric Railways Company of Providence, Rhode Island. It was acquired in 1923, rehabilitated, renumbered 524, and was scrapped in 1950. (C. R. Scholes collection.)

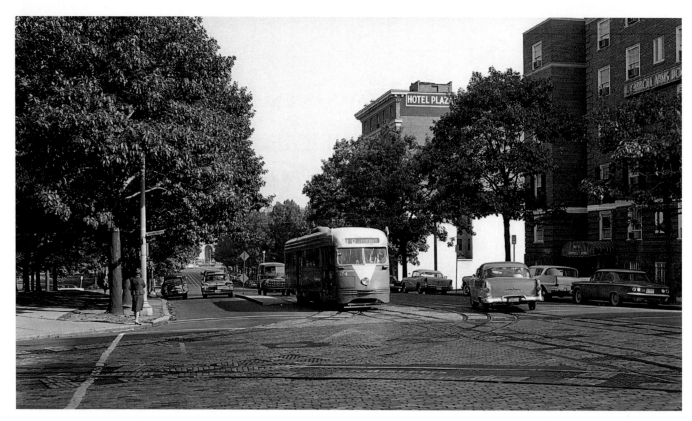

CTC route 90 PCC car No. 1174 is at 1st and C Streets NE on May 25, 1947. This car was built in 1938 and went to Tranvias de Barcelona (Barcelona, Spain) in 1964. (C. R. Scholes collection.)

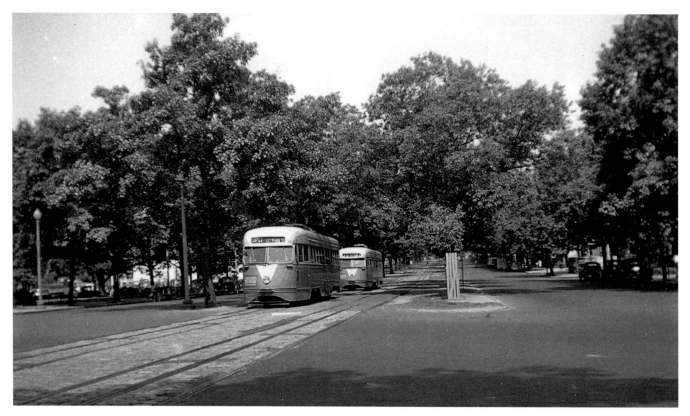

On June 25, 1947, CTC route 90 PCC car No. 1372 (built in 1942 and went to Gradsko Saobracatno Preduzege, Sarajevo in 1958) followed by PCC car No. 1486 (built in 1944, repainted in the DCTS paint scheme, and went to Tranvias de Barcelona in Barcelona, Spain in 1963) are on Pennsylvania Avenue at 5th Street SE. (C. R. Scholes collection.)

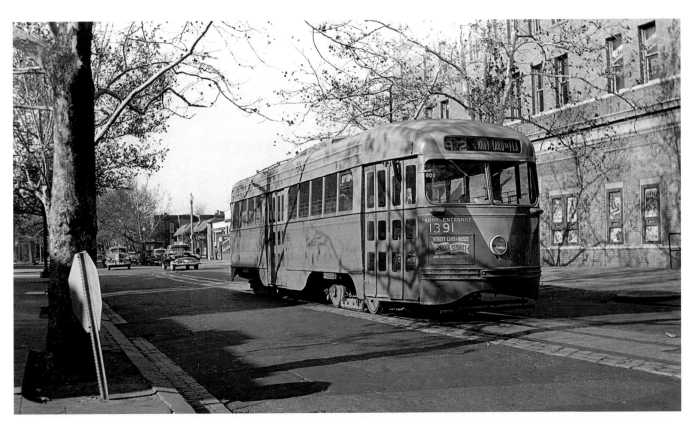

CTC route 92 PCC car No. 1391 is on the cutback loop on T Street NW between 7th Street and Florida Avenue for an eastbound trip to the Navy Yard via Florida Avenue in 1950. This car was built in 1942 and was scrapped in 1962. (Bill Stevenson photograph - C. R. Scholes collection.)

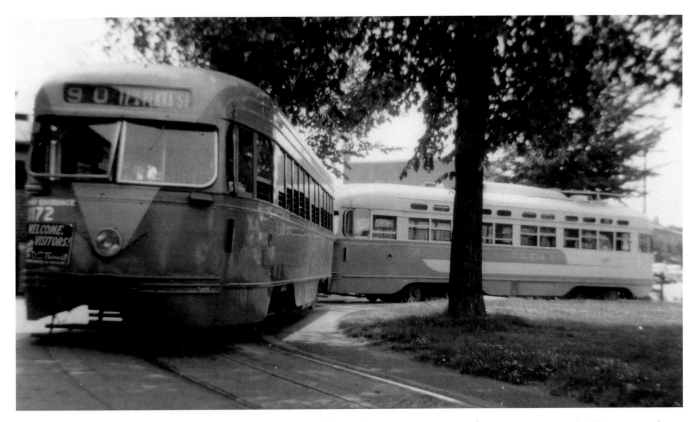

On May 29, 1959, DCTS route 90 PCC car No. 1172 is at the 17th and Pennsylvania Avenue SE loop. This car was built in 1938 and was scrapped in 1966. (Kenneth C. Springirth photograph.)

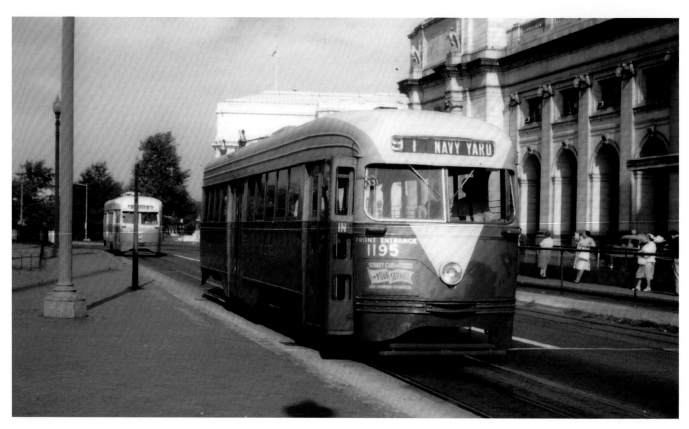

DCTS route 91 PCC car No. 1195 is at Union Station for a rush hour trip to the Navy Yard on June 9, 1959. This car was built in 1938 and went to Leonard's Department store in 1966. (Kenneth C. Springirth photograph.)

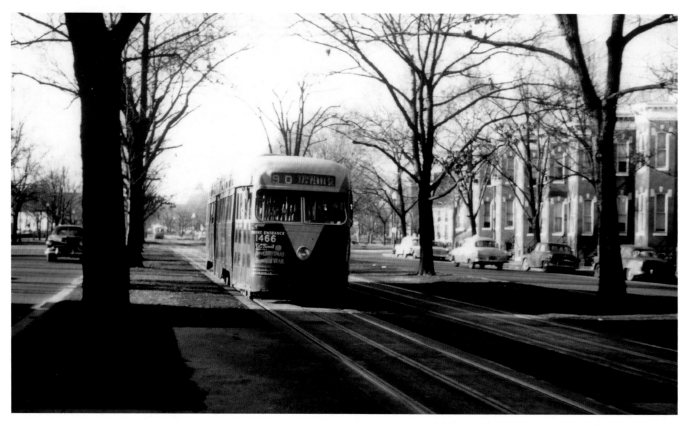

On a sunny winter January 1, 1960, DCST route 90 PCC car No. 1466 is travelling along Pennsylvania Avenue heading for 17th & Pennsylvania Avenue SE. This car was built in 1944 and was scrapped in 1963. (Kenneth C. Springirth photograph.)

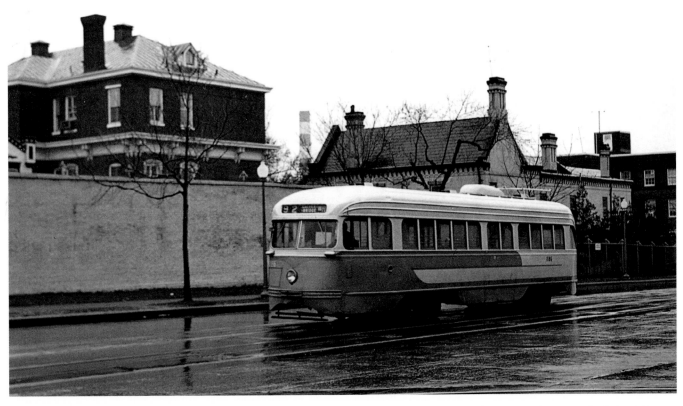

DCTS route 92 PCC car No. 1186 is on M Street SE at the Navy Yard car house on a rainy April 3, 1960. This car was built in 1938, was repainted in the DCTS paint scheme, and was scrapped in 1963. (Charles Griffin photograph - C. R. Scholes collection.)

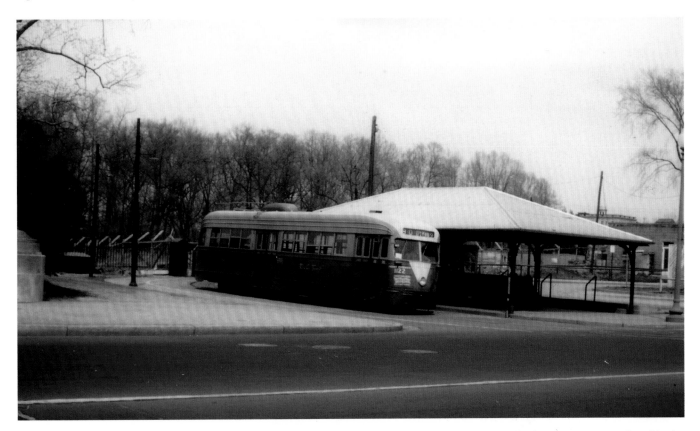

On April 15, 1960, DCTS route 90 PCC car No. 1122 is at the Calvert Street bridge loop. This car was built in 1937, was repainted in the DCTS paint scheme, and was scrapped in 1963. (Kenneth C. Springirth photograph.)

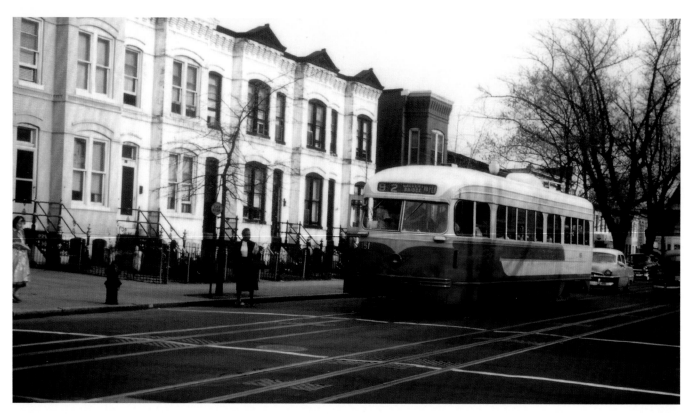

DCTS route 92 PCC car No. 1151 is on 8ᵗʰ Street at E. Capitol Street on April 15, 1960 with Calvert Bridge via Florida Avenue on the front destination sign. This car was built in 1938 and was scrapped in 1963. (Kenneth C. Springirth photograph.)

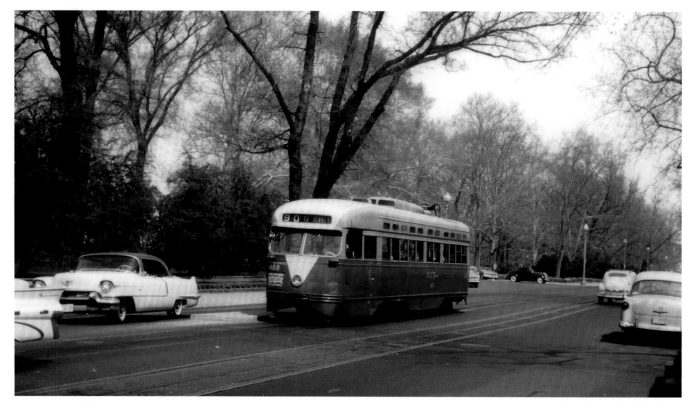

On April 15, 1960, DCTS route 90 PCC car No. 1468 is at 1ˢᵗ Street and Pennsylvania Avenue on a trip to 17ᵗʰ and Pennsylvania Avenue SE. This car was built in 1944 and scrapped in 1963. (Kenneth C. Springirth photograph.)

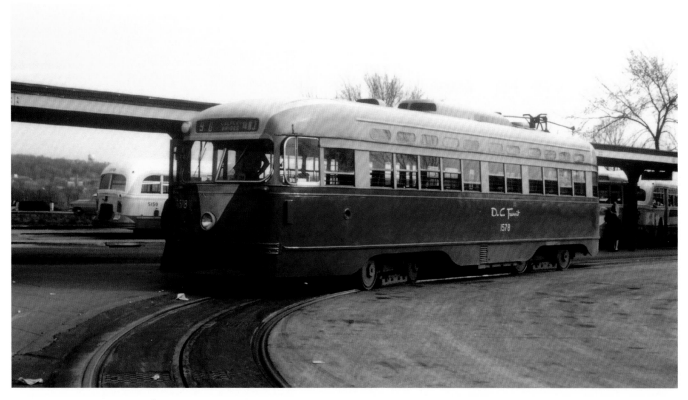

The Barney Circle loop at 17th Street and Pennsylvania Avenue is the location of DCTS route 90 PCC car No. 1578 on April 15, 1960. This car was built in 1945 and was scrapped in 1963. (Kenneth C. Springirth photograph.)

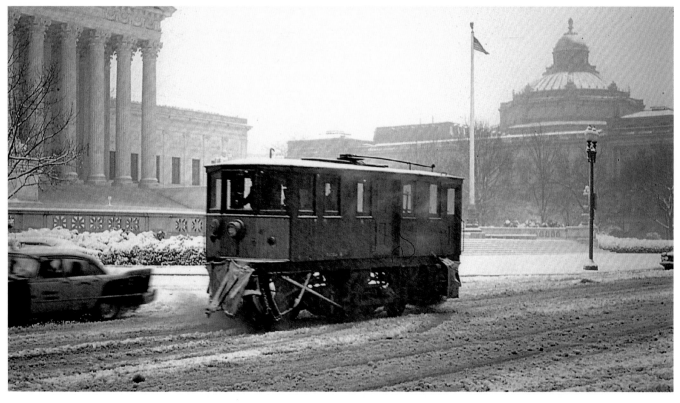

On a snowy December 11, 1960, DCTS snow sweeper No. 041 is on 1st Street and Maryland Avenue SW clearing the tracks. Snow sweepers were very important in Washington, DC, as road salt could not be used on streets that had the conduit system, because it would short out the conductor bars. This was one of two snow sweepers Nos. 040-041 built by McGuire Cummings Manufacturing Company in 1922 and each powered by two Westinghouse type 306 motors. These sweepers were scrapped in 1962. (C. R. Scholes collection.)

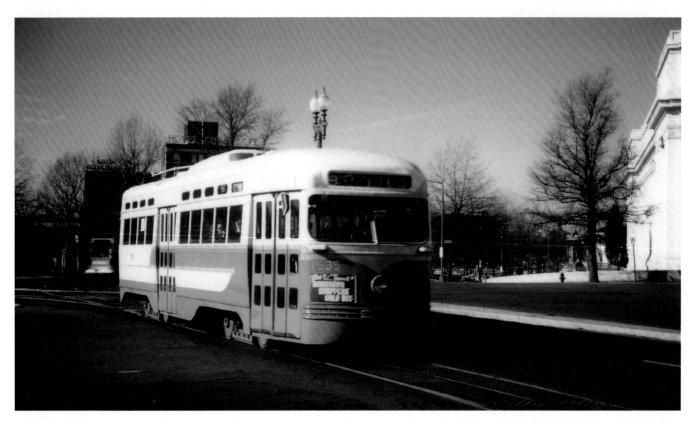

DCTS route 90 PCC car No. 1535 is on Massachusetts Avenue on December 15, 1961 in the DCTS paint scheme which gave the street cars a new look and symbolized a progressive transit system. This car was built in 1944 and went to Leonard's Department Store in Fort Worth, Texas, in 1962. (Kenneth C. Springirth photograph.)

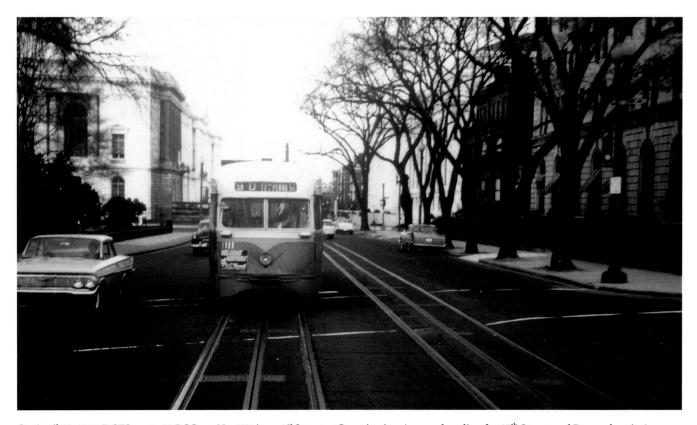

On April 16, 1961, DCTS route 90 PCC car No. 1111 is on 1st Street at Constitution Avenue heading for 17th Street and Pennsylvania Avenue. This car was built in 1937, was repainted in the DCTS paint scheme, and was scrapped in 1963. (Kenneth C. Springirth photograph.)

Chapter 13

DC Streetcar H St.–Benning Rd.

Washington, DC's government was looking at a plan for new street car lines including for H Street and Benning Road in the early 2000s. In 2004, three model 12 Trio street cars Nos. 101-103 were purchased from the Inekon Group in Prague, Czech Republic, as an add on to cars that were being built for Portland, Oregon. Plans to use an unused CSX track through Anacostia for a street car line were cancelled when the rights to use the line could not be obtained. The three streetcars remained in the Czech Republic.

While many H Street residents opposed the streetcar, DC government viewed a streetcar line as a way to entice development. Track construction began on H Street in 2009. The three streetcars arrived in Washington, DC, in December 2009 and were stored at Metro's Greenbelt rail yard. Citing a law that prohibited overhead wires in parts of the city including H Street, opposition emerged concerned about the aesthetics of the overhead wires. The District of Columbia Department of Transportation (DDOT) looked at wireless technology but concluded that it would entail major extra cost and maintenance issues. In May 2010, the DDOT placed a streetcar in a downtown parking lot so that people could see and board the vehicle. On Monday December 16, 2013, the first streetcar began safety testing and certification process. Three more street cars model 100 Nos. 201-203 were purchased from United Streetcar which arrived on January 21, 2014.

In February 2015, Leif Dormsjo, the new director of DDOT, contacted the American Public Transportation Association (APTA) requesting a Service Readiness peer review of the street car project. The review was conducted from March 9-13, 2015 and a number of recommendations were made which were documented in the *Peer Review for the District Department of Transportation Washington DC Final Report June 2015.* Three rail breaks (two on street trackage and one in the yard area) had occurred three months earlier. Some of the repair materials had to be obtained from a third party company, shipped from overseas, and go through US customs. The

report noted, "The breaks should be repaired quickly." Three cars Nos. 101-103 were built by the Inekon Group in Prague, Czech Republic. Three cars Nos. 201-203 were built by United Streetcar. Although the street cars look similar, there are many differences in driver training requirements and a separate parts inventory is needed. Train doors intermittently scraped against the side the edge of the station platform when opening and closing that, "damages the train door and platform edges." The report noted, "This seems to be a result of inadequate platform/train door clearance interface." Under "Other Observations," the report noted that "there were conflicts with parked vehicles along H Street." The report recommended, "DOT should therefore consider enlarging the 'park inside white line' signs and graphics to make them more evident to drivers and adding such elements as stenciling STREETCAR on the road next to the white line – to better inform the public of the reason for the white parking line." Lastly, the report noted, that at the existing Operations and Maintenance Facility, "we did not see a paint or body repair capability and considered this to be an informational item for consideration." The DDOT went to work on the recommendations.

On Saturday February 27, 2016, the 2.4-mile H Street/Benning Road streetcar line, costing more than $200 million, opened in Washington, DC. The author and his wife rode and walked the new street car line on Saturday April 16, 2016. There was excellent signage from the Metro Union Station to the Hopscotch Bridge (named because of the distinctive characters painted on the bridge sides) on H Street, which is the current western terminus of the DC Streetcar which operated every 15 minutes. Because of traffic congestion, the streetcars operate at a slow speed. The Washington Metropolitan Transit Authority bus route X2 (Minnesota Avenue Station via Benning Road and H Street to Lafayette Square) operates along the streetcar route. H Street between 3rd and 15th Streets is being revitalized, and the streetcar line is an important factor in attracting business and residents.

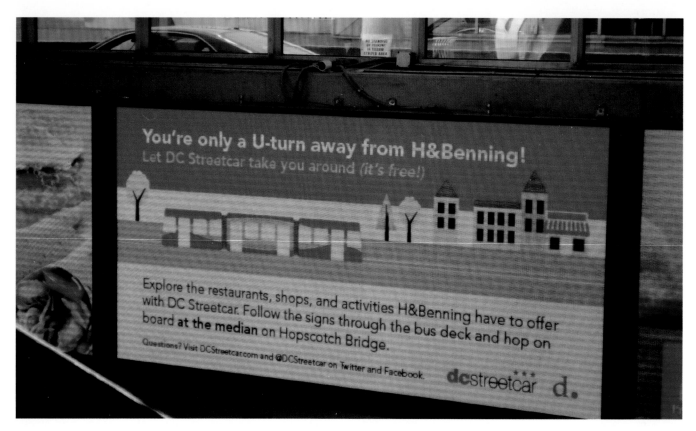

"You're only a U-turn away from H & Benning!" notes the sign at Union Station on April 16, 2016. There is excellent direction signage at Union Station to the streetcar line on H Street. While both Capital Transit Company and DC Transit System used the term street car, DC Streetcar does not separate "street" from "car" which is the reason "streetcar" is the term used in this chapter. (Kenneth C. Springirth photograph.)

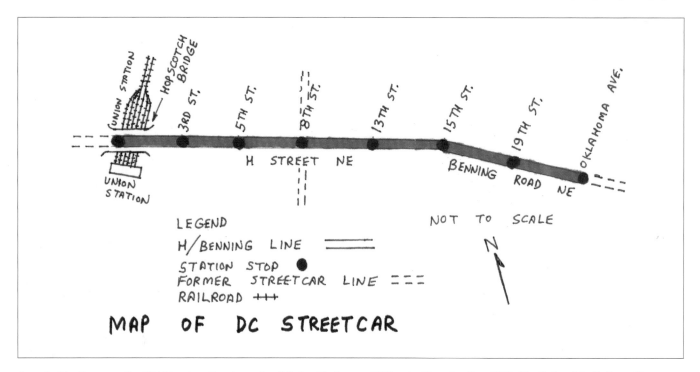

As noted by the map, the DC Streetcar line is north of Union Station on H Street – Benning Road NE. The Columbia Railway Company (CRC) began horse car service on a double track line on H Street in March 1872. CRC began constructing a cable system on October 28, 1895. In 1899, CRC converted to streetcar conduit operation. On May 1, 1949, buses replaced streetcar service on H Street and Benning Road. The H Street/Benning Road streetcar line opened February 27, 2016 (54 years after Washington, DC, completely converted to bus operation on January 28, 1962).

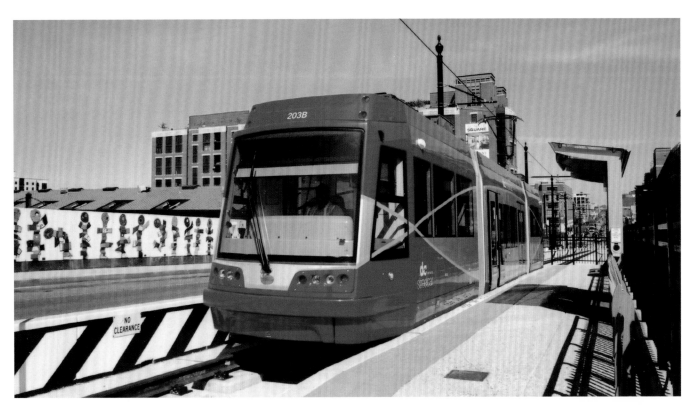

A sleek red and grey DC Streetcar No. 203 (one of three model 100 cars Nos. 201-203 built by United Streetcar) is at the western terminal located on the Hopscotch Bridge waiting for departure time on April 16, 2016. This bridge takes H Street over the Amtrak tracks just north of Union Station. The parade of distinctive characters painted along the side wall protecting pedestrians noted on the left side of the picture is why the bridge is referred as the Hopscotch Bridge. (Kenneth C. Springirth photograph.)

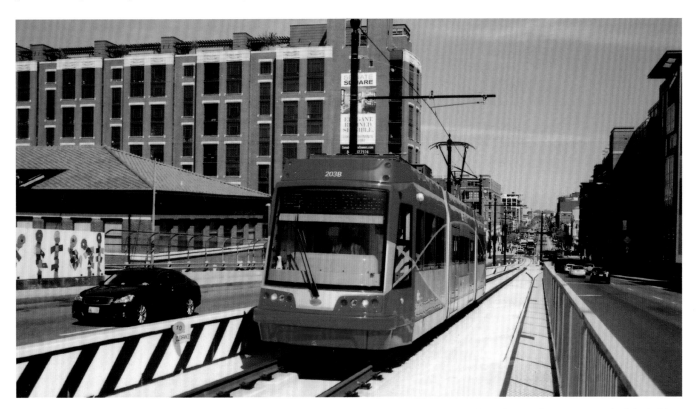

On April 16, 2016, DC Streetcar No. 203 is eastbound on the single track line on the Hopscotch Bridge. At the eastern end of the bridge, the double track begins on H Street. The 66-foot-long streetcar can handle a total of 150 people (seated and standing). Powered by 750 volts of electricity, there are three substations, and the overhead wire is supported by 75 poles. (Kenneth C. Springirth photograph.)

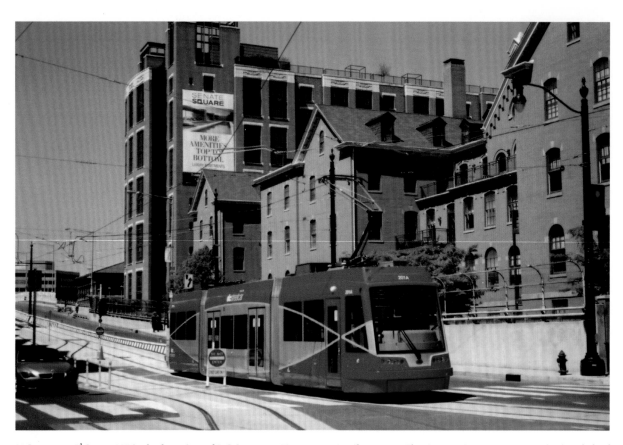

H Street at 3rd Street NE is the location of DC Streetcar No. 201 on April 16, 2016. The Senate Square Apartments just left of the streetcar advertise their close proximity to Union Station which has Amtrak, WMATA (Washington Metropolitan Area Transit Authority), MARC (Maryland Area Regional Commuter), and VRE (Virginia Rail Express) plus the DC Streetcar in the emerging H Street corridor. (Kenneth C. Springirth photograph.)

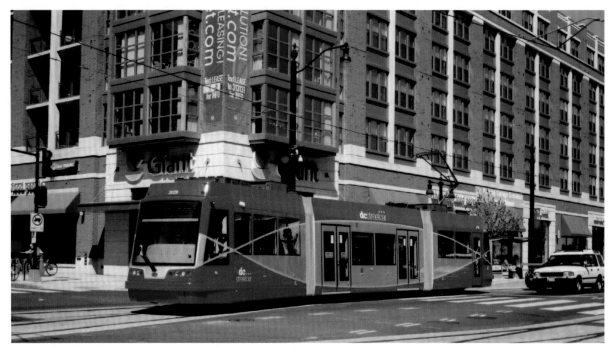

On April 16, 2016, DC Streetcar No. 202 is westbound on H Street crossing 3rd Street NE across from the Giant supermarket. This is in the Atlas neighborhood which runs along H Street east of Union Station to 15th Street and takes its name from the Atlas Theatre which was built in 1938, closed in 1976, and following renovation reopened as the Atlas Performing Arts Center in March 2005. (Kenneth C. Springirth photograph.)

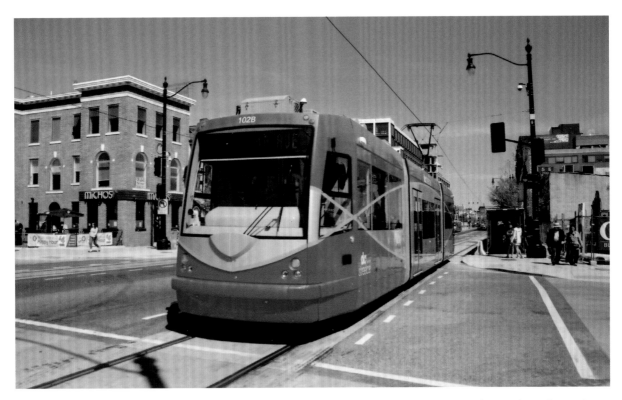

DC Streetcar No. 102 (one of three model 12 Trio cars Nos. 101-103 built by the Inekon Group) is eastbound on H Street crossing 5th Street NE on April 16, 2016. The streetcar has a low floor design for easier boarding and is wheelchair accessible. To the left of the streetcar is Michos, a Lebanese restaurant, in a stylish building. (Kenneth C. Springirth photograph.)

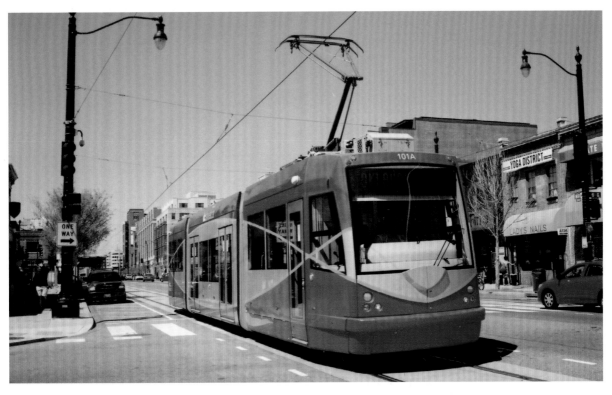

Eastbound DC Streetcar No. 101 is on H Street at 6th Street NE on April 16, 2016. H Street was originally constructed in 1849. With its closeness to Union Station, it became a thriving commercial district. Following a decline in the 1950s, after 2007, it has seen a rebirth. The Yoga District across the street on the right side of the picture is an example of the businesses that have been attracted to H Street which still has vacancies. (Kenneth C. Springirth photograph.)

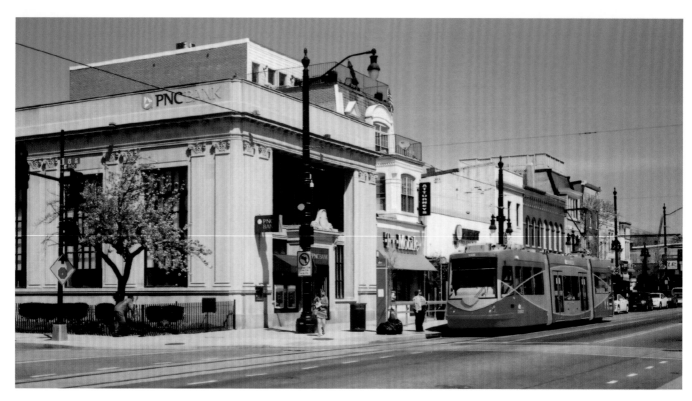

On April 16, 2016, DC Streetcar No. 102 is westbound on H Street at 8th Street NE at one of the 8 passenger stops on the line. At this intersection, the PNC Bank (a product of the 1983 merger of Pittsburgh National Corporation and Provident National Corporation) was designed by Washington, DC, architect B. Stanley Simmons and built in 1921 by J. L. Parsons for the National Bank of Washington. It later became Riggs Bank which merged with PNC in 2005. (Kenneth C. Springirth photograph.)

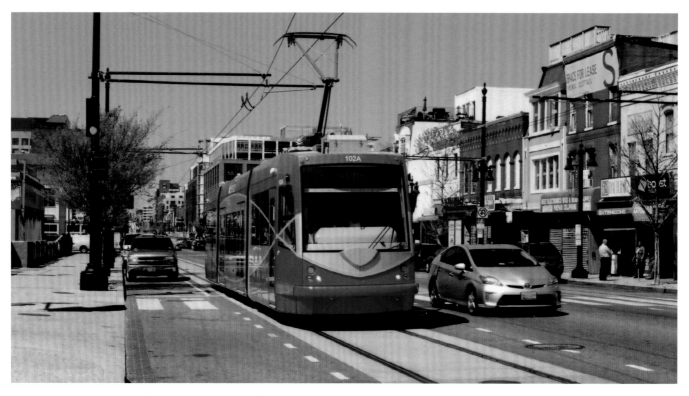

DC Streetcar No. 102 is eastbound on H Street at 9th Street NE on April 16, 2016 and Saturday headway (time interval between vehicles going to the same destination) that day was every 15 minutes. Average one-way trip time was 20 minutes. On the right side of the picture, a building advertises "Space for Lease" which illustrates the effort to fill empty buildings in this re-emerging commercial district. (Kenneth C. Springirth photograph.)

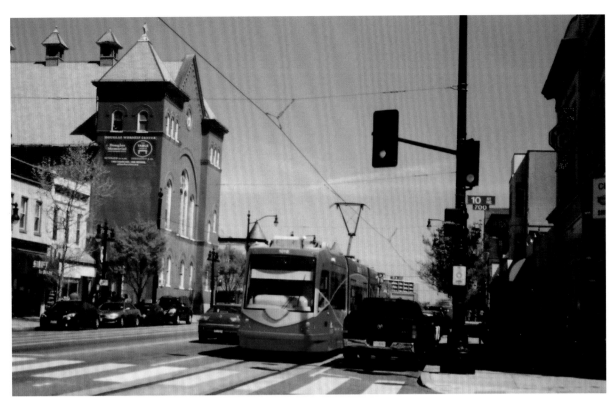

On April 16, 2016, DC Streetcar No. 101 is eastbound on H Street at 10th Street NE. Left of the streetcar is the Romanesque style (characterized by semi-circular arches and large towers) Douglas Memorial United Methodist Church that was built by J. C. Yost following the plans of Joseph C. Johnson for $18,000 in 1898. United States President William Howard Taft spoke at this church for the 127th session of the Baltimore Conference in 1911. (Kenneth C. Springirth photograph.)

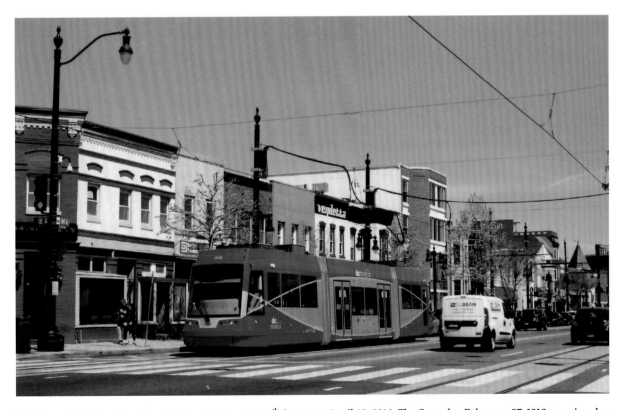

Westbound DC Streetcar No. 203 is on H Street at 12th Street on April 16, 2016. The Saturday February 27, 1916 opening day ridership was 8,124. Ridership for March 2016 (the first full month of operation) according to DC Streetcar was 2,419 for an average weekday, 3,053 for an average Saturday, and the total March 2016 ridership was 67,853. (Kenneth C. Springirth photograph.)

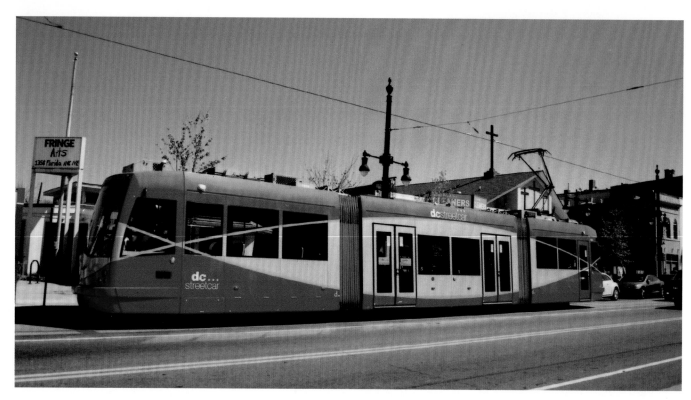

On April 16, 2016, DC Streetcar No. 102 is on H Street at 14th Street NE. The *District of Columbia Transit Alternatives Analysis Final Report October 2005*, notes that the H Street NE Streetcar "Increases Accessibility," "population is 7,736 per route mile," "Supports City Initiatives – directly serves a designated main street corridor," "Increases in Corridor Transit Capacity – 165%," and is a "Visual/Community Fit." (Kenneth C. Springirth photograph.)

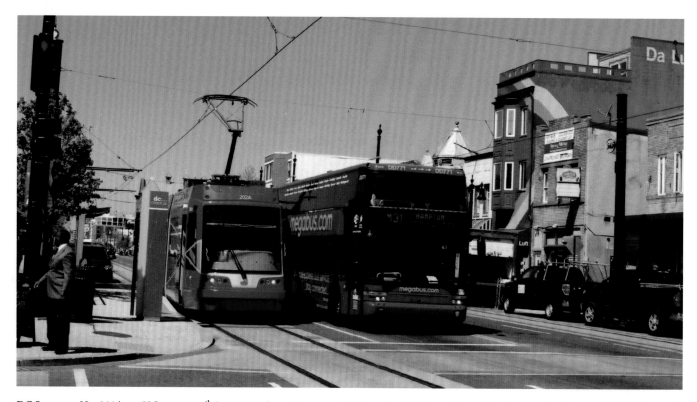

DC Streetcar No. 202 is on H Street at 13th Street NE alongside a route 31 Megabus (Philadelphia via Baltimore, Washington DC, Richmond, and Hampton) on April 16, 2016. A number of intercity buses use H Street because of its access to the interstate highway system. Historically H Street from 3rd to 15th Street was an important shopping district that witnessed a dramatic decline and is now making a recovery. (Kenneth C. Springirth photograph.)

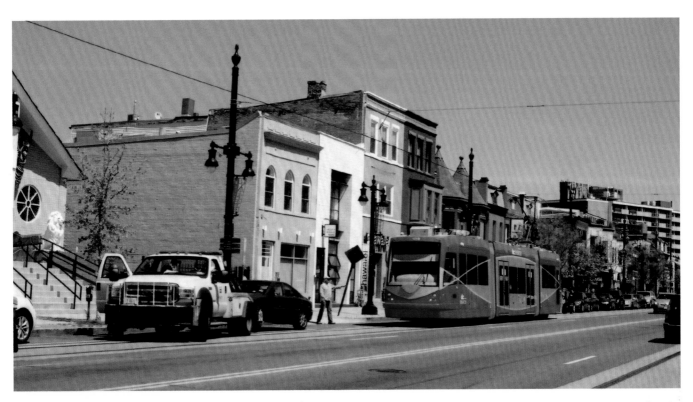

An automobile is being towed on H Street just east of 14th Street NE on April 16, 2016 so that DC Streetcar No. 101 can proceed on its westbound trip to Union Station. To avoid a $100 ticket, the entire motor vehicle must be parked within the white lines on the H/Benning streetcar line. (Kenneth C. Springirth photograph.)

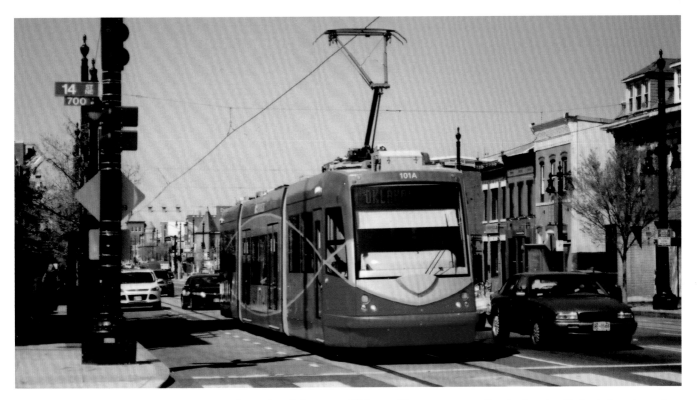

On April 16, 2016, DC Streetcar No. 101 is eastbound on H Street at 14th Street. The new streetcar line is already a factor in housing prices with H Street row homes starting at $500,000 in 2016. Much of the housing on H Street and surrounding area includes two- and three-story homes and row houses that date back to the early 1900s. (Kenneth C. Springirth photograph.)

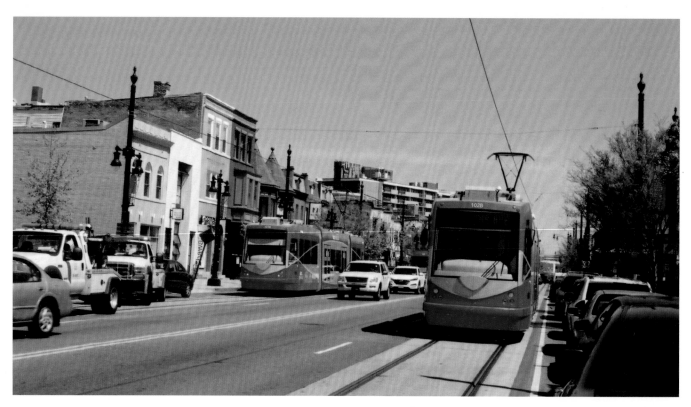

DC Streetcar No. 101 westbound is passing eastbound No. 102 on H Street at 14th Street NE on April 16, 2016. The 1872 opening of the Columbia Railway Company horse car line along H Street contributed to the residential and commercial development along the corridor. After World War II, decline occurred as residents migrated to suburban areas. Streetcar service on H Street ended on May 1, 1949. (Kenneth C. Springirth photograph.)

In this interior view of DC Streetcar No. 202, the operator's area is completely enclosed with a door for entering and exiting in this April 16, 2016 view. (Kenneth C. Springirth photograph.)

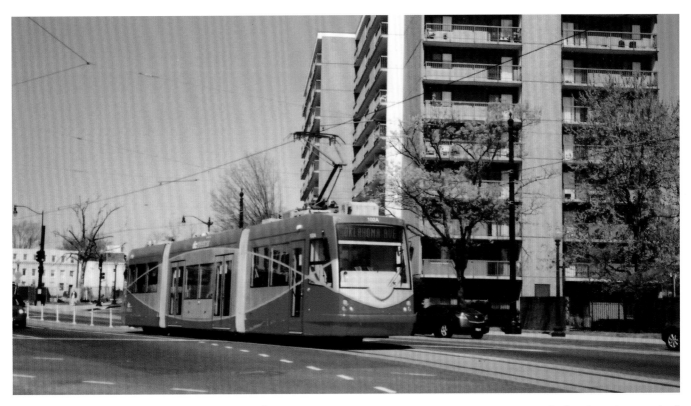

Eastbound DC Streetcar No. 102 is on H Street at 15th Street NE on April 16, 2016. This intersection is known as the "starburst intersection" where Bladensburg Road, Maryland Avenue, H Street, 15th Street, Benning Road, and Florida Avenue meet. In 1929, Sears, Roebuck & Company opened its first store in the Washington area at H Street and Bladensburg Road. (Kenneth C. Springirth photograph.)

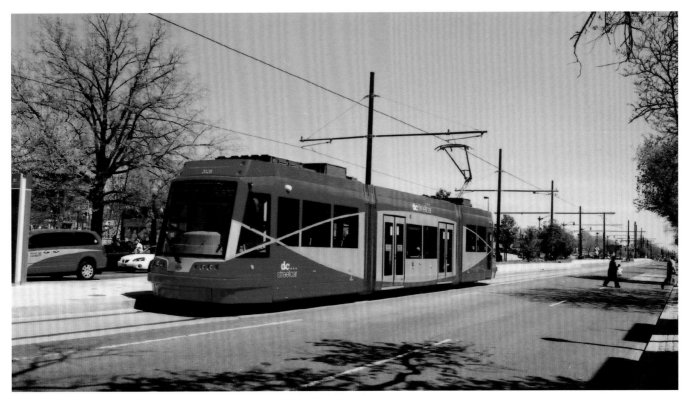

On April 16, 2016, DC Streetcar No. 202 is eastbound on Benning Road at 15th Street NE. The heavy volume of automobile traffic along H Street and decline in the area reduced pedestrian traffic. Beginning in the late 1990s, a revival began and the reintroduction of streetcars back on H Street is part of a plan to enhance commercial and residential development. (Kenneth C. Springirth photograph.)

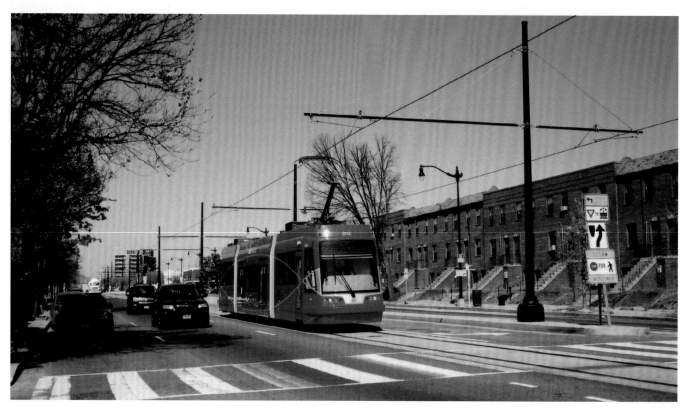

DC Streetcar No. 201 is eastbound on Benning Street at 18th Street on April 16, 2016. There are virtually no industries in this portion of the H Street/Benning Road corridor. As the environment of the adjacent residential areas continues to improve, there are more customer opportunities for existing and new businesses with the DC Streetcar providing an attractive transportation alternative in the corridor. (Kenneth C. Springirth photograph.)

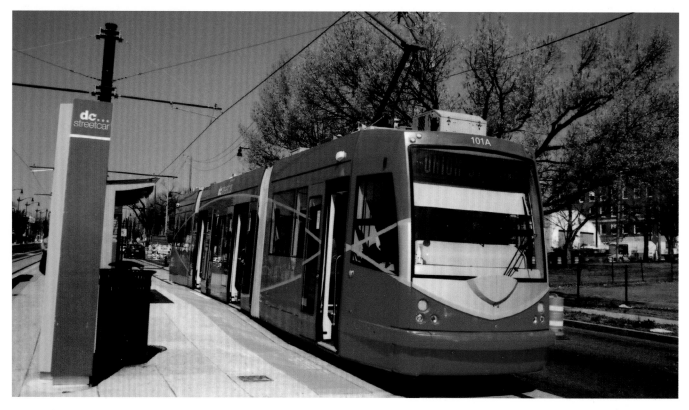

On April 16, 2016, DC Streetcar No. 101 is at the eastern terminus on Benning Road and Oklahoma Avenue NE. This is in the Carver Langston neighborhood of Northeast Washington, DC. (Kenneth C. Springirth photograph.)

National Capital Trolley Museum

A group of street car enthusiasts incorporated the National Capital Historical Museum of Transportation (NCHMT) in 1959. Working with Baltimore area enthusiasts, they established a museum site at Lake Roland in Baltimore County, Maryland, for both the standard gauge cars from Washington and the broad gauge cars from Baltimore. However, objections of some neighbors to the development of an operating railway museum in the Robert E. Lee Park caused NCHMT to seek another location. In 1965, NCHMT reached agreement to establish an operating railway museum at the Northwest Branch Park of the Maryland-National Capital Park and Planning Commission (M-NCPPC) in Montgomery County, Maryland at no cost to use the land; however, private sources had to be used to build all of the museum facilities. Baltimore area enthusiasts incorporated the Baltimore Streetcar Museum in 1966 and located their operating railway museum along Falls Road with assistance from the City of Baltimore.

NCHMT soon adopted the simpler trading name National Capital Trolley Museum (NCTM) and began construction in the fall off 1965. A three track carbarn was competed in April 1966. By August 1966, Washington, DC, snow sweeper No. 07, work car No. 0522, and Johnstown car No. 352 arrived at the museum. NCTM then built a 2,700 square foot visitor center. European cars No. 955 from Dusseldorf; No. 5954 from Berlin; No. 120 from Graz, Austria; Vienna motor car No. 6062; and trailer 7802 arrived in 1969. Laying track began in January 1969 with 3,800 feet completed by May 4, 1969. Erecting the overhead trolley wire began in July 1969. Vienna street car No. 6062 made the first trip on September 9, 1969 followed by Johnstown car No. 352 on September 13, 1969. Following a request by NCTM member Garey Browne to DC Transit System (DCTS) that their historic street car collection be donated to the museum, DCTS donated four cars to the museum. During March 1970, Washington, DC, street cars Nos. 766, 1053, 1101, and 1512 arrived at the museum. On September 11, 1970, the former DCTS air conditioned Presidents Conference Committee (PCC) car No. 1512 *Silver Sightseer* was destroyed by fire and was later scrapped. Vienna car No. 4220 (originally Third Avenue Railway System car No. 678 from New York City) arrived in 1971. On August 10, 1973 service car No. 0509 arrived at the museum.

An extension of the museum trackage was completed with the overhead wire installed and revenue service beginning on July 23, 1975 over the line that now provided a round-trip of 1.72 miles. Toronto Transit Commission PCC car No. 4603 arrived, was refitted with standard gauge trucks because of Toronto's nonstandard track gauge, and entered museum service in September 1996. Capital Transit Company PCC car No. 1430 was obtained from the Rockhill Trolley Museum in Rockhill Furnace, Pennsylvania, and arrived at the museum on November 3, 1997. Washington Railway & Electric Company (WRECO) car No. 650 was obtained from the Shoreline Trolley Museum during 2001. PCC car No. 1329 was acquired from Haagsche Tramsweg-Maatschappij (HTM) of The Hague, Netherlands, and was placed in museum service on July 28, 2001. A September 28, 2003 carbarn fire destroyed Washington, DC, cars Nos. 0509, 1053, 07, and 026; Johnstown car No. 352; Graz car No. 120; and Vienna car Nos. 6062 and 7802.

The possibility of the construction of a new highway, the Intercounty Connector (ICC) through Northwest Branch Park made development of the existing Museum campus impossible. The museum worked with M-NCPPC to design a new campus deeper in the Park and raised funds for an exhibit building (Street Car Hall) at this new site. As construction of Street Car Hall was underway, the ICC became a reality, and the Museum had to develop the rest of its new campus quickly with migration funding from the ICC. The museum closed its original facility in December 2008 and opened its new facility on January 16, 2010.

This museum provides an enjoyable educational look back to when street cars provided public transit in most United States communities. The February 27, 2016, reintroduction of street cars on H Street/Benning Road in Washington, DC, makes this museum even more important, because this is the first time in history that a transportation concept that almost went out of existence is coming back. Montgomery County (Maryland) Transit has two daily bus routes 26 (Glenmont Metro Station - Montgomery Mall Transit Center) and 49 (Rockville Metro Center - Glenmont Metro Station) that stop at Bel Pre Road and LayHill Road, which is about a mile walk from that intersection east on Bel Pre Road that then becomes Bonifant Road to the museum. Monday-Friday rush hour route 39 (Glenmont Metro Station – Briggs Chaney Park and Ride) actually passes by the museum. (Kenneth C. Springirth photograph.)

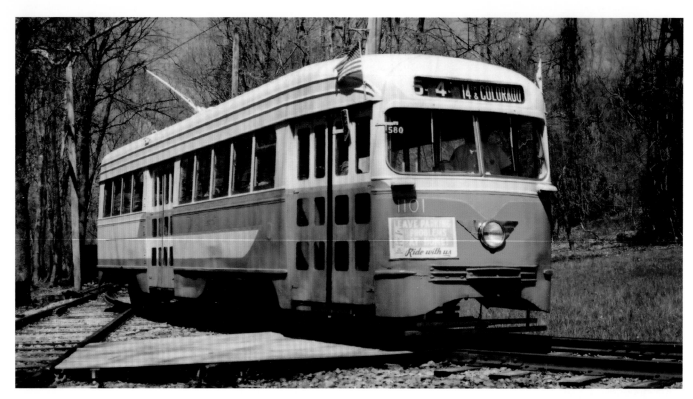

Former DC Transit System (DCTS) car No. 1101 is making a run at the National Capital Trolley Museum on April 17, 2016. Built by St. Louis Car Company in 1937, this car was powered by four Westinghouse type 1432 motors, seated 54, and weighed 33,800 pounds. The car operated on the last day of street car service in Washington, DC, on January 28, 1962. DCTS donated the car to the Museum, and it arrived in March 1970. (Kenneth C. Springirth photograph.)

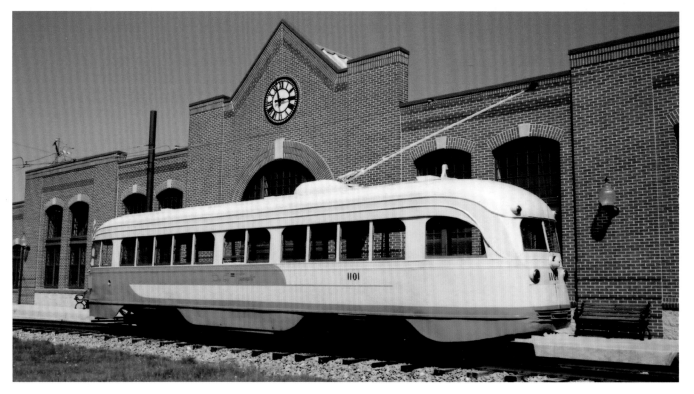

On April 17, 2016, former DCTS PCC car No. 1101 is at the National Capital Trolley Museum. The elegant streamlined style of this car, a tribute of years of outstanding design effort, symbolized the final years of street car operation in Washington, DC. Even up to their last day of operation in regular service, these cars provided a quiet clean comfortable ride. While the modern light rail vehicles of 2016 require debugging, generally the PCC car upon delivery was quickly placed in service. (Kenneth C. Springirth photograph.)

Capital Traction Company single truck car No. 522 is undergoing restoration in this scene at the National Capital Trolley Museum (NCTM) on April 17, 2016. This was one of 70 cars built by American Car Company in 1898. The double ended car, originally numbered 222, was painted green and cream for its assignment to the Pennsylvania Avenue route. In 1906, it was renumbered 522. Transferred to Capital Transit Company, it became rail grinder No. 0522. DC Transit System donated the car to NCTM in 1962. (Kenneth C. Springirth photograph.)

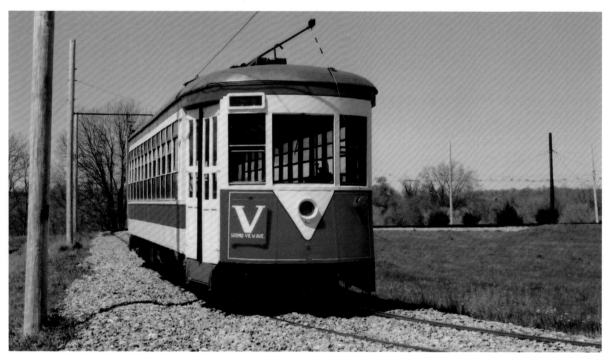

Former Third Avenue Railway System (TARS) car No. 678 is at the NCTM on April 17, 2016. This double truck car was built in the company's 65th Street shops in 1939. After the abandonment of trolley car service in the Bronx in 1948, this was one of 40 cars that went to the Wiener Stadtwerke in Vienna, Austria, under the Marshall Plan and served 20 years as No. 4220. The car was purchased by NCTM and arrived at the Museum in 1971. (Kenneth C. Springirth photograph.)

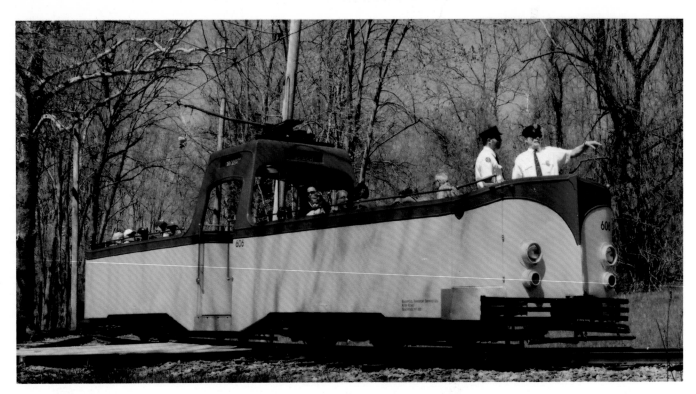

On April 17, 2016, Blackpool Transport Services (BTS) open air summer tourist car No. 606 is at the NCTM. This was one of 12 cars Nos. 225-236 built in 1934 by English Electric for BTS. Known as "the Boats," the cars were used on the seaside route in Blackpool, England. With a reduction in cars by 1968, BTS renumbered the remaining cars 600-607. In 2000, BTS traded No. 606 to the Gerald Brookins Museum of Electric Railways (Columbia Park) in exchange for a double deck car. NCTM purchased BTS No. 606 in 2009 from the Lake Shore Electric Railway Museum after the Gerald Brookins Museum closed. (Kenneth C. Springirth photograph.)

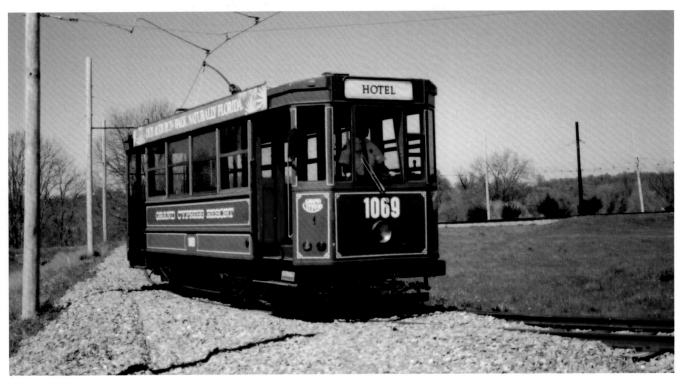

Single truck car No. 1069 is operating at the NCTM on April 17, 2016. Les Ateliers Metallurgiques de Nivelles of Belgium built this car in 1907 for Societe des Transports Intercommunaux de Bruxelles (STIB). It was in passenger service in Belgium until 1975. Following a restoration to its original condition in 1984, and painted a dark green, it was used at the Grand Cypress Resort in Orlando, Florida, to transport golfers. In 2004, it was acquired by NCTM. (Kenneth C. Springirth photograph.)